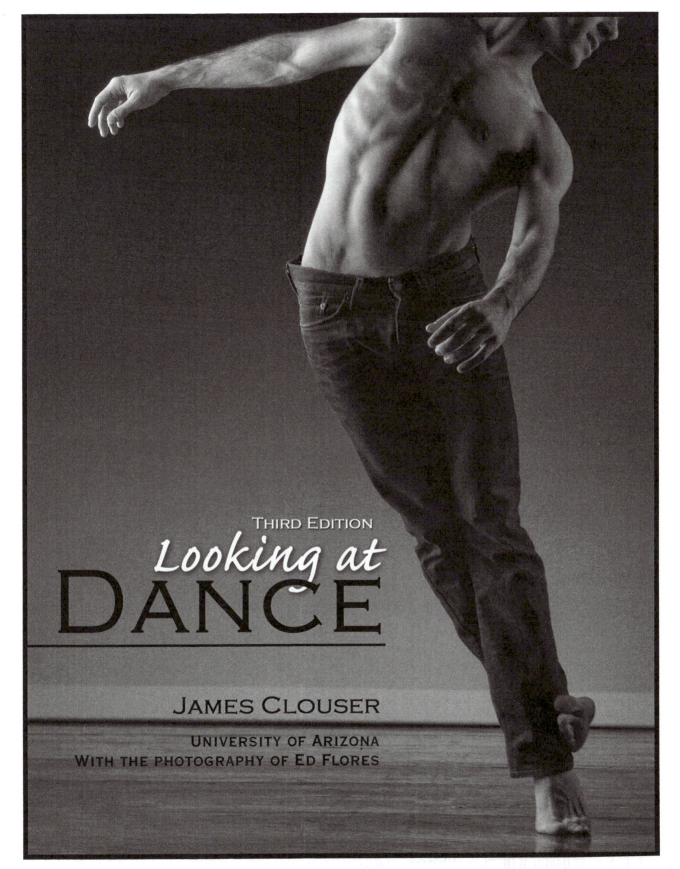

THIRD EDITION

Looking at DANCE

JAMES CLOUSER

UNIVERSITY OF ARIZONA
WITH THE PHOTOGRAPHY OF ED FLORES

Kendall Hunt
publishing company

D0073763

Cover image courtesy of Ed Flores, *Body and Line: The Photography of Ed Flores*

Interior images courtesy of Ed Flores; www.edflores.com

Kendall Hunt
publishing company

www.kendallhunt.com
Send all inquiries to:
4050 Westmark Drive
Dubuque, IA 52004-1840

CONTENTS

Preface

The idea for this book came from the editors of Kendall Hunt, a publishing company that specializes in college textbooks. I am indebted to them for their encouragement of my suggestion of producing an atypical text book, a first person guide that could not only be used in a college survey course but would be of interest to anyone being introduced to dance.

I am grateful to Arnold Spohr, Martha Myers and Mary Ella Montague for encouraging my early development as a teacher, and to Connecticut College, Sam Houston State University, The University of Houston, Texas Christian University and the University of North Texas where I came to love teaching this subject. I thank Jory Hancock for coaxing me out of retirement and the rest of my colleagues at the University of Arizona for allowing me to develop my pedagogical theories within their curriculum.

In this introduction to dance, a subject of enormous scope, I have focused my attention on the theatrical dance forms most likely to be seen in our theatres today and taught in our schools. Along the way, I hope I have also shed some light on the phenomenon of people dancing, not for pay or glory, but for joy and communion.

This is not meant to be a reference book so neither a formal bibliography nor an index has been included. At the end of some chapters I have included additional information that is more encyclopedic in nature, along with review material and suggestions for further self-directed exploration. You will also find the occasional quiz designed to help you identify and retain the most pertinent information. Not much of this information will be useful to you if you are not also looking at dance in a way you have never looked before. At the back of the book is a page for you to begin to record the dance works you experience while undertaking this study.

The order in which the chapters are meant to be read is arbitrary and I hope that readers will feel free to begin with what interests them most. You will find that throughout I encourage the reader to read carefully, to write with clarity, and to look with curiosity.

Everywhere people are leaping . . . jumping up, jumping out, jumping into something . . . inching forward, rolling back . . . leaning, hopping, shuffling, twisting, turning, reaching, flinging . . . slipping and sliding, falling and recovering . . . to cool off, to heat up, to complain, to question, to survive . . . to celebrate their lives in movement.

Depicted here is Anthony Raimondi celebrating the completion of his BFA at the University of Arizona's School of Dance.

Asking the Why Question and the What

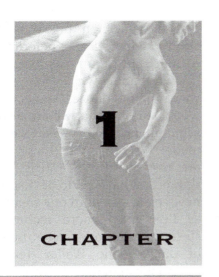

1

CHAPTER

"What is this thing that I love so much?"

I had been a professional dancer for four years when it first occurred to me to ask this question. I was with the Royal Winnipeg Ballet, in the back of a bus somewhere in the middle of a bleak Saskatchewan winter. My fellow performers were hunkered down in their seats, tucked under their overcoats, sleeping away the empty hours until we reached Moose Jaw.

My mind was on the lecture demonstration that I had led the day before, for the first time, at a school matinee in Saskatoon. I had been pleased when my director, Arnold Spohr, assigned me this responsibility and I eagerly devised what I believed to be an enjoyable and informative series of exercises and choreographic excerpts. There was a question and answer period at the end, just before we closed with a rousing and easily digestible finale. I don't remember what questions I thought would be asked, but I do remember being surprised by what roused the curiosity of the youngsters in our audience.

They wanted to know how long it took to get so good, how much money we made, if any of us were married, if the women's satin and glue toe shoes hurt, what the men wore for support under their tights. These questions were easy to answer. Then a tiny voice piped up.

"Why?"

It is remarkable how many thoughts can go through your head in a split second. Something in the way that why was sounded, with a shy and curious upturn at the end, told me the question was not why we did something this way instead of that way, but why we did this particular something . . . this thing called dancing . . . at all.

My first inclination was to quote a line from the film "The Red Shoes," the answer the story's doomed ballerina gives when asked, "Why do you want to dance?" She answers without hesitation, "Why do you want to live?" But I am ashamed to say that suddenly that romantic notion seemed an inadequate answer, shallow and corny. I was embarrassed to admit that I was hooked on something most folks knew little or nothing about. Instead, I mumbled something incoherent.

On that long ride from Saskatoon to Moose Jaw I looked down the aisle of the bus at my friends. Why did any of us do it? We had worked hard and sacrificed much to get as good as we were and we knew, if we kept at it, we were going to get better. We also knew that none of us were going to make money at it. Marriage was something we knew would mean a serious reconsideration of the direction our careers were taking us. Toe shoes do hurt and, like the other physical extremes that a dancer endures, can cause lasting trauma. Matters of aesthetics aside, a man's dance belt is not uncomfortable.

In the days and weeks and years since, I have asked myself a lot of "why" questions. Why do we play? Why do we sing? Why do we sometimes find ourselves dancing, moving alone or together? Why do we find ourselves gathering in all sorts of unusual places to watch others dance? Eventually I came to understand

that the question posed by that wondering child's "why" was a rhetorical one. It was not so much an inquiry as a statement, more of a "wow" than a "why." How wonderful it is that we can make dances, songs and pictures! How wonderful it is that we are drawn to repeat our acquaintance with what we, or others, have made! We remember these things when they are not there! We anticipate, even envision, things that have yet to be made, things that may never exist except in our creative imaginations!

I've given more lecture demonstrations since that first one, some under the mentoring of dance critic Walter Terry, a remarkably optimistic man who devoted his life and writing to the celebration of dance and to its scrutiny. Terry was not concerned with the existential ramifications of the question "why."

An army cryptographer during World War II, he devoted himself to deciphering and describing the art form of dance, peeling back its mysteries and conventions so that others could experience what he found so wondrous and powerful. He urged me to stop questioning and just start looking. The "why" of dance was evident to him when he looked at the "what" of dance. No other form of human expression is so peculiar and seductive, so invigorating and thought provoking, so amazingly adorned . . . so astoundingly diverse.

When is a movement just a movement and when is it dance? Most dictionaries give a general and not very satisfying definition of dance that identifies it as set movements accompanied by some sort of audible rhythm. Does that mean that a parade is a dance?

Some will define dance as expression through movement. Does that mean that a frustrated child with stomping feet and flailing arms is dancing? A poet might say that a flock of birds sweeping across the sky, or a stand of trees trembling in the wind are dancing. Could you say that a pennant of ragged toilet tissue clinging to your tree after Halloween night has found itself a breeze in which to dance?

The mating rituals of birds and insects have been studied, along with other animal activities which appear to be "dance-like," but how many of the world's myriad creatures break into a dance or a song just for the heck of it?

Walter Terry defined dance as the expression of physical, emotional or intellectual urges through rhythmic, ordered and dynamic human movement. Rhythm he defined as any repeated pattern of emphasis. Order inferred conscious decisions even if they include the permission to improvise. To many, dynamic means at a high paced "in your face" energy level. Terry used the term in the sense of dynamics being progressive changes in the energy level of the movements, be they quick or slow, strong or gentle.

Adhering to this definition, I could see that as much as I might appreciate the beauty of birds in flight or trees swaying in the wind I would not consider these phenomena to be dance. The stomping and flailing movements of a frustrated child are certainly human expression but are not dance unless someone imitates them, perhaps repeating them over and over with the purpose of expressing what it was like to see or be the child in his frustration. I am still not sure about the parade.

In the early 1970's, as a member of the faculties of Connecticut College and the American Dance Festival, I was fortunate enough to become acquainted with dance critic and historian, Selma Jeanne Cohen, with whom I shared a love of the Romantic Era of Ballet as embodied in the technique and choreography of the 19th Century Danish Ballet Master, Auguste Bournonville. At that time, the American Dance Festival was encouraging such cutting edge choreographers as Yvonne Rainer, Twyla Tharp and Anna Halprin, whose works were challenging traditional notions of what ought to be considered as dance. In her lectures and writing and during several extended lunches in the school cafeteria, Miss Cohen helped me make sense of dances that consisted of no more than the peeling of an orange or singing in the dark to the accompaniment of squeaking balloons.

Cohen's guide is a deceptively simple one. It purposely avoids the diverting question of aesthetic judgment. A dancer, something to dance and a place to dance it are required, along with two further things that I find particularly significant for they introduce the matter of motive. An audience is required and whatever supporting elements, such as lighting and costuming, are essential to reveal the dance to the onlookers. Purpose is involved. Someone wants someone else to look at something.

Following this guide, I came to intellectually accept the peeling of an orange, under theatrical

conditions, might become a work of art, but I still wonder how little kinetic appeal a movement performance can have and still be called a dance. Our bodies are not only wired with eyes for sight, nerves for touch, a nose for smell, ears to capture sound and a tongue to taste, we are also equipped with receptors embedded throughout our tissue that sense motion. Surely the power of dance to move us, physically, emotionally or intellectually is found in its kinetic persuasion.

These many years later, each fall as I prepare for my academic lectures, I reconsider the "why" questions I know I will be asked and that I would like my students to ask themselves. I know a discussion of aesthetics . . . why someone likes something or not . . . will present itself in due time. Instead of leading off with such heady matters I begin by presenting Terry's and Cohen's simple guides to looking at dance. And I urge my students to put away the "why" for a while and investigate the "what."

There is no one best way to begin an investigation of dance as a theatrical art form. Each person's curiosity about dance is aroused by something personal and particular. Perhaps that curiosity is initiated when someone is moved by the kinetic, emotional, or visual power of a live performance, or, perhaps, because someone's mother signed them up for dancing lessons. Perhaps it begins as the result of a college course someone takes because it meets a requirement for her or his graduation and is offered at a convenient hour. Perhaps it arises out of a genuine interest in human behavior.

Although the focus of this book is on the development of Western theatrical dancing, our understanding of the art form will be informed by looking, also, at dancing that is social or religious in intent rather than theatrical. Go to a prom or a square dance. Go to a club. Go to a folk festival or a Native American ritual like the Corn Dances of the Southwest.

Looking at dance means looking at other art forms as well, particularly those with which dancers collaborate or from which they might take inspiration. An investigation of the great musical scores written for dance would be fruitful, as would a study of great figures in dance who were not performing dancers, but rather, entrepreneurs, patrons, and advocates. The history of the inventions in backstage production, light projection, mechanical rigging and computer technology, for instance, will yield information surprisingly similar to that unearthed by a study of choreographic innovations. A good course in dance or theatre history is a good course in world history.

While investigating dance, it is important to keep in mind that the elements of theatrical dance are not always equal in importance. Does the dancer dictate the aesthetic of the performance, or does the place in which the performance is to be given? Does the choreographer endeavor to please the audience or please himself? Is the physical act of dancing of primary importance or is the dancer part of a bigger visual and aural spectacle? Look at the dancing that can so often be seen on television commercials. Is it devised to please the choreographer, the dancer, the viewer or the sponsor?

Look at the dances of an era. See how they reflect the taste of that era and its climate of ideas. Look at how the developments in dance are initiated and accelerated by social, political and economic conditions. While looking back at the Renaissance, the Romantic Era, the heydays of Petipa and Balanchine, the struggles of the African American performer, the noble aspirations of Ruth St. Denis, Isadora Duncan and Martha Graham, and the accomplishments of Broadway and Hollywood, look at the influence of the individual of genius, the performer, the teacher, the choreographer, and the entrepreneur.

There is no social trend that can explain the sudden emergence of the communicative dancer with the ability to jump higher, turn faster, stretch further and express more than anyone else. This dancer moves audiences and inspires other dancers to better themselves, bringing new options for movement expression to the choreographers. The choreographers, the dance makers, are fascinating individuals. They lead unique and colorful lives. For all the craft and theatrical savvy they may acquire, they are still involved in the most mysterious of activities. Looking back can help us understand what we are looking at today as ballet and modern dance are blending and new concert dance forms are emerging, particularly in the realm of jazz dance.

Information about the art form is going to come to the investigator in a series of haphazard phenomena, even when the investigator is

making a chronological survey of dance. It becomes of great importance to know how to look with wonder and describe with vivid accuracy.

Rudolf von Laban, a German dancer and movement theorist devised a system of movement notation that has proven useful to scientists and factory designers as well as to dancers and those who want to describe dancing. Laban analyzed movement by inspecting both its shape and its effort. He recognized that what all movements have in common is speed, direction, and intensity. By reducing these elements to their simplest variants, fast or slow, direct or indirect, heavy or light, he concluded that all movement could be seen as falling into a mere eight categories. The terms he chose to identify these eight basic efforts—dabbing, pressing, punching and gliding, flicking, wringing, slashing and floating—provide a basic vocabulary for describing dance. They will help you to avoid the clichés and hyperbole that can confuse a purely metaphoric approach to description.

When we want to speak or write about something as amazing and puzzling as dance, we are blessed with the English language, a language that can, because of its complexity, express both strong images and thoughtful nuance. Television, the media, the speed and ease of Internet communication have all taken their toll on the literacy of our country. Thoughtful discourse is giving way to the sound bite. I am perhaps old fashioned. I believe that without good writing skills it is difficult to capture good thinking.

Good writing about dance includes the clear and compelling reporting of events and feelings. It should go without saying, but doesn't, that our writing is meant to be read by someone who not only understands what we have to say but finds insight to the subject through our particular point of view.

To improve your writing, you must have someone constantly reading what you are writing. Even if you might be in a university and your class is small or there are enough graduate assistants to afford you steady feedback, I recommend that you develop a relationship with a writing advisor. Find someone whose skills are greater than yours, someone who will proofread what you write, keep your thinking straight, and constantly advise you to edit.

Some Other Names and Things to Know

American Dance Festival

A prestigious summer festival of contemporary dancing originally held on the New London campus of Connecticut College and now housed at Duke University in North Carolina. Dancers and dance lovers from across the country gather to study with the finest teachers of contemporary dance techniques and theory, and to attend performances given by emerging and established choreographers. Its continued success is due to the vision and efforts of dance educators Martha Myers and Charles Reinhart.

Bournonville, Auguste (1805–1879)

Choreographer and ballet master of the Royal Danish Ballet. His many buoyant and tender ballets are the only surviving body of works by a choreographer of ballet's Romantic era (1830 to 1850). Many of his ballets are set in the countries where he spent his summer vacations. His "Napoli," which closes with a vigorous tarantella, features an eruption of Mt. Vesuvius and an underwater scene. His "La Sylphide" is set in Scotland. For more information on "La Sylphide" and the Romantic era, see Chapter Three.

Cohen, Selma Jeanne

Dance historian, editor, and author. Of particular interest is her "The Modern Dance: Seven Statements of Belief" (Wesleyan University Press, 1966) in which she reveals the methods and philosophies of seven choreographers by asking them how they would bring the biblical subject of the Seven Deadly Sins to the stage.

"Dance as a Theatre Art: Source Readings in Dance History from 1581 to the Present" (Dodd, Mead & Company, Inc., 1974), includes a brief and remarkably concise history of theatrical dancing accompanied by a well chosen array of writings by significant authors, choreographers, teachers and critics.

Halprin, Anna

Choreographer and author. Halprin's work explores man's relationship to the environment, and has at times been considered controversial because of unusual performance venues and the occasional utilization of nudity. Her husband, the architect Larry Halprin, is known for his unusual city fountains, which are not created to be admired from the outside but draw the pedestrian to physically enter into their spaces and experience their changing characters.

von Laban, Rudolf

A system of movement notation developed by Rudolf von Laban (1879–1958) that enables a work of dance, particularly when combined with film, to be accurately recorded, maintained, and preserved. Labanotation identifies movement by its three basic elements, speed, direction, and intensity. Laban's colleagues and students included Harald Kreutzberg, Mary Wigman, Kurt Joos, and Gret Palucca. For more information about the German Abstract Expressionist movement read Chapter Six.

Go to the workbook exercises for Chapter One for a closer look at Laban's system of Effort/ Shape.

Rainer, Yvonne

Dancer and choreographer who became associated with the 1960's post-modernists of the Judson Church in New York City, a group that questioned the motives and artificialities of performing.

'The Red Shoes'

Classic 1948 film by Michael Powell and Emerich Pressburger about love and obsession in a ballet company. It features a world class cast of dancers and actors, and won an Oscar for its sophisticated use of Technicolor. It is a revealing portrait of politics within the arts. The questions it raises about loyalty, dedication and sacrifice are still relevant today.

The Royal Winnipeg Ballet of Canada

Founded in 1938 by two English women, Gweneth Lloyd and Betty Hey-Farrally, who had a vision that a classical ballet company could flourish in the prairie. The second oldest ballet company in North America, (the San Francisco Ballet is the oldest) the RWB makes performing tours across Canada and the United States, and is often invited to dance in Europe.

Spohr, Arnold

Canadian Ballet Director, a student of Lloyd and Farrally, and principal dancer of the Royal Winnipeg Ballet in its early years. Later, as the company's director, his determination, taste, and curiosity led the company to international prominence. During his tenure as Artistic Director *Time* magazine wrote, "There is nothing derivatively European or effete about the Royal Winnipeg, it has a personality all its own: Winnipeg is a ballet company notable for its youth, boldness, and exuberance, for a corps de ballet of unusual wit, dramatic sense and precision."

Tharp, Twyla

Choreographer and director. Merging the naturalism of movement sought by the post-modernists with the techniques of ballet, modern and jazz, she has choreographed for major dance companies and for film. In 2003 she won a Tony award for her Broadway production of "Movin' Out," which featured the music of Billy Joel.

Terry, Walter

Author, dance critic and dance advocate. During his tenure at the (now defunct) New York Herald Tribune, he popularized the art of dance through his numerous books, articles, and lecture demonstrations. Most of his books are now out of print but are easily available at good libraries and through Internet sources. His "The Dance in America" (Harper and Row) would be a good place to start.

Dance and Music

Some historians will argue that dance was born from music. Others believe that dance was the parent form and will point out that there is no sound without movement. I like to think of dance and music as fraternal twins, springing from the same roots, sharing some outward characteristics and experiences, but in no way identical. Neither is dependent on the other although they often come to one another's service.

In ritual events and other communal functions where dance is featured, music encourages participation and provides order. The Haitian drummer at a Voudon Ritual, however accomplished, is not there to display artistic or technical mastery, but to draw the dancers into a trance-like state.

Music has taken its rhythms from our hands and feet. In turn our hands and feet have taken their rhythms from the elaborations that the musicians have made. During the Renaissance the main function of a composer or instrumentalist was to provide music for the church and for dancing. The ballets of 20th Century choreographer George Balanchine accord the composer a more central role. Often he used music that had been written for other purposes but which he felt were ideal for visual realization. Sometimes the dancer in a Balanchine ballet is like a supplementary musical instrument added to the orchestra to give more clarity to the composer's ideas.

Some dances start with the choreographer's concept and an appropriate piece of music is identified or commissioned to accompany it. Sometimes an existing score challenges a choreographer's ear and a dance is made as a result of the music.

When Roland Petit created "Le Jeune Homme et la Mort," to a scenario by Jean Cocteau he used the rhythms and timbres of jazz music to accompany his choreography. When the ballet reached the stage, he replaced the jazz score with a Bach Prelude and Fugue. The contrast between the ballet's rather sordid story and Bach's uplifting music presented suicide as heroic choice, not escape.

One of the main concerns of both dance and music is the measuring of time. In Western music, time is measured by basic units called "quarter" notes, approximately the length of time between human heartbeats. Four "quarter" notes, or one "whole" note, represent the approximate length of a human breath. For purposes of clarity and convenience, Western Music counts its quarter notes in units of two, three, and four, etc. but rarely more than eight. One of these "measures" may be identified as having two quarter notes, or three, or more, thus the time signatures of such duple meters as $^2/_4$, $^3/_4$, $^4/_4$. It is common for people to mistakenly call this measuring of a dance or a piece of music its rhythm. A rhythm is a repeated pattern of emphasis of movement or sound.

The mazurka, the minuet, and the waltz are three different dance rhythms that are all counted in a ¾ meter. The mazurka has an unusually strong accent on the second beat. The three repeating steps of a minuet are equal in emphasis. We recognize the rhythm of a waltz by its strong first beat and the slight delay between the third beat of the measure and the next down beat.

The rhythm of rock music calls for a strong accent on the 2nd and 4th beats of each measure of four. The gavotte, another dance counted in $^4/_4$ begins each phrase on the 3rd rather than 1st beat. The most basic rhythm, of course, is the single repeating pulse, badum, iamb, I am, the rhythm of the human heart, of the tribal dance and the discotheque.

The Corn Dance

Every year, on Saint Dominic's Day, the fourth of August, when the end of the summer is nearing, when the earth is drying under the still early rising sun, Native Americans of New Mexico gather on the Santo Domingo Pueblo near the banks of the southward descending Rio Grande River.

Young and old are there. Some live on the pueblo or nearby. Some are artisans and craftsmen, the makers of traditional Native-American pottery, rugs, and jewelry. Some live in nearby Santa Fe or Albuquerque and, except for this annual visit, lead an existence that is more like that of the average American nine-to-five Joe than like the life of their ancestors. All of them have come home for the Corn Dance ritual, a celebration in song, drama, poetry, and dance.

The Corn Dance is a prayer for rain and bountiful harvest. It asks Mother Earth to look out for the wellbeing of the pueblo and all those who attend the ceremony.

For many years, the attendance of Native American ceremonies was forbidden to outsiders. The Native American had good reason to be suspicious of white invasions. Today, many of the Indian ceremonials tolerate visitors. Some, like the Santo Domingo Pueblo, in the interest of encouraging cultural understanding and assimilation, welcome them.

If you arrive early at Santo Domingo Pueblo, you may witness the transferring of the statue of Saint Dominick from the village church to the dance plaza on a bier festooned with cornhusks. Snare drums beat and guns are fired as the procession makes its way.

Dominick was the saint assigned to look over the village by the Catholic priests who accompanied the first Spanish Explorers to reach this place. He is given a place of honor in the dance plaza. The rest of the gathering spectators are going to have to suffer the beating sun all day but Saint Dominick has been placed in a shelter of cottonwood branches.

The man who leads the main procession of dancers into the plaza carries a long pole representing the fir tree that enabled the first people to climb up from the Underworld. From it are swinging a kilt with eagle feathers and some sort of animal pelt. At the top of a pole are a painted gourd and more feathers.

There are feathers everywhere, on the dancers heads and dangling from their waists and sashes. Instead of grooming themselves with the traditional plaits we might expect, the dancer's let their hair hang in tendrils that bring to mind the tantalizing wisps of rain that hang from summer clouds.

At first the steady drumming and the constantly repeating steps will trick you into believing the dance is simple, but if you look closely and listen hard enough to try to keep the beat, you will find yourself confused by their sophisticated complication.

You will notice that in the middle of the crowd of celebrants are some figures dressed as if their entire bodies had been painted in broad black and white stripes and who do not seem to be dancing. These are the Koshare, clowns whose role is both humorous and sacred.

They are pranksters. Any tricks they play on you must be tolerated, and any demands they make of you, for food or other innocent favors, must be granted for they represent the invisible spirits of the deceased. In return, the Koshare pass between the dancers, gathering up any fallen feathers or beads that might interfere with their concentration, tightening any drooping sashes and straightening any headgear that has been loosened by the ceaseless treading pace. The dancing will continue undisturbed until the sun disappears behind the mountains to the West.

Sitting Bull and the Ghost Dances of the 1880's

By the time Sitting Bill surrendered at Little Big Horn, most of the plains and pueblo tribes of the Native-Americans had been moved to reservations where they lived, "under the protection of the U.S. government," in deplorable conditions. In 1886, a Paiute prophet, Wovoka, announced he had had a vision that promised "the revival of the old Indian ways, the return of the buffalo, and the annihilation of the race responsible for all their troubles." There were rumors of the Sioux gathering in secret to perform some sort of war dance. The Sioux were indeed dancing, but their gathering was one of peace.

These secret dances were rarely witnessed by non-participants. It is now known that no one at these gatherings wore a gun or jewelry. There were often four hundred dancers in one circle, and it was not unusual for someone to fall exhausted into a trance-like state. The dance was mournful in nature, and the chants sang of the broken families that would soon be united if Wovoka's philosophy of peaceful perseverance could be sustained.

The paranoid government authorities could not conceive of such a philosophy and suspected the Sioux were plotting another insurrection. They asked the now elderly Sitting Bull to use his influence to stop the dancing. He refused. When the authorities sent someone to arrest him, a scuffle ensued and Sitting Bull, with several members of his family, was killed.

Consequently a Code of Religious Offences was passed that was used as late as the 1920's to crush Native American religion, and it was not until 1934 that this policy was reversed and the freedom to worship as one chooses was finally extended to America's original inhabitants.

Trance and Ecstatic Dance

The trance-like state achieved by some of the participants in the Corn Dance is not unique to the dances of the Native American. Ecstatic

states are induced by the rituals and dances of ancient and modern cultures around the world. Religion, art, and sometimes medicine are in play here.

In Ethiopia, it was long the custom for peoples plagued by a nervous disorder called *cherbé* to dance wildly, as if possessed by the devil. In Italy, this nervous disorder, which had an effect on the patient similar to that of the bite of a tarantula, was called *tarantissmo*. The speed and sharpness of attack required in the dancing of the *tarentella*, Italy's famous national dance, is said to resemble the movements of those so afflicted.

Each year on the days of St. Peter and Paul (June 28th and 29th), those who suffer from emotional and psychosomatic disorders gather in Apulia in Southern Italy for a ritual cure that involves violent dancing and the loss of consciousness.

Mass dance epidemics were common in the Middle Ages. The compulsive dancing of the many pilgrims who made their way in processions to the Cathedral of St. Vitus in Prague in seek of a cure is thought to have been caused by ergot poisoning brought about by the faulty storage of grain. St. Vitus' Dance, a children's disease in which the limbs twitch uncontrollably, is named after this phenomenon.

The skeptic in our rational society will dismiss the idea of the trance dance as no more than mass hypnosis, but there is proven research that there are things that produce an altered state of consciousness without the use of drugs: rhythm and repetitive movement being among them.

The ecstatic state is brought on through the urging of steady and ceaseless rhythm usually provided by drumming of some sort. The induction into a trance is not always brought about for medical purposes, or to rid someone of a curse. Sometimes the possessed dancer impersonates one of the spirit figures of his religion.

Sometimes, as in the Voudon rituals of Haiti, the possessed, in a state of altered consciousness, is said to have left his body so that a favorite spirit or god can take his place and enjoy the festival. This is similar to the Mexican Day of the Dead, celebrated in conjunction with the Christian Feast Days of All Soul's Day (Halloween) and All Saint's Day, November 1st. It is the tradition during the celebration of *Todos Santos* to make a great dancing procession into the town square where skeleton figures of the dead, family ancestors and world celebrities like politicians and movie stars are invited to enjoy, once more, the food and festivities of the living.

One of the most fascinating things to me about dance is looking at what people choose to wear on their bodies when dancing in front of their gods or their family, friends and communities.

Sometimes people dress up to dance. Feathers, ribbons and jewels crown their heads. Their bodices, waists, skirts, and pants are decorated. Epaulets make their shoulders look broader. Boots and sandals adorn their feet. Stilts and pointe shoes make their legs look longer.

Sometimes people dress down to dance, freeing the body from the restrictions of clothing and exposing its incredible muscular beauty. However, the presentation of the body in the costuming of its own skin is often theatrically enhanced by some adornment for the sake of aesthetic appeal as well as modesty.

Sometimes a mask is worn, as in the early days of court ballet, to hide the identity of the performer. Sometimes a mask is used to identify a performer with the character he or she may be portraying. Sometimes, as in the case of a possession trance, the body itself becomes the mask that reveals the identity of the spirit who comes to inhabit the body. Contemporary concert dancers seldom employ masks for purposes of concealment. Their masks are their trained bodies.

Circus – the Ring

In Ancient Rome the circus consisted of equestrian races, the display of exotic animals and gladiatorial combat. The first American circus opened in Philadelphia, in 1793. There were no races and there was no combat. Clowns, acrobats, jugglers, and trapeze artists were featured. Until the middle of the 20th Century and the emergence of television, circus remained widely popular. If one were to follow

Walter Terry's definition of dance, it would be easy to make a case that the "three-ring" circus of Barnum and Bailey, and The Ringling Brothers, should be included. The debate over whether the circus is dance or only dance-like becomes more interesting when you look at the content of the Quebec-based company, **Cirque de Soleil** and the other contemporary circuses that are attracting audiences around the world.

If one of these companies is not performing near you, or you are not able to go to Las Vegas where Cirque du Soleil has two or three entirely different shows that sell out every night, watch your TV Guide for their specials are shown frequently. They are available on video and DVD as well. After you watch some of their elegant performers, you can decide for yourself if they are dancing.

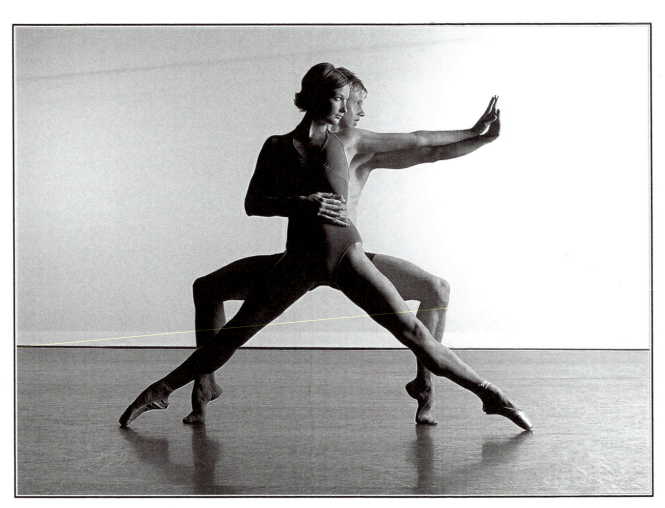

As codified during the reign of Louis XIV of France, ballet's *second position* was a modest stance with the feet no more than a foot's length apart, the heels and the inner aspects of the legs presented forward. In contemporary ballet, the turned-out leg and visible heel are still important but as University of Arizona BFA recipients, Andrea Day and Ryan Lawrence illustrate here, the width of the positions is often taken to extremes.

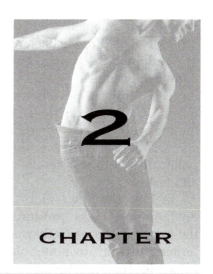

Ballet Front and Center

When I fly, I like my time alone to think, but I am not indisposed to a good conversation. When I introduce myself to the stranger seated beside me, I identify myself as a Professor of Ballet. My new friend blinks and time stops, just for an instant. I smile. I know he is thinking something that goes like . . . "Ballet? Isn't that where the girls hop around on the tips of their toes and the guys wear leggings so tight I'm embarrassed to look? . . . or . . . Ballet! An entertainment for the elite, a hard knocks profession. What in the world does a ballet dancer have to profess?"

In my travels and in my classes, I have come across very few people who did not have some conception of ballet, some picture that pops into their head when they hear the word. Images that we all associate with ballet are everywhere, the porcelain figurine on your next door neighbor's shelf, the ragged dancer in the calendar photo, the shiny satin toe shoe, the awkward child swathed in pink tulle, the swan, the dedicated athlete flying from a poster into your imagination. What is common to all these images is that there is nothing coarse in them; they represent an appreciation of things that are tasteful, refined and dignified in appearance.

Ballet is a highly stylized dance form in which the lower limbs are used for gesture as well as for support. It is characterized by the use of the outward rotation and presentation of the thigh, knee, shin, ankle, and foot. Although effort is admired, it is never shown by any disturbance of the shoulders or upper back. The distinctive arm and head positions associated with ballet have undergone continued refinement for over four centuries. More than mere decoration, they are an amazing marriage of physics and poetry.

Ballet has a distinct attitude . . . gravity can best be put to advantage by pushing away from it. Ballet is about achievement and aspiration. Its verticality makes it well suited to expressing hope or hopelessness. Ballet is a living, changing form, constantly enriching its vocabulary by utilizing modern and jazz dance innovations and world dance sources. Both the aesthetic and the movement vocabulary of ballet demand that the accomplished ballet dancer have a sophisticated vertical alignment of the skeleton held in place by an easeful arrangement of ligaments, tendons and muscles.

The elegance that this posture provides the dancer, on and off stage, has been at the heart of ballet since its beginnings. In 1581, the courtiers who performed in what historians agree was the first "ballet," were chosen for their elegant appearance. To be welcome at court a Renaissance gentleman was expected to converse with wit, fence with skill, be accomplished in musical matters, and dance the minuet without tripping.

The most powerful family in Florence, Italy, the cradle of the Renaissance, was the Medici dynasty. The family's interest in the rebirth of the classical ideals of ancient Greece was supported by their wealth and their political power. They were enthusiastic sponsors of such

young and talented architects, sculptors and artists as Palladio, Michaelangelo, and Botticelli. They adopted the young Leonardo de Vinci into their family circle.

The family's power was felt throughout Europe. Catherine de Medici (1519–1589) became the regent of France, when her son, Charles IX, succeeded to the throne. Catherine was adept politically and was a trendsetter in matters of art and fashion.

In 1581, the first ballet, "La Ballet Comique de la Reine," was produced in Paris under the sponsorship of Catherine de Medici as an "entertainment" to honor the marriage of her niece. To arrange the tableaus and dances for "La Ballet Comique de la Reine," Catherine engaged Italy's most successful dancing master, Baltazarini di Belgiojoso, who, in the interest of political correctness, changed his name to Balthasar de Beaujoyeulx.

Although the Renaissance was a rebirth of the ideals of ancient Greece, certain democratic principles were not adopted. A closed circle of elite nobles and churchmen held power. Their entertainment served a political function. Unconcerned with the lower classes, they did not adopt the use of the classical Greek stage and auditorium for onlookers.

"La Ballet Comique de la Reine" was presented in an open palace courtyard with the wedding guests looking down from the several levels of balconies lining the four sides of the room. It was an all day feast. Between meals, a series of elaborate tableaux, were presented. Mythological subject matter was chosen to flatter the bride, pump up pride in the French monarchy, and remind everyone that the Medicis from Florence, Italy, set the standard and controlled the Papacy.

As all was viewed from above, the principal choreographic concern of the court ballet became pattern. The steps were simple, but the configurations were intricate and performed with "coolness" and aplomb. There was some resemblance to the folk dances of the lower classes from which the steps were taken but all effort was refined away.

There was no bouncing and only the most delicate hopping. Knees were lifted carefully rather than exuberantly. Costumes were elaborate and heavy. Focus went to the feet and how they moved.

The dignified and steady pace of the dances allowed for the introduction of decoration. Small but precise movements of the feet were added, "battements" pointing outward or beating lightly against the instep or the calf of the supporting leg. The more accomplished the gentlemen of the court became, the more elaborate the steps could become and an aspect of technical virtuosity was introduced. Still, the main function of the court ballet was to flatter someone powerful.

The use of the power of dance for political motive reached its apogee in the person of King Louis XIV of France. No mere patron of the arts, Louis was a well-trained dancer who liked to play the leading role in his court ballets, often appearing in the person of Apollo, the sun God. Some might suspect that it was Louis' vanity that qualified him for the central role, not his technical accomplishments. His official portraits reveal him to be overly proud of his prominent and outwardly rotated calf muscle, a much-admired aspect of masculine beauty at the time.

There is an apocryphal story in the ballet world that when Pierre Beauchamps, one of Louis' ballet masters could not bring his royal student to accomplish an *entrechat six,* a flashy jump where the feet seem to flutter and criss-cross several times before descending, he invented a simpler but almost as spectacular substitute that to this day is known as the *entrechat royale.*

If he was even trying the *entrechat six,* Louis must have been pretty good. His interest in dance certainly exceeded any concerns about vanity or political self-aggrandizement. In 1651 he founded the first state sponsored professional school for training ballet dancers, the Académie Royale de Danse, and it was there that Beauchamps, with the composer and fencing master Jean Baptiste Lully, codified the five positions of the feet still used in classical ballet.

By the end of Louis XIV's reign, the court ballet had taken its place on the public stage. At first the performers were all men, but gradually women began to appear as well, their anonymity protected by the masks that were an intrinsic part of the costuming in early ballet. It was not through the steps of a dance that a performer conveyed a character, but through the mask. In 1681, a woman was first listed on the roster of dancers at the Paris Opera, one Mlle la Fontaine.

Dancing was becoming a respected profession as well as a pastime, and the schooling in ballet at the Paris Opera set the standard.

The changes that had to be made as the court ballet adapted itself to proscenium presentation had a profound influence on the "look" of ballet. Pattern was of chief concern when a dance was to be viewed from all sides. It was through centering and balance of design that a theatrical effect was made.

Presented within the frame of the proscenium arch, a dance will be seen by all from what is essentially the same viewpoint. Ballet had to decide what attitudes of the body, what postures and facings, looked best from "the front."

The complicated patterns of court ballet, which most often drew the audience's attention inward, were no longer effective. It was both rude and unattractive to have your backside facing the audience for any extended period of time.

Turn-out and the forward presentation of the heel became increasingly important, aesthetically and mechanically. The employment of turn-out not only "looked" better to the audiences, it provided the dancer with the ability to move sideways while still facing front.

Ensembles began to be organized in simple regimented lines at the side of the stage and the solo dancers moved back and forth between them or in diagonals across the stage. To avoid the look of flatness, the postures of ballet were angled to present the body in what were considered to be attractive and three-dimensional attitudes. The French term "épaulement" is still used today when referring to this concept of "shouldering" that is part of ballet's distinctive look.

Not only did ballet take on new attitudes of the body as it stepped onto the proscenium stage, it took on a new attitude towards performance. In the court ballet, the performer, even Louis XIV in his solo appearances, was part of a spectacle. Only in an allegorical sense was he presenting himself.

On the proscenium stage, the dancer, not the character, can easily became the center of attention. The psychological effect of "openness" that turn-out gives the performer has become as important to ballet as has turn-out's mechanical and aesthetic advantages.

Dancers use the word "form" in many ways. We speak of an art form as a particular means of human expression. We speak of the form of the human body or the form of a musical composition. We speak of the inner theatrical forms of presentational dance, the ensemble number, the solo or duet, the kick line, or the apotheosis, all devices employed by a choreographer to capture the audience and make them receptive to his or her ideas.

New ideas call for the invention of new forms. In turn, changing tastes lead to the abandonment of those forms no longer effective in maintaining this receptivity. The wonder of ballet is that its form and its inner forms have continually proved capable of expressing new ideas and adding to their relevance.

Look what ballet, born of Renaissance ideals and political machinations, was faced with when Europe was entering the 18th Century! The nobility, which had spawned ballet, that had needed it, used it and refined it, were still on the throne. But the world of Philip V of France was not that of his grandfather, Louis XIV.

There was a rapidly growing urban middle class, the bourgeoisie. A sense of individual liberty was growing in the consciousness of the proletariat, the working class. The aristocracy's attention was diverted from ballet by more serious social, political and religious concerns. Ballet, to survive, needed a new home, and it found it in the public theatres that were being opened in cities all over Europe.

It was a time of burgeoning democratic revolution. The ordinary folk of the rising lower classes who were beginning to fill the theatres were no longer interested in the allegories that flattered the aristocracy. Ballet's subject matter had to change but the audiences liked its "look." It was able to bring a touch of culture and at the same time dazzle with a good show.

Technical innovations in lighting, mechanical elevators and rigging made it possible for the scenery to be shifted with magical speed. With the help of a harness and wire, a pulley and a stagehand, a dancer could appear to fly. Theatres were equipped with trap doors through which one character could emerge with solemn magnificence and another could disappear in an explosion of smoke and fire.

These effects may have been initially exploited for their own sake . . . to astound, but like the growing technique of the dancers, these innovations also extended the range of a

choreographer's power to convey an idea. Ballet's significance as an art form was established, ironically, when it was criticized for losing its purity by catering to what some considered the vulgar taste of an unsophisticated audience who knew only novelty, not art.

Some choreographers and dancers of the early 18th Century were still driven by the classical ideals of harmony, symmetry and noble attitudes. John Weaver, an English ballet master, wrote that when watching a "genuine" performer,

"the Spectator will not only be pleas'd and diverted with the Beauty of the Performance and Symmetry of the Movements but will also be instructed by the Positions, Steps and Attitudes, so as to be able to judge of the Design of the Performer. And without the help of an Interpreter, a Spectator shall at a distance, by the lively Representation of a just Character, be capable of understanding the Subject of the Story represented, and able to distinguish the several Passions, Manners, or Actions, as of Love, Anger or the Like."

The pantomimes and dances that Weaver produced in accordance with his belief in the principles of the ancient Greeks were not nearly as successful as the works of his rival John Rich who diverted his audiences by being hatched from an egg and transformed into a flower. Other successful male dancers of the time included Claude Balon, whose dazzling elevation may have inspired the use of the term "ballon," still used today to describe a quality of jumping that involves easily achieved height, soft landing and immediate rebound. Most of the ballet masters were men but one female teacher and choreographer, Françoise Prevost, produced two outstanding female students, both named Marie, who were to strongly affect the future development of stage dancing.

Marie Camargo made her debut at the Paris Opera in 1726. Camargo had a strong personality and she was perfectly capable of performing all the *entrechats* and *cabrioles* that were being introduced for the men. Encumbered by the long skirts required of woman at the time, she resented not being able to show her virtuosity on the stage.

One evening, tired of being in the men's shadow, she took a pair of scissors to her properly floor length stage dress and petticoats, shortening them enough to show her feet and ankles. Her daring move was at first considered shocking, but was soon copied by all her female rivals. Naturally, they had to improve their own techniques to do so.

Camargo is also credited with another innovation that advanced the technical accomplishments of ballet dancers and expanded their movement vocabulary, the heel-less slipper. Allowing the heel to come in contact with the floor and the resulting stretching and strengthening of the Achilles tendon changed the look of ballet.

Bigger jumps could be accomplished. Feet could move faster and be flung higher. The ankle became more flexible and better aligned for sustaining balance and pirouettes. Aesthetically the eye was drawn to the foot. Along with an admiration for the well-turned calf muscle that was then becoming visible under the shortening skirts, a long foot with a high arch is still, almost 250 years later, highly regarded.

Prevost's other famous pupil was Marie Sallé who, unlike Camargo, was quiet and reserved. Although she, too, was technically strong, her flair as a dancer and choreographer was for the dramatic not the acrobatic. Jean Georges Noverre wrote of her, *"it is not by leaps and frolics that she went to your heart."*

Sallé, like Camargo, instituted reforms in costuming. She created a sensation by dancing without a mask. In her ballet "Pygmalion" (1734) she discarded the cumbersome petticoats and even her wig, and in a desire to look appropriately Grecian, danced in a simple draped muslin robe that made her resemble a marble statue.

Marie Sallé was not alone in disliking the use of masks, a custom still highly prevalent in the 18th Century. The choreographer and ballet master, Jean Georges Noverre, who trained at the Paris Opera but spent the major part of his career in Stuttgart and Vienna, discarded the use of masks in his works, also. Among the other reforms called for by Noverre, who engendered both support and resistance to his ideas, was a call for the composition of dances to suit the characters being portrayed.

Up until that time, most dances were made up of the same steps that were taught in dance classes. The differentiation between the characters of a ballet was provided by the stage costuming and masks. Noverre believed that

the steps themselves should be expressive of the character. In his still widely read treatise, *"Lettres sur la Danse et les Ballets,"* he railed against what he considered to be the bad taste and out-dated customs presented by his contemporaries.

If Noverre could have looked at the ballet of his time from the perspective of ours, he might not have been so dissatisfied. Ballet overcame its dependence on royal patronage, improved the facility and artistry of its performers, and adapted its costuming to accommodate changing fashions. Its classically based forms have proven capable of expressing both timeless and contemporary concepts.

The most significant ballet created in the 18th Century, one that is still danced today in one version or another, was "La Fille Mal Gardée," choreographed in 1786 by Jean Dauberval to a delightfully sunny score by Ferdinand Hérold. "La Fille Mal Gardée" (which translates awkwardly as "The Unchaperoned Daughter" or "Vain Precautions") reflected the changing nature of the ballet audiences of its era. The leading characters of "La Fille Mal Gardée" are not gods and goddesses, kings or queens. Instead, we are introduced to a fussy old widow, struggling successfully to run a farm, who wants her pretty daughter, Lise, to marry a doltish rich suitor instead of the handsome but penniless young man she loves and wins. Lise's ultimate victory may seem a sweetly romantic and inevitable happy ending to audiences of today but at the time, when class lines were only beginning to crumble and women were still considered property, it had more significance.

"Fille," as it is called in the dance world, is still performed today in one updated version or another, one of the best being that by Sir Fredrick Ashton for London's Royal Ballet. Often, recreations of the ballets of the 18th and 19th Century can be coy and stilted. Ashton successfully uses the accomplishments of our contemporary dance artists to invoke an accurate and affectionate look at our past.

After 200 years, ballet found its subject matter separated from its aristocratic roots and expressive of its contemporary environment. Its look of elegance was, however, not abandoned.

Noverre was the conscience of ballet in the 18th Century. Camargo exemplified for the 18th Century the fascination with dance as the beauty of outward form. Sallé symbolized for that era the fascination with dance as an expression of inward feeling. Looking at the development of theatrical dancing as an art form, we will find that these opposing viewpoints occur again and again.

Both ideals are valid and strongly held by their supporters. Public taste, however, will swing from one to the other. When the formal perfection of dance seems to become overly academic, or begins to generate meaningless acrobatics, having little relevance to contemporary concerns, there will be renewed interest in the expressive power of dancing. Likewise, when the expressive aspects of dance begin to offer little more than overwrought and predictable dramatics, when pathos turns to bathos, the formalists return to refresh the form.

Some Other Names and Things Worth Knowing

Ballerina

A word of Italian origin often used to describe any female who engages in the practice of ballet. In professional terminology it has become a title that should only be used to recognize and honor an experienced dancer who is capable of taking on solo roles with success. The Italian term for male dancer, *ballerino,* is not used. In this country, a male dancer is called just that, a male dancer, although the French term **Premier Danseur** is used to identify a leading male dancer of a ballet company.

Apotheosis

The raising of a person or thing to divine status. A theatrical device that ends many ballets of the 18th and 19th Century. The apotheosis of "The Nutcracker" returns the dreaming young heroine to the safety of her sleep. Although the Swan Queen and the Prince drown themselves for love, the apotheosis of Swan Lake shows them reunited and sailing across a sky where good overcomes evil. Many famous stage plots, like that of the ballet "Sylvia," present dilemmas that can only be solved by the eventual arrival of a god or two who often appear overhead and

are lowered to the stage by machinery, hence the term **Deus Ex Machina**.

Ballet's Partner, the Floor

As an art form, "ballet" is recognized around the world. The word "ballet" is the same in French, English, Russian and other languages. Related to the Italian *ballare*, to dance, it can be traced to an older word meaning the floor of a threshing room. A threshing-floor is composed of many long wide boards laid side by side with small spaces between them through which the loosened kernels of grain would fall into an empty space below.

The large open space of an empty threshing room was an ideal place for a community to gather and celebrate with dancing. The resilience of its floor encouraged the execution and enjoyment of steps that rebounded. Jumping is still an important element of ballet and pine boards still give the best spring, although other woods and composites that will last longer or cost less are used. Most new stages today are built to present other things than dance and many of them are too hard to be ideal for ballet.

The concrete-like composite floor used in television and movie studios facilitates the movement of the cameras but not the movement of the dancers. Constant dancing on a hard floor will put a dancer at great risk for injury. Jazz dancers have adopted athletic footwear to protect their feet and ankles. Knee and shoulder pads are sometimes incorporated into dance costuming for protection.

Where has the Rosin Box Gone?

The boards of the threshing-floor were smooth enough to allow a certain amount of sliding and swift turning but were not so slippery that a dancer could not finish pirouettes or leaps with security. Preparing the floor for its thin shoes of leather, canvas, or satin has always been a concern of ballet. The judicious scattering of crushed or powdered rosin on unpolished wood was once common practice.

A rosin box, not much more than a foot square and an inch deep, was in the corner of every ballet studio and backstage at every ballet performance. It became a ritual as well as a necessity for a dancer to return again and again

to the box and grind some additional rosin into their heels or toes in search of the perfect partnership of shoe and floor.

In the 1960's, dance companies began to lay a thin linoleum-like cover over their existing stage floors, providing a surface that, without rosin, was ideal for all kinds of footwear and bare feet as well. Today "Marley" floors, commonly known by the name of the manufacturer of the first successful prototype, are a more common sight in a dance studio than the rosin box.

It is still common practice in some major schools of ballet to prepare an unpolished wooden floor by sprinkling it with water. It is tradition for the watering can to be the responsibility of the lowliest member of the class. In 1963, I had the remarkable opportunity to visit the Kirov Ballet in St. Petersburg (then Leningrad). In the back row of the daily classes provided for the professional members of the company were a few students from the 9th form of the school, dancers who were about to graduate and were, perhaps, in line for professional contracts. The lowliest among them, the one who always arrived early to do his watering duties, was the best of them. In fact, he was the best dancer in the room. I asked my interpreter for his name, and it is still there, scribbled boldly across my journal, Baryshnikov!

Ashton, Sir Fredrick (1904–1988)

British choreographer whose work is distinguished by romantic atmosphere, modesty, restraint, and sophisticated musicality. Some consider his muse to have been the British ballerina Margot Fonteyn, for whom he created "Ondine" and "Marguerite and Armand," in which she was paired with the young Russian defector, Rudolph Nureyev.

Ashton was an accomplished character dancer and can be seen at his best in the Powell and Pressberger film of the Jacques Offenbach opera, "The Tales of Hoffman."

Character Dancing

Not all the characters portrayed in a ritual or in a narrative dance are heroes and heroines. There are villains to intimidate us. There are

comics to make us laugh. There are grotesques to make us shiver. There are exotic peoples from other lands to seduce us. There are wise figures that act as guardians and guides.

The heroic or romantic roles are taken by performers whose physiological appearance and psychological demeanor are of a refined nature. The other more vigorous roles are taken by "character" dancers, performers who are adept at recreating folk rhythms and images and who have a flair for the comic or the dramatic.

Ballet companies that have been in existence since the 18th and 19th Centuries have a cherished history of character dancing. In some, like Russia's Bolshoi in Moscow and the Kirov in St. Petersberg, the respect paid to the leading character dancers is equal to that given to the ballerinas. This is not the case in American companies where the art of character dancing is in danger of extinction.

Contemporary choreography, though it may require the dancer to be adept at modern and jazz dancing and, sometimes, even tap, rarely calls for character dancing skills. Ballet companies in this country usually expect all their dancers to have the physical attributes of the hero or heroine type. The character type is more likely to be found on Broadway.

Too often, when young American companies present the older classics like "Coppelia," "The Nutcracker," and "Swan Lake," the roles originally intended for character dancers are performed in a manner that is more refined than robust. The contrast they are meant to provide with the more balletic moments of the production is lost.

The First Professional Dancers

Both evidence and common sense tell us that movement expression is common to all cultures. We can only guess when the first individual or individuals made dancing something through which they were assured enough income that they didn't have to do anything else. Some will joke that the first professionals were erotic dancers. But in their case they were only using dance to sell something else. It is more likely that the first professional dancers were those who were trained to partake in ancient

religious ceremonies or rituals designed to honor the ruling classes. The Kabuki dancers of Japan have been professional performers for centuries.

The Orchestra

In ancient Greece, there were skilled dancers who, for their livelihood, entertained at dinner parties and other social functions and appeared in theatrical presentations. The words "chorus" and "choreographer" come from the title of the man who trained these dancers, the *choreogus*.

The circular performing space of the open-air Greek theatre was called the *orchestra*. Today the term orchestra refers to the space close to or under the stage where the accompanying musicians may perform without being a visual distraction, or to the viewing space for the audience that is on the main floor. During the middle Ages, the orchestra could be a crowded and rowdy place for there were usually no seats provided.

The Dithyramb and Dionysus

Theatrical dancing in ancient Greece is believed to have developed from the **Dithyramb**, a song and dance performance presented during the spring festival of the god **Dionysus**. Originally, the Dionysian festivals encouraged licentious behavior, but over time public conduct became more modest and the days were ordered with formal ritual and performance. Often, there was a dance competition.

Since the Renaissance, the ideals of balance, order, and harmony have been admired and are often metaphorically associated with the Greek god, **Apollo.** The Greeks' admiration of Dionysus must not be overlooked. Dionysus represents the wildness of spirit that breathes new life into worn out forms.

Dance and Competition

There have been moments in the history of theatrical dancing when a great deal of attention has been paid to the athletic accomplishments of the performer and the distinction between dance and sport became blurred.

Sporting activities are full of fascinating movement and are undeniably expressive. Some, like skating, diving, and gymnastics are dance-like in that form is one of the criteria for winning a competition, but they are not dance. Sports are about winning and cheering on our favorites. Dance is about doing and witnessing.

There is, however, a competitive nature to dance. It seems to be in our nature as humans to want to know who is best. We compete for power, we compete for glory, and we compete for fun: the best dancers win admiration, the best dancers win the best jobs.

Baz Lurhmann's 1992 film "Strictly Ballroom" (available at any good video rental outlet) presents a humorous but thought provoking argument about dance. Is it a competition, an art form, or a personal expression?

Noverre Jean Georges (1727–1810)

Choreographer and Ballet Director. His treatise *Lettres sur la danse, et sur les ballets* faulted the excesses that were beginning to creep into ballet productions in the name of spectacle, rather than art. Trained at the Paris Opera, his main post was with the Wuppertal Ballet, which still exists today as the Stuttgart Ballet.

Prevost, Françoise (1680–1741)

Noted ballerina and teacher at the Paris Opera, who retired in 1730. Among her students were two women who would make unique contributions to the development of the ballet aesthetic, Marie Camargo and Marie Sallé.

No one's list of the dance masterpieces of the 20th Century would be complete without George Balanchine's "Serenade," a ballet which contrasts 20th Century speed and attack with 19th Century lyricism and longing. One of its most iconic moments, illustrated here by the members of the University of Arizona Dance Ensemble, comes at the very end as an ensemble of idealized women slowly glides away from the audience, their bodies arching up in greeting and submission.

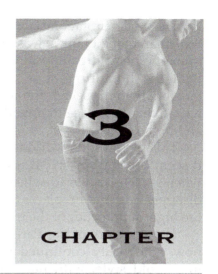

A Romantic Notion

CHAPTER **3**

There is a well known series of lithographs, created in 1845 by Alfred-Edouard Chalon, that capture a fleeting moment in the evolution of theatrical dancing and represent for some, rightly or wrongly, what ballet is all about. The image of the ballerina as a wraithlike sylph clad in layers of gauze, hovering as light as air on the tip her toes, was crystallized in 1832 with the Paris Opera production of choreographer Filippo Taglioni's "La Sylphide."

There followed a brief but intense twenty-year period in which ballet became a central player in the artistic movement called Romanticism. The offerings of the choreographers of the day, Taglioni, Juan Coralli, Jules Perrot, and Arthur Saint-Leon among them, with some help from the poet, critic, and essayist, Théophile Gautier, became as highly considered as did the poetry of Coleridge and Wordsworth, the painting of Turner and Blake, and the music of Liszt and Wagner.

The title role of "La Sylphide" was devised by Taglioni for his daughter Marie who, the year before, had proved a sensation in a brief ballet scene in the premier of Meyerbeer's opera, "Robert le Diable." The dance historian Jack Anderson describes the scene in these words,

" . . . Robert le Diable was a tremendous success, thanks to Meyerbeer's powerful operatic music and to a ballet sequence so unusual to be almost unprecedented. This episode was set in a ruined cloister where ghosts of lapsed nuns rose from their tombs to dance by the light of the moon. The sight of flickering moonbeams—a lighting effect created by suspended gas jets—Gothic ruins, and dancing phantoms cause audiences to shiver with delight. Equally remarkable was the choreographer's daughter, who seemed to float across the stage as if she truly were the spectre her role called upon her to portray."

As a child, Marie Taglioni did not seem to be ballerina material. She was scrawnier than most female dancers of her day, and her face was undistinguished except for her large eyes. Rather than voluptuous, she seemed chaste. More troubling than that, her arms were too long and her feet lacked strength. These shortcomings were corrected through years of rigorous lessons under the unrelenting eye of her father.

To accentuate rather than hide the length of her feet, she devised a way of stitching her slippers that provided her with the support to suspend her dancing while on the very tips of her toes, an innovation in foot work that was coming into vogue. The athleticism with which she was eventually able to jump and balance was disguised by the way her arms were held in a delicate, foreshortened manner and floated after the music. Her first appearance in "La Sylphide" was aided by an elevator that made it appear as if she was hovering outside a window, but it was her technique and artistry that convinced everyone that she was truly a creature of the air.

The male protagonist of "La Sylphide," a Scotsman named James, was the epitome of the romantic hero, dreamily idealistic, dissatisfied with the humdrum of a balanced life, and passionate in his search for beauty. The ballet's narrative takes place in a modest village lodge and in the nearby forest.

This picturesque world is not as ordered as it seems on the surface. It is a world ruled by witch's spells, a world where sylphs are seen disappearing into fireplaces and reappearing in the highest branches of the trees.

The directors of the Paris Opera had, until now, stubbornly continued to present ballets in the old style, with narratives based upon mythology. The Opera's recognition of the relevance of Romantic notions and folk legends thrust ballet into the spotlight and made celebrities of the women who emerged to dance their demanding leading roles.

There are two aspects of Romanticism, the ethereal and the earthy. The female in the Romantic ballet was often required to appear first as a full blooded woman, a peasant or a gypsy, perhaps, and then, in the same ballet portray some sort of spirit, a dryad or a sylph, a ghost or a vampire. Ballet directors and choreographers were now turning to folk legends for their scenarios.

One of the most popular old wives tales warned that a young woman who died before she was married would join the spirits of others such as she and return as a "wili," a man-hating ghost who, every night, danced in graveyards until dawn.

In 1841, choreographer Juan Coralli, in collaboration with the poet and ballet critic, Théophile Gautier, devised a narrative that told of the romantically inclined Count Albrecht, who, though already engaged to a noblewoman, directs his affection to a charming peasant girl, Giselle. After learning of Albrecht's duplicity, Giselle loses her reason and dies.

When Albrecht visits Giselle's grave at midnight, with a huge bouquet of lilies to make a show of his remorse, he is accosted by the wilis. Their queen, Myrtha, commands that the ghost of Giselle dance with Albrecht, a dance meant to end in his exhaustion and death. It is only through the loving encouragement of Giselle that Albrecht survives until the first rays of dawn call the wilis and Giselle to return to their graves.

This scenario provided everything that the Paris Opera audiences were now hungry for: hearty folk dances to invigorate and apparitions to amaze, a wine festival and a graveyard, a handsome hero who proves to be a cad, a mad scene, and a sad ending lifted from fatalism by the lofty concept of redemption through love.

To play the title role, Coralli and Gautier chose Carlotta Grisi, one of Taglioni's rivals. Grisi brought to the project the talents of a second choreographer, her husband, Jules Perrot, who provided much of her solo choreography. It was surely an uneasy collaboration, but "Giselle" was hailed by audiences and critics, among them Gautier himself.

"Giselle" is still performed today and its leading role stands as a test for any accomplished female dancer who aspires to be considered a genuine "ballerina," an artist who transcends her technique. In the first act she must be hearty enough to be believable as queen of the peasant harvest celebration, but she must be refined enough to attract Albrecht's advances.

It is never quite clear what Giselle's health problems are, a bad heart or weak lungs, but she must be convincing in conveying the delicate condition which leads to her madness and death. In the second Act she must evoke feelings of sympathy and love while dancing, as would a ghost, without revealing the physical effort required of the demanding choreography.

Grisi was not Taglioni's only competitor. There was Fanny Cerrito, a blond Italian with plump cheeks, well turned calf muscles, and a winning smile. And there was Fanny Ellsler who, like Cerrito, was more suited to the earthy side of Romanticism than the ethereal.

Gautier used his public voice as a journalist and critic to generate an intense rivalry between Ellsler and Taglioni that resulted in the continuing popularity of the two ballerinas and put Gautier right where he wanted to be, in the public eye. Taglioni, he described as a "Christian" dancer and Ellsler he deemed "pagan."

The enthusiastic words with which Gautier, in his 1845 *Les Beautés de l'Opera*, described Ellsler in her Spanish solo, "La Cachucha" suggest that his interest in dance may not have been entirely artistic in motivation.

Now she da rts forward; the castanets begin their sonorous chatter. With her hand she

seems to shake down great clusters of rhythms. How she twists, how she bends! What fire! What voluptuousness! What precision! Her swooning arms toss about her drooping head, her body curves backwards, her white shoulders almost graze the ground.

In 1845, an enterprising English gentleman, Benjamin Lumley, was manager of Her Majesty's Theatre in London, whose productions often rivaled those of the Paris Opera, at least in matters of notoriety. He conceived of presenting four rival ballerinas on the same stage, at the same time, in the same ballet.

Naturally, he chose Taglioni, who, though approaching retirement, was still considered a hot ticket at the box office. Grisi was invited. Lumley would have liked to have engaged Ellsler as well but there was no possibility she and Taglioni would have shared the same stage. Instead, Lumley settled for Fanny Cerrito whose beguiling personality would appeal to the dandies of London.

His fourth choice was a comparative unknown from Denmark, Lucille Grahn, about whom there was a great deal of curiosity. She was reported to have had a great success in a new version of "La Sylphide" created for her in Copenhagen by her ballet master August Bournonville.

Jules Perrot was commissioned to provide the choreography for *"Pas de Quatre,"* which he devised as a series of ensembles that evoked both lyricism and passion alternating with solos that displayed the unique qualities of each ballerina.

Perrot was now estranged from Grisi, who had shifted her affections to none other than Théophile Gautier. Lumley worried that, with such clashing personalities in close proximity, the rehearsals would be a bedlam of demands and recriminations. To the contrary, everything progressed in a most civil manner, the only hitch being an argument over the order in which the ballerinas would appear. This was solved by having the women appear in order of age, the youngest first, Grahn, progressing to the eldest, Taglioni.

The opening night was an immediate success. During the final tableau, representing the crowning of Taglioni as *La Reine de la Danse*, the audience rushed down the aisles toward the stage and threw flowers at the feet of their personal favorites.

Soon after "Pas de Quatre," Perrot took his broken heart to the Maryinsky Theatre in St. Petersburg, Russia, which was intent upon importing the best in European ballet. The aesthetics of the Romantic ballet fell out of favor in Paris. Taglioni eventually retired and became a respected teacher and choreographer.

The last flicker of the luminance of that "Golden" age of ballet may be metaphorically said to have coincided with the tragic death of Emma Livry, a protegee of Taglioni's. While portraying a butterfly in "Le Papillon," which Taglioni had created to display her student's ability to portray fragility, Livry's gauze costume brushed too close to a gas lamp and she was enveloped by flame.

Not much dancing of importance happened at the Paris Opera for a number of years. The ballet hierarchy reverted to its stodgy bureaucratic ways. Intrigue became the means for gaining power. A ballerina was as likely to be the mistress of a rich ballet patron as she was a woman taken seriously for her art.

By the end of the 19th century, the male dancer, whose prominence had already begun to fade when the Romantic ballerinas were in the spotlight, disappeared entirely from any place of importance. None can be seen in canvases of the painter, Edgar Degas, whose work depicts the reality of the Paris Opera in the latter part of the 19th century. The white haired dancing master, who appears in several of Degas' paintings of the Opera's ballerinas in the classroom, playing the *piccolo* violin to accompany his students, is Jules Perrot, who made a successful return home from Russia.

Another prominent French choreographer who spent several years teaching and choreographing in St. Petersburg was Arthur Saint-Leon. Although several of his works are still performed in Russia, American audiences only know of him as the original choreographer of "Coppelia," one of the most popular of all ballets.

"Coppelia" was created for the Paris Opera in 1870, during a period when the men's roles in ballet were being danced by women. These *travesty* performers did not disguise their feminine shapes but instead wore form-fitting costumes to assure the audiences that underneath their brusque pretence at masculinity they were women, as desirable as any ballerina or *coryphée*.

Much of the success of "Coppelia" is due to its musical score by Leo Delibes, which stands with those of Tchaikovsky, head and shoulders above other trite and haphazardly amalgamated ballet scores whose contributions to the artistic whole are sometimes little more than perfunctory. So masterful was Delibes at producing a unified whole, which in its parts contained attractive rhythms, delicate waltzes and soaring melodies, that his other ballets, "Sylvia" in particular, the story of an Amazon huntress and man hater who finds herself in love, are frequently revived despite the weaknesses of their scenarios.

Not counting its score, the scenario of "Coppelia" is its strongest asset. It is based upon a short story, "The Tower," by E.T.A. Hoffman; whose writings inspired several of 19th century ballet's significant theatrical works. Its narrative provides the opportunity for a colorful variety of dances that seem to occur from the needs of the moment and which further the action as much as does the ballet's pantomime scenes.

The heroine, Swanilda, is an independent young woman of the lower middle class who is not sure that she is ready to settle down with the young man that everyone, including herself, expects her to marry. This young man, Franz, is no prince. He is the town flirt. There is a trace of the Romantic hero in Franz but now the object of distraction is not an airy apparition but a life-sized, life-like doll with porcelain cheeks and enamel eyes. That a young man would find this artificiality attractive was a reflection of, and perhaps a satirical comment on, the current Parisian taste in fashion and make-up.

None of this has much to do with Hoffman nor does the ballet's sub-plot or back story in which the Burgomeister of the village, in an effort to encourage local pride and population growth, offers a bag of gold to any young couple willing to marry and start a family.

Hoffman's contribution comes in the introduction of a character both comical and sinister. Based upon the villain of "The Tower," Dr. Coppelius is an anti-social eccentric who, for some convenient theatrical reason, lives across the town's central square from Swanilda, above the doll shop he has opened as a cover for his secret experiments with black magic and alchemy.

In the second act, the juxtaposition of superstition and every day common sense reaches its climax, turning from comedy to pathos and back again to comedy. The old Coppelius believes that he has finally brought his doll, Coppelia, to life, and for the first time experiences joy, an emotion that has throughout his life eluded him. But then, his beloved but ungodly creation turns into an impish child and wreaks havoc in his workshop. When the mischievous doll is revealed to be Swanilda in disguise, Dr. Coppelius' last romantic notion is crushed.

Hoffman's original story ends with the hero, bedazzled by the life-like doll, throwing himself in despair from the top of a bell tower. The ballet ends happily with the marriage of Franz and Swanilda. The wedding festivities serve as an excuse for a display of brilliant dancing. Following old-fashioned tradition, the allegorical figures of Prayer, Dawn, Toil, War and Peace appear to bless the nuptials. Fancily dressed revelers called "Follies," meant to represent the evening hours, lead the rousing finale.

Male dancers have been restored to "Coppelia," and its choreography has undergone constant adaptation to include contemporary advancements in technique. In Saint-Leon's plot, the tower of the original story appears as the spire of the village church. The occasion of the dedication of a new bell becomes the occasion for the celebration of the newly arranged, reward-induced marriages.

The only weakness in the ballet, according to Fredbjorn Bjornson of the Royal Danish Ballet, who was noted for his portrayal of both Franz and Dr. Coppelius, is the abandonment of Coppelius in the third act. He is allotted less than thirty seconds to convince the audience of his transformation from disillusionment and righteous anger to the benign acceptance of Franz and Swanhilda's bag of gold, a genuinely offered but hopelessly inadequate offer of reconciliation.

With the relocation of Dr. Coppelius to the status of a sideline figure, ballet abandoned its preoccupation with the dreamy notions of Romanticism. Its heroines, although still idealized, were no longer just supernatural creatures but often real women with an advancing technical virtuosity that demanded to be displayed.

Scenarios began to reflect the academic advancement that was being made in the ballet studios. A broader style began to develop. Ballet's heroes began to be patterned after the medieval knight, a dedicated man in search

of purity. Villains were no longer complex characters for whom sympathy could be found. They fascinated because they were innately wicked. The polarities of the Romantic era shifted from air and earth to good and evil. In the Romantic ballet, the plot often dictated the form of a ballet. Now a form was developing, the elegance of which began to dictate what plots were appropriate to fill it.

It was not in Paris where this transformation in ballet occurred, but in St. Petersburg and Moscow. The plans of the Russian Czars to open the windows of Russia to the West involved making sure that Russia was not seen as a barbarian nation. As early as 1738, French ballet masters were employed to refine the dancing of the Russians.

In 1766, Catherine the Great extended her personal patronage to the Imperial Theatres, and the importation of ballet masters and choreographers continued. The French choreographers Didelot, Perrot, Saint-Leon, and the legendary teacher Carlos Blasis made their contributions to Russian ballet as did the Swede, Christian Johannsen, a pupil of the French-trained, Danish master, August Bournonville.

The figure who was most responsible for the development of ballet's remarkable classical era was an enterprising young man from Marseille who, in 1847 was engaged as a *premier danseur* in St. Petersburg and as a choreographic assistant to Saint-Leon. His name was Marius Petipa.

Some Other Names and Things Worth Knowing

Romanticism

A viewpoint regarding the nature of life and the arts that reflect it. It is characterized by the search for a personal idealism and the allure of the exotic.

"La Sylphide"

A typical and still popular ballet of the Romantic Era. Its first version was created by **Filippo Taglioni** in **1832** for his daughter Marie.

The version that is most widely known today was created in **1836** by the Danish ballet master, **August Bournonville,** to showcase the talents of his protegee, **Lucille Grahn**. Grahn is said to have been one of the first ballerinas to be able to include in her performances pirouettes performed while rising, *en pointe*, to the very tips of her toes.

Taglioni, Marie (1804–1884)

Thrust into celebrity by her success in *La Sylphide*, she remained throughout her career the undisputed Queen of the Dance. Clamoring crowds greeted her stage and personal appearances, fashionable women adopted her hairstyles. It was reported that fans would celebrate at their after-performance suppers by consuming a soup concocted from her dancing slippers.

Ellsler, Fanny (1810–1884)

French ballerina who rivaled Marie Taglioni in popularity. Her world tours spread the popularity of ballet. So many members of the United States Congress left their duties to attend a matinee she was giving in Washington, D.C. that the legislative session was adjourned for the day. When Ellsler danced in the United States her partner was often an American trained dancer, George Washington Smith, noted for his rope dancing, a novelty act popular in variety shows.

Gautier, Théophile (1811–1872)

French poet, novelist, journalist, and dance critic. The popularity of his written work, his place amongst the *intelligencia* of Paris, and his love of ballerinas sustained the prominence of the Romantic ballet. Some feminists feel that the pedestal upon which he placed the ballerina did a disservice to women.

"Giselle"

An 1841 ballet presented at the Paris Opera with choreography by Juan Coralli and Arthur St. Leon. Its score by Adolph Adam employs the sophisticated use of *leit motif*, the identification of a particular character or emotional situation with a particular musical theme. The first act of Giselle

represents the earthier side of the Romantic age and the second act represents the ethereal.

Perrot, Jules (1810–1892)

French ballet master and choreographer who devised the dances for the famous **Pas de Quatre** of **1845**. Cesare Pugni's musical score for *Pas de Quatre* still exists as does a popular recreation of the ballet by Anton Dolin. Though Dolin has included certain pirouettes that would not have been done at the time, particularly in the solo passages for the dancer portraying Carlotta Grisi, his version presents an evocative and sometimes humorous look at one of ballet's most fascinating eras.

Lee, Mary Ann (1823–1899)

Philadelphia born ballerina who danced at the Paris Opera, along with another American dancer, Augusta Maywood. In Boston, in 1845, she starred in the first American production of "Giselle". It is supposed that Lee had a good sense of humor. There is an apocryphal story that reports that when she retired in Philadelphia and began mounting the productions she had learned in Europe, she gave "La Bayadère, the Maid of Kashmir" a much more appropriately American title, "Buy It Dear, 'Tis Made of Cashmere".

Anderson, Jack

Dance critic and historian. Although a text on the history of dance can prove obsolete within a generation of its publication, Anderson's richly descriptive, "Ballet & Modern Dance: A Concise History," a Dance Horizon publication of the Princeton Book Company, has survived several printings.

Coryphée

One of the lower ranks of female dancers in the hierarchy of the Paris Opera Ballet. At the top of the ranking is the *étoile*, the star, a designation not lightly conferred. During the post-romantic era, a *coryphée* was most likely to be prettier than she was accomplished.

En pointe

To convey a sense of character that was essentially romantic, Taglioni and her contemporary ballerinas rose to the tips of their toes. The first "pointe shoes" were no more than a tube of heavily darned satin with a leather sole into which the foot was squeezed. They gave the dancer only a fleeting moment of support. The contemporary pointe shoe is the result of an ongoing collaboration between cobblers and ballerinas. It features a box of satin and glue to protect the toes and a narrow shank of leather, wood or steel to provide strength while maintaining flexibility.

"The Pointe Book," by Janice Barringer and Sarah Schlesinger, published by Dance Horizon Books of the Princeton Book Company outlines the fascinating history of the pointe shoe. It discusses the teaching of pointe work, the care of the shoe and the foot and includes a chapter on pointe related injuries and their remedies.

Even though classical ballet is considered by many to be a "Russian" endeavor, it has retained its original French vocabulary as a common language for dancers around the world. Here, Candace Bergeron (2011 BFA and member of Colorado's Ballet Nouveau) performs a *cabriole devant*. The *cabriole* is named after the lighthearted capering of a goat but in ballet, it is often transformed into something exciting and dramatic.

Just What Is So Russian About Russian Ballet?

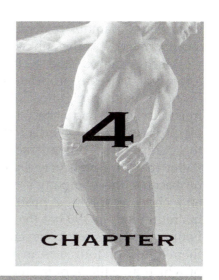

4

CHAPTER

It has been nearly a century since Serge Diaghilev, a devotee and entrepreneur of the fine arts, first brought a troupe of Russian dancers to Paris in 1909. The color, vitality and artistry of the Russians so astounded the easily bored and just as easily excitable trend-setting Parisians that soon after, throughout the entire Western world, the words "ballet" and "Russian" became irrevocably linked.

At the same time Diaghilev and the Russians were establishing their supremacy in the dance world, back in St. Petersburg (or Leningrad as it was re-named after the Marxist revolution), the retired ballerina Agrippina Vaganova was developing a system of teaching that uniquely blended classical aesthetics and physics. Today, the Vaganova method is still producing exceptional artists whose allure to the West is due in part to their "Russian" mystique. It would be rare to find a ballet company today that did not have a direct Russian influence reflected somewhere on their roster of artists, be they performers, choreographers or teachers.

Russia has always had an active folk dance tradition that reflects its nation's Eastern regions. Ballet was initially a European expression and was not taken seriously in Russia until the 18th century when the czars, as part of their goal of refuting the world's view of Russia as a barbarous nation, began importing ballet masters from Western Europe.

Catherine the Great, who was German born, imported ballet masters, as Catherine de Medici

had done, to arrange festivities for her court. This time the experts were not being brought to Paris but from that city which had established itself as the center of all things important in ballet.

There is a delicious irony in the fact that only a very few of the "Russian" dancers Diaghilev brought to Paris were taught by Russians. Their strongest influences came from the Danish-trained Swede, Christian Johannsen, (who was the student of Bournonville), the Italian, Enrico Cecchetti and the Frenchman, Marius Petipa.

Marius Petipa began his dancing career in Marseilles, a port city that had little reputation for refined taste. Apparently his talents were overlooked by the mavens in Paris. In 1847 he accepted a position in St. Petersburg as a dancer and as choreographic assistant to the chief ballet master of the Imperial Ballet, Arthur Saint-Leon, another Frenchman. It was an amazing coincidence of talent and opportunity.

The Russian dancers that became the raw material for Petipa's choreographic inspiration were of sturdy peasant strength and determination but they had an aristocratic sensibility. Many of the young girls who were entered in the school had been born as the result of clandestine relationships between the nobility and their servants. If such an unwelcome child were talented and hard working she would receive a good education at the dance academy and life long career skills. At the time of her enrollment in the Academy, the birth certificate of Anna Pavlova, who became one of the

world's most famous celebrities, read . . . mother, chambermaid . . . father, unknown.

Marius Petipa had a talent for creating appealing dances appropriate to any occasion or exotic locale that might occur in a ballet. Petipa must also have had a very pliable personality. He proved himself so adept at working within the complicated bureaucracy of the Imperial Ballet that in a relatively short period of time he became the company's chief ballet master and choreographer, a position he held until his retirement in 1903 at the age of eighty-five. Petipa created seventy-seven works, many of them three or four acts in length, and many of which are still popular today, "Swan Lake," "The Sleeping Beauty," "Don Quixote" and "La Bayadère" among them.

When we speak of "classical" ballet we are referring to ballet that follows the Petipa model . . . purposefully balanced construction and choreographic exploration confined to the basic positions of ballet as it was presented in the 19th century. "Classical" ballet is to some the ideal expression in dance of the classic ideals of harmony and balance that were championed during the Renaissance.

In his choreography, Petipa followed a classic literary and music model, employing the devices of introduction, statement, variation, development and recapitulation. This is evident in his full-length works whose first two acts or scenes present contrasting worlds. A third act will bring these worlds into conflict and a fourth will bring resolution.

Occasionally this resolution was of a tragic nature as in "Swan Lake," but more often Petipa chose to close his ballets with celebration. A wedding could be filled with a variety of dances that would fulfill his personal need to explore choreographic design, please his audiences, and challenge his dancers.

He sometimes turned to his assistant, Lev Ivanov, to provide the choreography for scenes of a lyrical nature. It can be said that Ivanov was the first Russian-born choreographer of international significance. Today we best know his work for the second and fourth acts of "Swan Lake," the white acts that continue to encourage the image of the ballerina as an exotic bird-like creature.

As stage-worthy as Petipa's ballets have proven to be over time, they did not bring the Russian ballet the same prominence it enjoys today. Petipa continued to rely upon guest artists from Italy and France to please his audiences and train his dancers, but few Russians were asked to dance in Paris.

Not until the Legat brothers, Nicholas and Sergei, began to teach, and Enrico Cecchetti, Italy's leading ballet master was brought to St. Petersburg, did the Russian ballet begin to produce dancers who combined that certain combination of facility, physical appearance, and artistry which would distinguish them as world class.

Into this picture stepped Sergei Diaghilev, a liberally educated man with refined tastes and artistic aspirations. A highly educated and canny gentleman, he knew that any artistic talents he might himself possess would be of an amateur nature. Such a level of artistic achievement was unacceptable to him. His calling was that of an entrepreneur of the arts. His taste and cleverness would lead artists to audiences and audiences to artists.

When in Paris, overseeing an exhibition of the work of a new wave of young Russian painters, he became acutely aware of Parisian taste. Much of what was being presented in dance he found to be lacking in vitality. The dancers who were being applauded in Paris were, in Diaghilev's opinion, less interesting than the younger dancers in Russia who were being groomed by Cecchetti, among them, Anna Pavlova, Vaslav Nijinsky, and Tamara Karsavina.

Diaghilev immediately set about getting permission for a selected group of the Maryinsky ballet's younger artists to perform, under his supervision, in Paris.

The initial 1909 Parisian success of Diaghilev's company was beyond what anyone could have suspected except Diaghilev himself. He knew that Paris would be stunned by the delicacy of Pavlova and Karsavina and by the sight of the young Nijinski, more creature than human being, suspending his jumps in mid-air.

You have to remember that there weren't many accomplished male dancers in Paris at that time and the ballerinas had made an art of flirting from the stage. What do you suppose they thought when Diaghilev and Fokine confronted them with the Polovtsian Dances from Borodin's opera "Prince Igor" with its seductive women, veiled and undulating, and

its horde of attendant warriors leaping until they were shining with sweat?

This was not exactly the picture of Russia that the czars had meant to encourage, but Paris went wild for the Russians. Before the last performance was over, Diaghilev had begun contacting young designers to create work for a second season. Many seasons followed, and soon Diaghilev's Ballets Russes was embarking on tours that took them to the far corners of the world. After the outbreak of the Russian revolution, the Russians made their home in Monte Carlo, which during World War I became a haven for the wealthy. Among the patrons that Diaghilev turned to for support were the retired Colonel de Basil, the Marquis de Cuevas, and the fashion designer, Coco Chanel.

Whereas the Petipa model conceived of an evening of ballet as something unified and satisfying in its wholeness, the Diaghilev model presented an evening made up of three or four separate works, each unique. It is the model for ballet made popular in America by the Ballet Russe de Monte Carlo, one of the several companies claiming the inheritance of the Diaghilev legacy after his death. It is the model followed by Lucia Chase, Richard Pleasant and the designer Oliver Smith when founding the Ballet Theatre in 1939 (later to become the American Ballet Theatre).

A typical program might open with Mikhail Fokine's "Les Sylphides," a twenty-minute story-less ballet that evokes the atmosphere of the Romantic Ballet. This is to reassure the audience that whatever is coming next, no matter how avant-garde it might be, no matter how "un-balletic" it might look, the dancers are grounded in history and authentic ballet training.

The second ballet of the evening would often be Fokine's "Scheherazade" a tale of jealousy, adultery, orgies, anger, execution, and suicide, danced on a red floor cloth before a seductive brilliantly colored harem set designed by Leon Bakst.

Diaghilev's strategy was not unlike that of an elegant salesman in a fine perfume shop on the Champs Elysees in Paris who offers you several unusual scents to enjoy in hopes you will choose at least one of them. "Les Sylphides" and "Swan Lake, Act II" are redolent of evening and moonlit air. "Scheherazade" smells of desert heat and sex. To further tickle the nose of his patrons, Diaghilev would often choose to end the evening with a ballet that had a lighter "fragrance," something frothy and champagne-like perhaps.

George Balanchine, whose early work was encouraged by Diaghilev, often said the responsibilities of supervising the repertoire of a ballet company were like those of a master chef who knows how to present appetizers, main dishes and tasty desserts that lead to the satisfaction of a good meal.

Another young choreographer, Leonide Massine, whom Diaghilev had recruited fresh from school in Moscow, provided several closing ballets for this formula with skill and abundance. Massine was a small man with a wiry physique not particularly well suited to classical ballet. He excelled in the light comedy roles he made for himself and in the percussive dancing of Mediterranean men, particularly the Spanish Gypsy. He haunted the bars of Spain, learning by observing the local flamenco dancers. Diaghilev paired him with the composer Manuel de Falla and the artist Pablo Picasso.

This typical formula program is often impolitely referred to as "bread and butter." During its touring years in the 1940s and 1950s, a Ballet Russe de Monte Carlo program would most likely close with Massine's "Gaité Parisiènne," a frothy concoction danced to the music of French composer, Jacques Offenbach. Here, Massine has cast his eye on the behavior of people when they are "on a night out" and are apt to do impetuous things.

Massine takes us into a Paris nightclub, somewhere in the not too respectable district of Montmartre. As in a situation comedy, we meet four characters: a baron, a glove-seller, an operetta star and a lonely little Peruvian tourist who is lost and has mistaken the nightclub for his hotel. There are flirtatious waltzes and a show-stopping can-can. The ballet's unexpectedly quiet rather than rousing final moment asks us not to remember the merriment of the ballet, but how someone can be lonely in the middle of such merriment as has been depicted.

The name Ballets Russes is associated with glamour and intrigue. The stars of Diaghilev's company became celebrities. Their personal as well as professional activities made good press. Diaghilev cannot be accused of overstepping the bounds of good taste but there was always the hint of some scandal or controversy in the air at a performance of the Russian ballet.

The 1948 film, "The Red Shoes" in which Massine and other ballet stars appear, paints a clear picture of a Diaghilev-like ballet director producing a ballet based on the E.T.A. Hoffman tale of a young woman obsessed with dancing.

The young Vaslav Nijinsky became Diaghilev's favorite and protégé. Everyone acknowledged that Nijinsky was a phenomenal dancer, but not many of Diaghilev's colleagues agreed with his assessment of Nijinsky as an able choreographer. Nevertheless, Nijinsky was given the assignment of creating a short ballet "L'Après Midi d'un Faun" to the impressionistic music of Claude Debussy.

In a forest glade we discover a creature from Greek mythology, half man and half goat, admiring himself in the reflection of a pond. His reverie is disturbed by the appearance of a small group of forest nymphs. The faun watches from a distance until he musters up the courage to approach one of them.

The flatness of the slow moving choreography that Nijinsky invented to invoke the silhouettes of dancers on ancient Greek vases was perceived as odd by an audience expecting something more complicated and physically astounding, but it was the closing moment of the ballet that raised concerned eyebrows, when Nijinsky, as the faun, slowly lay himself face down on the scarf of the nymph who had eluded his advances, quietly but ecstatically convulsing in orgasm.

Some critics found the depiction of such an act, however tastefully done, to be unacceptable theatrical behavior and demanded that the ending of the ballet be changed or the dance not be performed at all. The sculptor Rodin and other Parisian intellectuals came to Nijinsky's defense, and the ballet was presented without alteration throughout the season.

Another of Diaghilev's protégés was Serge Lifar, a dancer who shared Nijinki's creature-like qualities though not his phenomenal elevation. Lifar danced the role of the faun for many years with great success. A contemporary version of "The Afternoon of a Faun" by Jerome Robbins is often presented by the New York City Ballet.

In Robbins' version, the setting is a ballet studio with canvas walls that wave gently as if there were a fresh breeze blowing. The faun is a young male dancer who is doing stretching exercises and admiring himself in the mirror. The mirror is the fourth wall of the stage, the audience. The nymph is a young female dancer who has come into the studio with her hair still down. She is expecting no one else to be there.

The two dancers first see one another through their reflections in the mirror. When they finish their encounter, which has evident but never overt sexual undertones, the young woman leaves the young man alone, as the nymph left the faun. No scarf has been left and the young man turns his narcissistic gaze once again into the mirror.

For Nijinsky's next choreography, Diaghilev engaged the composer Igor Stravinsky to provide the score for a ballet that would depict an ancient Russian spring ritual involving human sacrifice, in which a chosen victim (in Nijinsky's scenario, a woman) dances herself to death.

Stravinsky's earlier ballet scores, written for Fokine's "Firebird" and "Petrouchka," had enjoyed great success. Despite their occasional tendency to employ dissonance, they contained lush harmonies, recognizable rhythms, and catchy folk tunes. His score for "Le Sacre du Printemps" as it was titled, "The Rite of Spring," was another matter.

Just as Nijinsky rejected the employment of the traditional ballet vocabulary and turned once again to the use of parallel and directly turned-in movements to evoke the primitive qualities desired, Stravinsky rejected the familiar underpinnings that had been a part of his earlier work. His score was filled with primitive sounds and confoundedly complicated rhythms.

At first Nijinsky was overwhelmed by the difficulties of the score and the resistance of the classically trained dancers who were not comfortable turning-in and didn't want to. To rescue his protégé, Diaghilev engaged the services of Marie Rambert, a young Hungarian dancer, to assist in musical matters. Her expertise was in Dalcroze Eurhythmics, a method for analyzing and performing rhythm that was widely popular with modern dancers at the time.

Rambert helped Nijinsky through one particularly troubling passage that was to be counted in five, a meter with which classical dancers were not familiar, by having the dancers chant over and over the name of someone about whom they had mixed feelings, "One, two, three, four, five, Ser-gei -Dia-ghi-lev! Ser-gei-Dia-ghi-lev!"

Soon after the curtain rose on the premiere of "Le Sacre du Printemps," a murmur began

to arise from the audience. It is not clear if the initial verbal comments were a result of the audience's reaction to the turned-in postures of the dancers or was a complaint caused by an adverse reaction to the opening passages of the music which features an eerie melody played by a bassoon in its highest register.

People began yelling at one another, calling for quiet or for "no more of this nonsense." Soon the din was so loud that no one could hear the offensive music at all, not even the musicians. The conductor began to shout at his players to keep them together, and to the audience as if pleading for their silence. Back stage, Nijinsky, who was not in his own ballet this time, and Diaghilev had to station themselves behind the stage scenery where they loudly called out the ballet's counts so the dancers could finish the ballet with some semblance of order.

I would like to have witnessed that performance, but even more I would like to have been a guest of Diaghilev's for breakfast in his hotel suite the next morning. I can see him now with the white streak that ran through his black hair and prompted some of his friends and most of his enemies to call him "chinchilla."

He is sitting in a big armchair wearing a silk dressing gown with an unfinished breakfast tray before him and the morning newspapers strewn at his feet. There is a look of contained triumph on his face. Sulking in a far corner is Nijinsky, still in his pajamas, wondering if the front-page attention "The Rite of Spring" was receiving had anything at all to do with his talents.

Nijinsky made only two more ballets. "Jeux," again to the music of Debussy, presented, through the allegory of tennis, the complications of a three-way relationship. It was not understood or appreciated by the public and was soon dropped from the company's active repertory.

Nijinsky's last ballet, "Tyl Eulenspiegel," to the music of Richard Strauss, told the story of a German folk hero who thumbs his nose at his enemies even after his execution as a revolutionary insurgent. It was created later in Nijinsky's career, after he had broken from Diaghilev to marry and was forced to return to dancing to support his family.

Nijinsky claimed that Diaghilev had not paid him adequately for the choreography of "Tyl Eulenspiegel" and took out a court order demanding that Diaghilev's company cease and desist from performing it. When the order was finally served, just before the curtain was about to rise on a performance in St. Louis, Nijinsky was in his costume ready to perform the ballet as was required by his dancer's contract.

Such conflicts seemed to plague Nijinsky, and while still a comparatively young man he was confined to a mental institution. The journals and drawings that he produced while in the hospital have been published, and are as fascinating as the story of Nijinsky's career.

Stravinsky continued composing for the ballet and entered into a fruitful collaboration with George Balanchine that continued when Balanchine immigrated to America.

When Diaghilev died in 1929 and his Ballets Russes was dissolved, the artists of his company who were unable or unwilling to return to their native Russia, now a communist nation, started new performing and teaching careers in countries on every continent except Antarctica. (The first ballet class known to be taught in Antarctica was given in 1994 by the American choreographer and dancer, Mark Hilleary, no relation to the explorer.)

George Balanchine came to the United States at the invitation of the rich and highly educated millionaire, Lincoln Kirstein, to form what Kirstein envisioned would become an American ballet company. In Balanchine's estimation, American dancers were haphazardly trained compared to the Russians. In his wisdom he knew that the first thing to do was establish a tradition of sound preparation. In 1934, he opened the School of American Ballet with a prestigious faculty composed of his Russian colleagues. The following year he formed his first company, which, after going through many struggles, emerged as the New York City Ballet.

The first significant work created by Balanchine for his new American dancers was "Serenade," created during a summer workshop in Hartford, Connecticut under what were makeshift conditions. "Serenade" is considered by many to be Balanchine's most enduring masterpiece. Pleased with its lasting popularity, Balanchine always asserted that he had made the ballet as a training piece for his new dancers. . . offering them the experience of entering and exiting as soloists and in groups. . . challenging them to sustain a romantic mood

while dancing difficult choreography in perfect unison.

When making "Serenade," Balanchine was forced to design patterns for the unusual number of seventeen dancers, not all of who were available at every rehearsal. On one particular evening, a dancer arrived late and proceeded to wander among the others searching for her place. Balanchine found the moment interesting and left it in the ballet.

When a dancer fell to the floor in exhaustion after a particularly long and grueling rehearsal, Balanchine returned to that moment the next evening and created what has become known as the entrance of the dark angel.

The most well known image of "Serenade," one that has become an icon for American ballet, occurs near the beginning. An ensemble of women hold up their right hands as if to greet, or ward off, some approaching force. This came about by accident during a preliminary stage rehearsal, when some poorly focused lights were shining too brightly in the dancers' eyes.

Balanchine loved becoming an American. He loved the jazzy energy of the country. He loved the dancing of Fred Astaire and Ginger Rogers. He loved how the long limbs of American dancers looked as they cut their way though his speedy choreography. He was less concerned with making story ballets than he was with making ballets that took their choreographic inspiration and dramatic coloring from the music and the dancers with whom he was working.

Despite the Petipa legacy that informs Balanchine's choreography, and despite his experience with Diaghilev's Ballets Russes, Balanchine's work is not looked upon as "Russian" ballet but is considered to be American in spirit.

It was the teaching of one of Balanchine's contemporaries, Agrippina Vaganova, during the Soviet Union's isolated years behind the Iron Curtain, that resulted in the image of Russian ballet that most Americans carry today.

Vaganova had been an able solo dancer but had never risen to the rank of prima ballerina. She knew that she was intelligent enough to have become more accomplished and suspected that her lack of success was due to an inadequacy in the current training methods that were still designed to favor those with innate physical gifts and neglected the potentials of the slower learner. When she retired she was not offered the position in the Maryinsky Academy that she was hoping for and began teaching privately.

After the Marxists took power and the Maryinsky theatre and school were temporarily closed, many of the dancers came to Vaganova's studio for classes to keep them in shape for the dancing positions they were now finding in the popular music halls. What they needed from Vaganova was a way to warm up their bodies several times a day without exhausting themselves to the point where they had no energy left to dance the flashy ballet routines they were asked to present three or four times a day between showings of popular films. Vaganova obliged and with the assistance of these dancers began to develop a system of teaching that used épaulement for efficiency as well as for aesthetic effect.

Lenin and the other Communist leaders eventually decided that the ballet, which had been a political tool for the deposed aristocrats, could be of political benefit to the new regime as well and reopened the Maryinsky theatre under the new name of the Kirov. Vaganova was at last invited to teach in the Academy and eventually became its director. The school is now called the Vaganova Choreographic Institute in her honor.

Vaganova's students were taught to move with broad and sweeping arm and leg movements. Her innovations included the expansion of the circular nature of ballet's traditional attitudes into elongated ovals.

The first student of Vaganova's to be considered a one hundred percent Soviet Russian ballerina was Marina Semyonova. The few old films of Semyonova that are available reveal her to indeed have the noble attitudes and rich plasticity of movement that we find and admire in Soviet and post-Soviet Russian dancers today.

Shielded from any further influence from the West by the Iron Curtain, Soviet Russian ballet developed in isolation. Little was known about the excellence of dancers like Semyonova until the Soviet government sponsored the international distribution of some films of Soviet ballets that had been choreographed by Soviet choreographers for the talents of Soviet performers, all in the interest of spreading a little art around to ease diplomatic tensions between the Soviet Union and the Western powers.

Suddenly we were introduced to dancers of the caliber of Galina Ulanova, artists whose

maturity of performance transcended the rather old-fashioned ballets in which they were presented, ballets with musty scenarios that dared not deviate in any way from communist party philosophy. The diplomatic success of the exchange of dance companies found some Russian companies touring foreign cities.

In 1961, a young dancer of the Kirov, Rudolf Nureyev, made a daring public defection in Paris. On stage Nureyev had an electric presence. Off stage he had a colorful and impulsive personality. His defection returned to Russian ballet the glamour and celebrity it had enjoyed under Diaghilev. He was invited to dance with many of the major ballerinas in the West and established a long and artistically satisfying partnership with Great Britain's luminous Margot Fonteyn who had been considering retirement before Nureyev revitalized her career.

Nureyev's performances were invariably sold out and he was frequently met at the stage door by enraptured teen-aged girls screaming, "We want Rudi. . . in the nudey."

Other defections followed, notably those of Natalia Makarova and Mikhail Baryshnikov, dancers with such ideal technical facility and artistry that they set the standard for what ballet should be. There are more dancers coming to American from Russian now that the Iron Curtain has fallen. Not all of them are of the caliber of Nureyev, Makarova or Baryshnikov and few of them have embraced Western styles of ballet as successfully as did these three. American ballet may be acknowledged as choreographically superior to its Russian counterpart, but the notion still persists if you are to be considered a good ballet dancer you need to be a Russian or dance like one.

Some Other Names and Things Worth Knowing

Cecchetti, Enrico (1850–1928)

An influential ballet master and teacher for the Ballets Russes who put the finishing artistic touches on many of Diaghilev's Russian protégés.

Towards the end of the 19th Century, the Italian dancers were considered to have the strongest techniques. Cecchetti was brought to Russia to improve the technical prowess of the dancers of the Maryinsky Theater. His teaching was exceptional in its attention to artistic detail and the attractive and evocative carriage of the arms. His methods are still highly respected and taught throughout the world today although they are now considered by some as being inadequate by themselves to meet the technical demands and the extreme extension of the limbs demanded of our contemporary ballet dancers.

Diaghilev and his Composers

Diaghilev did not consider the elements of music, set design and costuming to be of less importance than the dancing. When a ballet was made to existing music, he engaged the services of experienced arrangers and conductors such as Antal Dorati to make sure the score was of the finest musical quality. To provide the music for the new creations of his Ballets Russes, Serge Diaghilev turned to the most exciting young composers of his day, Igor Stravinsky, Richard Strauss, Claude Debussy, Serge Prokofiev, Erik Satie, and Manuel De Falla.

Diaghilev and his Designers

To create the designs for his Ballets Russes, Diaghilev commissioned the most forward looking fine artists of his day: Leon Bakst, Alexander Benois, Natalie Goncharova, Georges Roualt, Pablo Picasso and Salvador Dali. Their designs, often featuring oriental color and line, contributed to the exotic allure of the Russian Ballet. Well-produced examples of their work are easily found in any public library.

Fokine, Mikhail (1889–1942)

One of the first and most influential choreographers presented by Diaghilev. Fokine rejected the stylized eccentricities and excesses that had begun to characterize the Russian classical ballet at the beginning of the 20th Century. Strongly influenced by the American solo dancer, **Isadora Duncan**, who danced barefoot in simple and flowing costumes, Fokine sought to bring more realism and natural movement into ballet. Ironically, the

one Fokine ballet that is most often performed today is "Les Sylphides," a story-less evocation of the Romantic Era as depicted by the earlier "La Sylphide."

Nijinsky and the Entrechat Dix

In Chapter Three we spoke of the *entrechat six*, a step peculiar to the ballet vocabulary in which the dancer jumps up from the floor from the fifth position and swiftly crosses her or his feet three times before descending, again into the fifth position. A simplified version of this step is the *entrechat royale*. The more difficult *entrechat huit*, with four crossings, is only managed by the strongest of male dancers. Nijinsky, who was rumored to have an unusually long calcaneus bone in his heel which afforded him extra leverage for elevation, was able to perform the *entrechat dix*!

Nijinska, Bronislava (1890–1972)

Sister of Vaslav Nijinski and teacher of Serge Lifar, she choreographed Stravinski's "Les Noces" and Poulenc's "Les Biches" for Diaghilev's company. She eventually settled in California. Among her students were Maria Tallchief and Cyd Charisse.

Pas de Deux

Petipa's use of the classical model of introduction, statement, development or variation and recapitulation was not limited to the formal construction of his ballets. Each ensemble dance and solo variation was built upon these principles. The celebratory duet that Petipa usually placed near the end of most of his ballets had become the model for the classical **pas de deux**, or dance for two. In the more opulent ballets, or when the duet is presented out of context as a showpiece, it is called the Grand Pas de Deux. Sometimes it is simply referred to as "the pas."

In its most basic form, the classical pas de deux begins with an **entrée** that introduces the two dancers. This is followed by a longer, more leisurely section called the **adagio.** Here the male dancer is most likely to be found behind the female, supporting her at the waist or by the hands and wrists. The adagio serves to illustrate the more lyrical nature of the leading characters. In a more abstract sense, it gives the

choreographer an opportunity to show the beauty of human body as it moves from one ballet position to another. Each dancer then performs a solo **variation** designed to illustrate the vitality of the character and the ease with which the dancer can accomplish the seemingly impossible.

The closing section, the **coda,** brings the dancers back to spin and jump even faster and higher, sometimes in a circus-like fashion, which pleases the audience. A Grand Pas de Deux is often supported by a small ensemble to add variety and give the principal dancers the occasional chance to catch their breath.

Épaulement (shouldering)

A manner of maintaining the shoulders in juxtaposition to the direction of the head and body in ballet. It began to develop when dancers moved from the courts to public stages. As used by Romantic choreographers such as Bournonville, épaulement presents the dancer with gracious charm. The highly sophisticated épaulement taught by Vaganova, which combines locomotor and aesthetic principles to obtain great breadth of movement and plasticity, is indicative of the Soviet and post-Soviet Russian dancers.

The British Ballet

There were several English dancers in Diaghilev's company, most of whom, like Ninette de Valois and Alicia Markova, assumed French or Russian names. After the glory days of the Ballets Russes, they returned home. Great Britain also became the temporary or permanent home of many of the Russian-born dancers, choreographers and teachers. At the Vic-Wells Theatre in London, de Valois formed a company that was to become, after several permutations, one of the world's most respected classical ballet companies, the Royal Ballet. A prolific choreographer herself, de Valois encouraged the development of other gifted British choreographers: Sir Fredrick Ashton, John Cranko, and Sir Kenneth Macmillan.

Markova and her customary dancing partner, Anton Dolin (who was also English) danced briefly for de Valois. Several touring companies were formed around their talents and brought ballet to small cities in Great Britain and around the world.

Marie Rambert, the Hungarian modern dancer who had assisted Nijinsky with "The Rite of Spring" also settled in London where she formed a small company that produced the British choreographer, Antony Tudor, and gave the American, Agnes de Mille, her first opportunities to create ballets.

When Ballet Theatre was formed in New York City in 1940 Tudor, Markova, and Dolin were invited to be the company's "British wing." Although Rambert became a sought after ballet coach, the company she founded now performs modern dance.

Serge Lifar (1905–1986)

Russian dancer who joined Diaghilev's Ballets Russes in its later days. He was noted for the youth and beauty of his portrayals. When he was subsequently made Director of the Paris Opera Ballet, he supervised the re-working of the school's syllabus, bringing the Russian influence back to the French and adding some of his own elegant innovations. He was the first to add to the traditional five positions of classical ballet. His "sixth position" was a parallel stance with the feet close together.

Anna Pavlova (1881–1931)

Russian ballerina associated with Diaghilev in his early seasons. Not one to share the spotlight with others, she formed her own company that toured the world, and introduced classical ballet to thousands who had never seen it before. Although she was a dancer of great vivacity and charisma, she is most remembered for her mesmerizing portrayal of *"The Dying Swan,"* choreographed for her by Mikhail Fokine, to the music of Camille Saint-Saens.

Karsavina, Tamara (1895–1978)

Russian ballerina who created many roles in Michael Fokine's ballets for Diaghilev's Ballets Russes, including 'The Firebird; Petrouchka and Les Sylphides. After settling in England, she assisted in the establishment of The Royal Ballet and was a founding member of the Royal Academy of Dance, which is now one of the world's largest dance teaching organizations.

Tamara Toumanova (1919–1996)

Glamorous Russian ballerina who was a star of the Ballets Russes at the age of sixteen. It was said that she was born in a boxcar as her family was fleeing from the Communists. Her dark hair and eyes and eccentric features brought her to the attention of Hollywood producers. She co-starred in one film with Gregory Peck and played Anna Pavlova in "The Sol Hurok Story" although she was an entirely different sort of dancer. Gene Kelly utilized her exotic qualities quite differently when he dressed her in a black slit skirt and high heels as a lady of the night in "La Ronde," one of four ballets he created for his "Invitation to the Dance."

The Baby Ballerinas

In the 1930s, Diaghilev engaged three extremely young and talented teenagers to dance leading roles in his company. Toumanova was one of them. The others were Irina Baronova, who worked with both Balanchine and Massine, and Tatiana Riabouchinska, who, with her husband David Lichine, also a member of the Ballets Russes, was in great part responsible for the animated Dance of the Hours sequence in the Disney film "Fantasia" Lichine's lighthearted ballet "Graduation Ball" is still in the active repertory of many companies.

The Five Moons... Oklahoma's American Indian Ballerinas

Special note should be made of the five American Indian ballerinas from Oklahoma who each began their career in the Ballets Russes: **Yvonne Chouteau**, who, with her husband Miguel Terekhov of the Ballets Russes, helped establish a highly respected dance program at the University of Oklahoma; **Moscelyne Larkin**, who, with her husband, Roman Jasinksi (also of the Ballets Russes), helped establish the Tulsa Ballet; **Rosella Hightower**, who became Prima Ballerina of the Marquis de Cuevas Ballet, an off-shoot of the Ballets Russes, and was one of the first to dance with Rudolf Nureyev when he defected. For a brief time, she directed the Paris Opera Ballet; **Marjorie Tallchief**, who married Ballets Russes star George Skibine and helped establish the Dallas Ballet: and her sister,

Maria Tallchief, who was a principal dancer for several American companies but whose career was particularly associated with the New York City Ballet. She was married to George Balanchine from 1946 until 1951.

American Ballet Theatre

Founded in 1937 under the patronage of heiress Lucia Chase as the *Mordkin Ballet*. (Michael Mordkin, former star of Diaghilev's Ballets Russes was Miss Chase's ballet teacher). Reorganized in 1939 as *Ballet Theatre*, the company had a Russian, British, and American wings and presented mainly shorter works in the Diaghilev mode, including works by such American choreographers as Agnes de Mille and Jerome Robbins. The company did many bus and truck tours of the United States and in 1956, was renamed *American Ballet Theatre* (*ABT*). In 1960, as part of an early *glasnost* effort by the US government, *ABT* became the first American ballet company to dance in the Soviet Union. Today, in reflection of what is perceived to be current audience tastes, the company's repertory includes many elaborate full-length classics, which has enhanced their reputation, attracted many international stars to their ranks, but limited their touring capabilities.

Agnes de Mille (1905–1993)

At the center of the American wing of the new Ballet Theatre, de Mille's "Rodeo" (to the music of Aaron Copland and first created for the Ballets Russes de Monte Carlo) and her "Fall River Legend" (recounting the story of Lizzy Borden to the music of Morton Gould) became centerpieces of the company's repertory. De Mille's work on Broadway in such musicals as "Oklahoma" and "Carousel" were formative examples of how dance could be employed in the exposition and development of the story line of a musical.

Antony Tudor (1908–1987)

An English choreographer brought to the United States (at the suggestion of Agnes de Mille) to head the British wing of the new Ballet Theatre. Tudor choreographed all sorts of ballets but he is best know for his psychological works in which the main characters are at odds with the social behavior required of them: "Lilac Garden" (to the music of Chausson), which explores class barriers in Victorian England; and "Pillar of Fire" (to the music of Schoenberg), which tells of a lonely and despairing woman's discovery of love. Thanks to the Tudor Foundation, many of his works are now being revived, but they are difficult to perform for their expressiveness requires an understanding of Cecchetti placement and épaulement. The American ballerina, Nora Kaye, was renowned for her interpretations of his ballets.

Eugene Loring (1911–1982)

Milwaukee-born dancer who trained in Balanchine's early performing groups and later worked in Hollywood. His ballet, "Billy The Kid" (created in 1938 with a score by Aaron Copland) stands as one of the first and most successful "Americana" pieces created at that time.

Robert Joffrey (1930–1988)

Initially trained in Seattle by Mary Ann Wells. After a brief career in Europe with Roland Peitt's Ballet, Joffrey began teaching in New York City and formed an attractive young performing group. The Joffrey Ballet soon became the resident company at New York's City Center presenting a repertory of exciting new works by Gerald Arpino, Twyla Tharp, and other emerging choreographers, as well as meticulously researched and reproduced works of historical importance. After Joffrey's death the company moved its headquarters to Chicago.

A Dance Explosion in America

Establishing and maintaining a successful dance company is an expensive endeavor involving a complex synergistic relationship between aspiring artists, needy audiences, enthusiastic advocates and generous patrons. In 1960, dance was a risky profession to enter: New York, San Francisco, Atlanta, and Chicago were the only cities that could offer a ballet dancer any sustained and serious job opportunities. In 1963, a grant from the Ford Foundation enabled regional companies in such cities as Boston, Philadelphia,

Kansas City, and Houston to achieve professional status. Recognizing the importance of dance in the cultural life of our communities, other benefactors followed suit. Today, from Seattle to Miami, there are professional ballet companies in almost every American city of substantial size. Despite their ongoing financial challenges, these companies have skilled dancers and present important works from the romantic, classical, and contemporary repertory.

The Ford Foundation Grants were not without controversy. Who, in a democratic society, should be the arbiter of excellence? In this case, it was George Balanchine, and his decisions further extended his influence on American ballet.

Ballet's Outstanding Men of the 20th Century

At the beginning of the 20th century, ballet was not an acceptable profession for young men. The activity was deemed frivolous to those in America who valued financial success or still had Puritan blood in their veins. To the uniformed, the life style appeared suspect. Dancing was fine for the Russian men, the mysterious and high-flying **Nijinski,** and the handsome and persuasive **Michael Mordkin**, and **Adolf Bolm**. The next male ballet star who galvanized the public's attention after Diaghilev's Ballets Russes dissolved was **Igor Youskevitch** (1912–1994), a Ukrainian athlete who began ballet training in his twenties. He was most often paired with Alicia Alonso and at the end of his career he retired to teaching at the University of Texas in Austin. In 1955, a young Danish dancer, **Erik Bruhn**, achieved stardom when he danced Count Albrecht in "Giselle", opposite the legendary Dame Alicia Markova. Bruhn had an impeccable classical technique and a noble profile but he was also an electrifying presence in dramatic roles such as the Butler in Birgit Cullberg's "Miss Julie" (based on the Strindberg play), and as Don Jose in Roland Petit's "Carmen". While the adulation for foreign stars was continuing, out in Utah, two brothers, Christian and William Christensen, were teaching ballet. Three of Christian's sons, **William, Harold, and Lew**, were among their students and went on to have a lasting effect on dance in America, as teachers,

performers, choreographers, and teachers. Out of George Balanchine's New York City Ballet emerged a generation of sharp and exciting male dancers led by Jacques D'Amboise and Edward Villella, both of whom helped popularize dance in America by their frequent television appearances. Two Russian defectors then took the world spotlight, first Rudolf Nureyev and then Mikhail Baryshnikov.

Mikhail Baryshnikov

Russian-born ballet dancer who defected from the Kirov Ballet in 1979. He became the star of the American Ballet Theatre and for a brief time was its Artistic Director. He danced for Balanchine, and in the ballets of such contemporary American choreographers as Eliot Feld, Martha Graham, and Twyla Tharp who created some of her best work for his unique talent: "Sinatra Songs" and "When Push Comes to Shove."

His physical proportions, both mechanically and aesthetically, were ideal for princely classical ballet. His talent for movement and his curiosity led him to explore freer contemporary styles which he danced with equal success.

He has appeared as an actor on Broadway and in films. For his portrayal of an émigré Russian ballet star who enjoys the attention of women in "The Turning Point," he earned an Academy Award nomination.

The opening sequence of the film "White Nights" features Baryshnikov in a performance of the ballet "Le Jeune Homme et la Morte" by the French choreographer, Roland Petit, in which his athleticism, classical control, acting abilities and personal mystique were perfect for the role of a disaffected young man contemplating suicide. You will find more about this ballet in Chapter Two in the entry titled "Dance and Music."

"The Young Man and Death," which follows a surrealist scenario by Jean Cocteau, depicts the malaise and despair that can follow a devastating event, in this case, World War II. The ballet, alone, is worth seeing, but the film has other interesting moments. Baryshnikov also does some jazz dancing with his co-star, Gregory Hines, and performs a sequence of Twyla Tharp's contemporary choreography on the stage of what is meant to be the Maryinsky Theatre, where Baryshnikov might have been the star but was no longer welcome.

After retiring from classical roles, he formed an association with choreographer Mark Morris, The White Oak Project. You will find more about Morris, a clever and sometimes brash choreographer noted for his unusually sophisticated musicality in Chapters Six and Eight.

The Latin Explosion

After the Communist Revolution, the majority of Diaghilev's dancers did not return to Russia. They stayed in Western Europe or emigrated to Great Britain, America, Canada, Australia, South Africa, and South America, where they formed companies and opened schools, training their students in the traditions of excellence they had brought with them. Alicia Alonso made a different choice. After her career in the United States, she returned to her native Cuba (now under the Communist control of Castro) to open a dance academy for her homeland's impoverished children. In particular, the Latin temperament has proved to have been a perfect match for these well-trained and ambitious teachers. Many of the world's leading ballet companies such as the Royal Ballet and American Ballet Theatre dancers trained in Cuba or South America at the top of their roster. The Latin dancers wear ballet's classical deportment with ease, and their épaulement is not distorted. They dance with evident attack and great muscular joy. Their ability to sustain multiple pirouettes, and even change velocity while doing so, thrills audiences. They seem to have conquered verticality, which their teachers would tell you, they have.

Long before Freud and Jung pointed out the revelatory power of the unconscious, the arts were making use of the dream to explore both simple and complicated ideas. Agnes de Mille's bold use of the dream ballet in "Oklahoma" revolutionized musical theatre in 1943 but the dream ballet has been around, certainly since the Romantic Era. The best known example today might be "The Nutcracker", the fantasy of a young girl hoping to grow up in happiness, beauty, and security. This portrait of Gretchen Lawall, made by Ed Flores, explores the dreams of both dance and dancer.

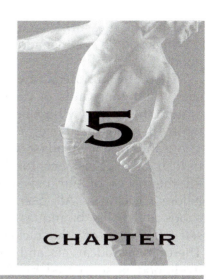

The Nutcracker

There were no angels in the first production of "The Nutcracker." There was, instead, a river of rose water that accompanied the ballet's young heroine and her Prince to the Land of the Sweets. But representing a river of rose water on stage requires costly sets and stage effects, and the sophisticated technicians and artisans needed to realize them. Today, most productions of "The Nutcracker" feature instead, a host of attending angels.

The next time you go to a production of "The Nutcracker" look closely at these angels. You may find among them, hidden under the halos and one-size-fits-all A-line costumes, young dancers whose age or development, talent or physical limitations do not allow them to be presented in more demanding roles. All that is required of them is to be able to perform a simple *pas de bourée*, smile, remember their place in line, and be on time for rehearsals and performances. Their importance to the production is, however, highly significant, and the appearance of the angels is often greatly anticipated.

If "The Nutcracker" were to be regarded as an industry, and it often is, its angels could be seen as the oil that lubricates the gears. There may be a ballet star or two, perhaps guest artists with Russian names, to boost ticket sales and briefly excite our senses, but the angels also contribute to the success of the production.

Each of the ballet's angels probably has a mother or a father who has also been playing the role of an angel. These non-dancing angels have driven countless miles to classes, rehearsals, and even board meetings. They have donated time, money, advice, and expertise to bake sales, set and costume construction, and fund raising drives. And the dancing angels have invested their own time, commitment and dreams.

"The Nutcracker" is a dream ballet. And for the many organizations across America that present it annually, it is a dream of a ballet to produce. Despite its large cast and elaborate production needs, most struggling ballet organizations, large or small, manage to produce it annually. A good production of "The Nutcracker" is the pride of a community, a reassurance that this is a good place to live. A good production of "The Nutcracker" sells tickets and fills the house. It pays for itself and more. It supports the presenting organization's other activities and offerings throughout the year.

The benefits reaped by "The Nutcracker" are not to be measured in revenue only. The opportunity to be involved in a production attracts students to the organization's training school. During its extended runs, it provides opportunities for young solo dancers to cut their teeth on increasingly demanding roles. It attracts audiences to watch and admire the progress of these dancers. Its swift scenic transitions, which include a fantastic growing Christmas tree, challenge and sharpen the work of scenic artists. It tests a ballet company's organizational abilities and has become a

yardstick for measuring their accomplishments. It brings people together and it makes them feel good.

There are hundreds of costume and scene shops and thousands of dance supply stores around the country whose businesses are based upon the popularity of "The Nutcracker." Thousands of stagehands service the Nutcracker industry. Advertisements for "The Nutcracker" fill the pages of our newspapers for weeks before Christmas. All over the country, gift shops and ballet boutiques in theatre lobbies sell all kinds of Nutcracker paraphernalia. There are woodcarvers and toymakers whose livelihood is supported by the production of endless versions of those little old-fashioned colorfully painted nutcrackers with large jaws and strong teeth. The history of how "The Nutcracker" has become an icon of American culture has been chronicled by Jennifer Fisher in her book, "Nutcracker Nation."

The first production of "The Nutcracker" was presented in 1892 at the Maryinsky Theatre in St. Petersburg, Russia, under the patronage of Czar Alexander II. Its scenario, loosely following one of the tales of Hoffman, was devised by Marius Petipa, The actual creation of the steps was assigned to Petipa's assistant, Lev Ivanov. Little of Ivanov's original choreography remains intact other than the 2nd act *pas de deux* for the Sugar Plum Fairy and her Cavalier. It is a jewel of a duet, which presents the Sugar Plum Fairy as the warm and gracious hostess for the proceedings. It gradually builds to a dynamically exciting climax, yet it manages to retain the crystalline quality of the music.

It is perhaps the music for "The Nutcracker" that is its most winning factor. It boasts one of the most familiar ballet scores by one of the world's most popular composers, Peter Ilyitch Tchaikovsky. This melodic and imaginative music was written, amazingly, section-by-section and sometimes, bar by bar, to match Petipa's pre-determined and highly detailed plans for the ballet's action.

When "The Nutcracker" was first presented, it was well received, but its cozy first act setting, a Christmas party in the living room of the mayor of a middle class German town, seemed unremarkable next to the more sumptuous settings of the other ballets Marius Petipa produced in Russia. Its appeal was to new audiences, the rising middle class who were then beginning to have the time, money and inclination to develop a theatre going habit. It made them feel comfortable and cultured.

Serge Diaghilev's Ballets Russes, which began by presenting more avant-garde and exotic works, resorted to presenting "The Nutcracker" in its waning years in an attempt to please Western audiences who were beginning to develop a taste for ballet and felt most comfortable with "the classics."

There exists a misconception that it was George Balanchine who introduced "The Nutcracker to American audiences. The Ballet Russe de Monte Carlo, an off-shoot of Diaghilev's original company, often presented a cut down touring version without children, arranged by Alexandra Fedorova (Fokine's sister-in-law). In 1944, the San Francisco Ballet, supervised by Lew Christensen presented the first full-length production of "The Nutcracker" in the United States. Christensen and his brothers, Harold and William, were important pioneers in the development of classical ballet in America, and were responsible for the formation of both the San Francisco Ballet and Ballet West in Salt Lake City.

Born in Utah and trained in both vaudeville dancing and classical ballet, the Christensens worked with Balanchine during his early years in America. Perhaps it was the success of that first San Francisco production and the distinctly American *chutzpah* and business acumen of the dancing brothers that prompted Balanchine to forgo his usually plot-less ballets to create his own version of "The Nutcracker."

It may not have been the first, but it was Balanchine's 1954 production, choreographed for the New York City Ballet, that put "The Nutcracker" on the map in America. Today almost every ballet organization in the country, professional and non-professional presents it and so do some modern dance companies. Along with baseball, apple pie, and Christmas shopping, it has become a ubiquitous part of American culture. Christmastime in the Dallas/Fort Worth metro-plex, an area not particularly noted for its strong and lasting support of ballet, boasts over a dozen independent productions

The ballet's story is simple. It tells of a young girl, Clara in most American productions, Masha in Russia, who dreams that the wooden

nutcracker, given to her for Christmas by her eccentric uncle, Herr Drosselmayer, comes alive in the form of a handsome young prince, defeats an army of rats, and takes her on a magical journey through the Land of Snow to the Land of Sweets.

Although some productions of "The Nutcracker" vary in story a little by allowing Clara to become the featured ballerina in the 2nd Act, or by delving into the darker, more Freudian aspects of Hoffman's tale of a pre-adolescent girl dealing with her burgeoning sexuality, the basic plot remains the same from production to production. One of the fascinations of "The Nutcracker" is how the basic story can stay the same while the particulars are so widely varied.

The David Taylor Dance Theatre, a Colorado company which tours the Western states, depicts the mice and rats as "hepcat" jazz musicians. At one time the Washington Ballet's ever-changing version, then supervised by Mary Day, featured Red Cross medics complete with stretchers to clear the stage of the wounded mice and toy soldiers. The dance department at Southern Methodist University presented a version costumed entirely in black and white, which featured jazz-based choreography. An Alberta Ballet production featured nine Ukrainian folk dancers in a show-stopping Cossack dance.

The New York Theatre Ballet, which specializes in playing for school children and community centers, begins their version with a large trunk on an empty stage out of which all the sets and costumes emerge. The Pacific Northwest Ballet's version, with elaborate and fantastical sets by Maurice Sendak, author and illustrator of the children's classic "Where the Wild Things Are," was filmed and shown in first-run theaters and is now one of the many versions available on video. Its central character is played by three successively more mature young women, an idea that works effectively on stage but can become confusing in camera close ups.

Balanchine's version, once the sole property of the New York City Ballet, has become increasingly popular; his choreography for the 2nd Act *pas de deux* is now presented by many companies, including some who have not received legal permission to do so. It has achieved the status of public domain.

The video available of the Balanchine version is marred by the lackluster appearance of McCauley Culkin (of "Home Alone" fame) as the young Nutcracker Prince, but the dancing of Darci Kistler as the Sugar Plum fairy is outstanding. Balanchine's realization is chillier, more sparkling and glittery than the original gracious Ivanov version, and to some, more in keeping with our fast-paced lives.

In 1992, a version of "The Nutcracker" with an even more contemporary sensibility became available on video. Choreographed by Mark Morris, a talented and often controversial American choreographer of modern dance, and re-titled "The Hard Nut," this version incorporates more of the original Hoffman story and features a quarrelling family and barefoot unisex snowflakes.

Witnessing a live performance of the Nutcracker is witnessing a ritual. The experience begins as you enter the lobby where you find yourself surrounded by chattering children who are wearing their very best clothes. The gift booth is a wonderful place to find a Christmas gift for those that are hard to buy for. The woman you buy from will be interesting to talk to for she is probably the mother of one of the dancers. Ask her what role her child is playing and you may learn a lot about the dedication of dancers and their mothers and, perhaps, something about the politics of casting.

I recommend that you get to your seat early. There will be a lot of information in the house program to be absorbed beforehand so that you won't be asking questions during the performance and will be able to better recall it all when it is over. I am always interested in who is dancing the most important roles: Clara, Herr Drosselmayer, the Sugar Plum Fairy and her Cavalier. I also like to know who is dancing the subsidiary roles and how many dancers have been assigned more than one part.

Are the dancers playing the children really children or are they older more accomplished dancers pretending? How many of the last names of the donors, guild members or board of directors are the same as the last names of the cast members?

There is sure to be a lengthy scenario provided in the house program. Read it for later reference but don't worry about memorizing the details. The first act can be confusing; it is like finding yourself at an old-fashioned Christmas

party with all sorts of odd and interesting people that you don't know. You are not going to be able to take it all in on the first viewing. Just attend to what catches your eye and don't worry about what you miss!

When Tchaikovsky's musical overture begins you will most likely find it familiar. The overture to any stage production is designed to put the audience in the proper mood for the adventure that is about to ensue, and it must give latecomers a chance to take their seats. The overture to "The Nutcracker" is a long one and its structure does not allow it to be shortened to a length comfortable to today's audiences, who are both more respectful and more restless than the audiences of St. Petersburg in 1892.

To solve what some see as a slow start problem, the Colorado Ballet once experimented with making the overture an event in itself. Chances to conduct a performance of it were auctioned off to the highest bidders. Although this gambit may have added a little money to the Colorado Ballet's fund raising efforts, it was disconcerting to have the marketing of a ballet intrude upon its performance. Luckily it did not become a new chapter in Nutcracker traditions.

My advice is to listen carefully to the overture. It is lively and delicate but at certain moments it soars. Its length can be tantalizing. "The Nutcracker" is meant to start slowly. The adventures don't begin until well into the first act by which time, if all has gone well, you are prepared to suspend your disbelief as snowflakes take on human form and all the candy you loved as a child comes to dancing life.

Some Other Names And Things Worth Knowing

Cavalier

A term first used in the 17th century to identify the supporters of Charles I during the English Civil War. It is now commonly used to identify a gentleman who acts as an escort for a lady. The principal male dancer in the "Nutcracker" is not of particular importance to the story; he is there to support the ballerina portraying the Sugar Plum Fairy and to thrill the audience with elegant and skillful dancing in his solo passages.

Herr Drosselmayer

A principal character in "The Nutcracker" whose role is composed mainly of pantomime. He is usually portrayed as a mysterious older man. His role is that of guardian. He guides us through a world in which magic and the supernatural have not given way to rationality. Drosselmayer is, essentially, a less sinister version of Dr. Coppelius, the old alchemist and doll maker in "Coppelia," another of the ballets inspired by the writings of Hoffman. See Chapter Three.

The Divertissement

A ballet following the Petipa model is likely to contain several moments when the narrative action is suspended and a series of dances are presented whose function is as much to display the virtuosity of the dancers and the wit of the choreographer as it is to bring atmosphere to the story. For most lovers of dance it is the reason to go to classical ballet.

In the first act of "The Nutcracker" there is a small diversion from the plot when Herr Drosselmayer entertains the Christmas party guests with an array of life-sized dancing dolls. The major portion of the second act is divertissement. A Spanish dance presents hot chocolate to the guests. Shepherdesses with reed flutes present marzipan. There is a waltz for flowers made of sugar. The music that Tchaikovsky wrote for these dances is played all over the world at Christmas time. We hear it on radio and television and even in the muzak piped into department stores and elevators.

It is not unusual for particular solo or ensemble variations from one of Petipa ballet's divertissement to be interpolated into another production. In the original "The Sleeping Beauty" there was no coda at the end of the Grand Pas de Deux that closed the last act's wedding celebration, presumably because the role of the Prince was played by a respected and mature artist whose athletic skills were fading. When Nicholas Sergeyev, a ballet master who had worked with both Petipa and Diaghilev, first staged the ballet in Great Britain, the leading male

dancer was younger and a coda was expected. For accompaniment, Sergeyev used a passage of music written for a Cossack dance that was performed by the Three Ivans, characters from a Russian fairy tale. To replace the Cossack dance Grigorovitch borrowed the Russian dance that Tchaikovsky had written for "The Nutcracker."

Becoming an Expert. Balletomane or Rasika?

"The Nutcracker" might be said to be the "ultimate" story ballet; it features a progressive and fantastical narrative, a heroine, a hero, and a "villain". It has conflict and resolution and many charming incidental moments along the way. Its familiar scenario and musical score are amazingly complete in that they provide the opportunity for the audience to experience anticipation, mirth, conflict, compassion, disgust, horror, sorrow, heroism, love, tranquility, and wonder. When these moments, or moods, are well done we are satisfied . . . it is a good production. When they are not well done, we are not satisfied . . . it is not good enough. The more times we see "The Nutcracker" the more discerning we become (and hopefully, not opinionated)!

In the 1930s during the era of the Ballets Russes, the term "balletomane" was coined to identify those who followed the ballet with near manic interest and thirst for inside knowledge. Today, more than ever our audiences are becoming knowledgeable fans whose pursuit of inside knowledge adds to their enjoyment of the theatrical experience (or lack of enjoyment if they are critical of a certain production).

There is a similar cultural phenomenon in Indian Dance and Drama, particularly in Kathakali, where exaggerated staging is used to tell a familiar story. It is not the story but how well it is told that becomes important. A successful performance should elicit a full range of "rasas" or essential mental states (which are uncannily similar to the moods that can be elicited by "The Nutcracker"). Those who are drawn to attend Kathakali performances become experts and are called "rasikas".

The social and economic revolutions of the 19th century and the development of psychology brought a new look to dance, an inner-focus, an exploration of the relationship between effort and shape, as illustrated here by Ryan Lawrence.

Just What Is So Modern About Modern Dance?

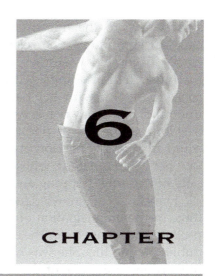

6

CHAPTER

Art does not create change; it registers change. The change takes place in the man himself. The change from nineteenth- to twentieth- century thinking and attitude toward life has produced a difference in inspiration for action. As a result, there is a difference in form and technical expression in the arts.

Martha Graham (1941)

In the years leading up to the end of the 19th century, there were not many opportunities for an American dancer to establish a serious career, particularly for an American woman. There was work to be found in variety shows, revues and vaudeville but no respect. Good ballet training was hard to find and was concentrated in the East, centered around Philadelphia, the home of Mary Ann Lee who had, in the earlier part of the century, become the first American ballerina to star at the Paris Opera.

On Broadway, there was a long running show, "The Black Crook," that used a variety of exotic dance sequences to tie together its rather meandering plot. A step above a "leg show," it paid its dancers well enough and steadily enough for them to establish some personal independence.

Today we are so shaped by personal independence that we take the concept for granted. The notion that all men were born with the right of personal independence was only becoming widespread as the 20th century approached. The concept of a woman of personal independence had been suggested in the ballet and opera of the Romantic Era and in the writings of such female authors as George Sands, George Elliot, and Emily Bronte, but at the turn of the century, the idea of a woman wishing to get a job and make her own decisions was still unthinkable by some and threatening to others.

Among the many adventuresome women who found themselves dancing in the cast of "The Black Crook" were two who were searching for something other than the artificiality of ballet or the crudeness of the music hall: Isadora Duncan and Ruth St. Denis. They appeared in "The Black Crook" at different times and their careers took divergent directions. Their personal visions of what the new dance of the 20th Century should be were not entirely the same but they are considered to be the pioneers of a new form of dance expression that over one hundred years later is still referred to as "Modern Dance."

Isadora Duncan was optimistic about the hope of the great civilization that would come with the new century. She was convinced that the best model for the new civilization, and the new dance, was that of ancient Greece. She most often performed alone, presenting

49

solo dances to the music of the finest of the classical composers. She rejected the stiff and overly decorated costumes of the ballet and the music hall and appeared in flowing Greek robes, barefoot, with her hair and her bodice unbound. Some saw her as a harbingar of a new freedom, a dancer of natural simplicity who could invoke joy, passion and sadness. Others saw her as an amateur, whose dances consisted only of running, hopping and skipping.

Duncan is acknowledged as a significant force in the emancipation of women, but she is probably best known for the excesses of her very public private life. She was openly the mistress of Gordon Craig, one of the most influential of the new stage designers. Her children by the industrial magnet John Singer were drowned in an automobile that slipped backwards into the Seine River. Her one marriage, to a young Russian poet, was politically and emotionally ill-advised. Duncan died dramatically when she accepted a ride in a Bugatti convertible with a flirtatious stranger and the long scarf she was wearing caught in one of the vehicle's wheels and snapped her neck.

Contemporary research into Duncan's choreography has shown us that she was no amateur. Her dances were well constructed, dealt with serious subjects, and required skill, passion and stamina to perform. Her dancing and her philosophy, that dance should appear on the stage as a natural activity, had an acknowledged affect on the Ballets Russes choreographer, Mikhail Fokine.

Duncan believed that in civilized society every child's education should include dance (not ballet which she saw as harmful) but something freer that encouraged good health and good posture. She opened such a school in Paris and then in Moscow. From among her pupils a performing group was developed to present her ideas to a wider public. Unfortunately, they became referred to as "Isadorables," and soon, imitators began to appear, less talented and less "natural."

One of the most famous apocryphal stories that prevail in the dance world tells of how Ruth St. Denis received her inspiration from a cigarette poster showing an exotic Egyptian scene. Unlike Duncan who looked to the civilization of ancient Greece, St. Denis found her material in the Orient and in the early native civilizations of the New World. Unlike Duncan, who strove for naturalism, St. Denis favored the stylized and the dramatic. To express her interest in Mexico she did not research and re-present a folk dance, she invented a narrative built around the blood sacrifice of the Mayans.

With her husband, the dancer and choreographer Ted Shawn, St. Denis formed a company that toured the world. To attract and train dancers for their company, they opened a school in California. The purpose of the Denishawn School was to educate the total dancer...mind, body and spirit. Through the efforts of the company's chief musician and composer, Louis Horst, an emphasis was placed on musical values and choreographic training that began with the principles of pre-classic dance forms.

There was a phenomenon at the time called "Delsarte" that greatly influenced training of the Denishawn dancers. François Delsarte was neither dancer nor choreographer. His interest was in painting and the evocative nature of human gesture and posture. His theories inspired those interested in movement expression and there arose a fad for communities to form "Delsarte" groups that would present evenings devoted to the telling of stories or evocation of moods through the employment of "Delsartian" principals. These evenings were more mime than dance and did not require the participation of professional performers. The moods evoked were often sentimental and cheaply arrived at.

Delsarte's principals, however, were taken seriously at the Denishawn School, as were those of Eugene Dalcroze, who developed a method for teaching music through movement (Eurhythmics). Ted Shawn used these ideas in his teaching. His application of these principals in his own choreography gave an underlying emotional power to the abstract dances he created and called musical visualizations.

When St. Denis retired, Shawn concentrated his energies on touring with an all male company and opened Jacob's Pillow, a school nestled in the Berkshire Mountains of Massachusetts that still features an annual festival of the best in dance.

Many of the Denishawn dancers struck out on their own, defining their individual philosophies and attracting their own devotees. In the work of these Denishawn offshoots and

the first generation of dancers who trained with them, we can see what was originally recognized as being "modern" about modern dance.

Perhaps the most evident thing that outwardly differentiated modern dance from ballet was its adoption of parallel stance and locomotion. Some did this in an attempt to evoke a more natural look. Others, as did Martha Graham in her early work, consciously avoided the ballet vocabulary and its association with decoration and stylized etiquette.

In searching for a new vocabulary more suitable to express her personal outlook on life, Graham turned to the introspection of the self. Inspired by her interest in psychology, Graham found that her movement urges came not from the head or the heart but from the gut. For her, an emotion was not to be expressed by an effete posturing of the arms and head, but by a visceral contraction and release of the muscles of the lower spine and abdomen that would give an honestly expressive rather than decorative shape to the body's extremities. To this day, the use of the "Graham contraction," whether to be expressive or to create design, identifies much of modern dance. After Graham's death in 1991, her company became involved in a long court ballet over the rights to her choreography. Much of her work is easily available on video.

Dance critic Arlene Croce once complained that the problem with most dances is that they give up all their secrets in one viewing. This is not true of Graham's work. Seeing her "Diversions of Angels" (to music by Norman Dello Joio) would be a good way to start to understand what Graham was about. It is about the beauty and dedication of the dancer. Her filmed lecture demonstration, "A Dancer's World," which illustrates the technical and artistic training of a Graham dancer, has been released on video which also features Graham dancing in two of her most notable works, "Appalachian Spring" (for which she commissioned music from Aaron Copeland), and "Night Journey" (to a score by William Schuman) which tells the Oedipus myth from the mother's point of view.

Recently the Graham Company has revived Graham's 1935 work, "Panorama", a stirring but spare piece of social protest for thirty-three dancers that is made of no more than four elementary movement motifs. Its relevance might make you think it is newly choreographed.

Early modern dancers were self-consciously involved in exploring gravity. They rejected ballet's erect approach. Instead of defying gravity, they welcomed it. Some, like Graham, saw gravity as a symbol of life's inevitabilities and embraced the earth. Others, like Doris Humphrey saw the earth as something from which to rebound.

Humphey's partner, Charles Weidman, whose dances were often humorous, ("Flickers"), sometimes pantomimic and always socially pertinent ("Lynchtown").

At the heart of much of the teaching of modern dance we can still find Humphrey's concept of "fall and recovery," which sought to reveal the beauty of those suspended moments when the direction of a movement is about to change. You rise and suspend, only to fall . . . but the impetus of a fall is also suspend-able and turns again to rising. Emotion is expressed in the catching of a breath.

Humphrey's choreography was outwardly different than that of Graham, more lyric, as was that of her partner, Charles Weidman whose dances were often humorous, sometimes pantomimic and always socially pertinent. Humphrey and Weidman's protégé, dancer and choreographer José Limon, created in his lifetime a great many dances rooted in Humphrey's concepts that are still being presented today and continue to inspire his admirers to create works following the same principals.

Likewise, Graham's work still has its champions. Her employment of "contraction and release" and Humphrey's use of "fall and recovery" were philosophical as well as mechanical choices that still seem pertinent today.

Not all the influences on modern dance came from the Denishawn legacy. Eastern philosophies were becoming popular and from Europe came not only the influence of Delsarte and Dalcroze but also the beginnings of a new attitude towards the function of performance that was eventually given the name "abstract expressionism." The term was initially coined to describe the work of contemporary painters who involved themselves in the challenge of producing work that was at once non-figurative and self-expressive. In dance, its origins can be traced to the work of Mary Wigman in Germany and that of her colleagues, Kurt Joos, Harold Kreutzberg, and Rudolf von Laban.

Mary Wigman considered dance to be a form of expression equal to music and to prove it she made powerful dances that were often danced without the assistance of any music at all or only by a basic percussive pulse. There has been no name like "contraction and release" or "fall and recovery" given to the concept of movement that she most often embraced, but it, too, had its polarities. Perhaps it can be described as reaching out and coming back an equal distance with an equal force, rather like the "big bang" theory. The more you would expand, the more you were going to have to shrink. The ultimate reaching upwards would be levitation and a flight that would lead to the ultimate fall . . . death itself.

The few brief film clips of Wigman and her work that still exist today might lead you to believe she had a primitive, unrefined technique, but the truth is she was a respected teacher of ballet who once developed the entire graded syllabus for the training school for the ballet of the Berlin Opera House. There was at that time in Germany an intense interest in health and physical culture and in experimental forms of training and theatrical presentation. Wigman's explorations in "modern" movement were met with interest.

Mary Wigman had witnessed Germany's defeat in World War I and was uncomfortable with the vision of Aryan supremacy that the rise of Adolph Hitler was once again using to seduce her country. She sent one of her best "modern dance" students, Hanya Holm, to open a school in New York.

Through her teaching and her work as a Broadway choreographer, Holm had an enormous influence on the development of American dance. Every summer she taught at Colorado College, a small school at the foot of Pike's Peak in Colorado Springs. There are still many who recall with pleasure the summers they were fortunate to spend with her. To attract students, the college offered advanced credit for those seeking to earn a higher academic degree. Dance in America was beginning to earn the respect of the country's academic institutions.

Mary Wigman's colleague, the choreographer Kurt Joos, was, like many in Germany, at odds with the political climate and eventually settled in South America. His company however toured worldwide. Although Joos always maintained that his "The Green Table" was not an anti-war ballet, it is recognized as one of the century's most potent statements about the futility of conflict.

Rudolf von Laban must have been an intriguing person. His interest and expertise in movement efficiency spurred him to intellectually analyze dance from both a physical and an emotional point of view. His theories of effort/shape and space/harmony have been widely accepted by contemporary teachers and choreographers. The system of movement notation he devised can accurately describe not only the shape of a movement but also its quality, direction, speed, and intensity.

Labanotation is widely used in the dance world to preserve the works of an art form that is essentially ephemeral. Film is also used today for purposes of recording a dance work or its performance, but a film cannot show all the details at once and a dancer could have made a mistake in filming. It is the notated score that can settle the details unless the original choreographer is around and remembers things differently.

Martha Graham left the Denishawn Company in 1926 to give her first independent concert in New York. The next year she opened her own school. In 1928, Doris Humphrey and her partner, Charles Weidman left their posts with Denishawn to open their own school and company, also in New York. Hanya Holm opened her Wigman school in New York in 1931. Jack Cole, became a choreographer of movies and Broadway musicals and established himself as the most sought after teacher of American jazz dance technique.

In 1911 a young Japanese dancer, Michio Ito, went to Dresden, Germany to study with Harold Kreutzberg. Before coming to teach and choreograph in New York in 1916, he had become personal and philosophical friends with the poets William Butler Yeats and Ezra Pound. The influences of Ito can be seen in the work of the Denishawn dancers and I find it most interesting that, when at the end of 1920's St. Denis and Shawn began to center their activities on the east coast, Ito moved to California.

Ito's leading dancer, Lester Horton, became a skilled choreographer and innovative teacher. Among Horton's students were many whose work still shapes American modern dance: Bella

Lewitsky, Alvin Ailey, Donald McKayle, James Truitte, Carmen de Lavallade, Joyce Trisler, and others.

The "revolution" we call Modern Dance was not just about how to move; it was also about how art should be made and by whom. The women who pioneered Modern Dance were asserting for themselves something that male artists in the West had come to take for granted: the right or prerogative to follow personal inspiration without catering to the tastes of some private or institutional patron. If we look back in history, we will see that this prerogative was inherent in the cultural phenomenon known as Romanticism, when rationality was set aside and there was a focus on feelings and intuition. There was also among the early modern dancers a sense of noble purpose and the faith in the ability of an inspired artist to perceive universal truths and to communicate those truths to others.

What an exciting time it must have been to be a dancer in America! I wonder what I might have thought of the new shapes and energies in Holm's "Trend," Humphrey's celebrative "The Shakers," or Weidman's "Lynchtown" which dealt with racial injustice. Would I have been moved by Martha Graham in her solo, "Lamentation," enclosed in what might be described as a cocoon of stretch jersey, her intense emotions distilled to amorphous but evocative shape?

Much has been written about those early days of modern dance and the place it has earned in out national consciousness. Today the image of Graham, along with those of De Mille, Balanchine and Alvin Ailey, can he found on a United States Postage stamp.

Looking back, we might think that those early efforts were surrounded with glamour, accomplishment and recognition. In truth, it was a period of struggle and personal sacrifice. Dancers were fiercely loyal to their mentors, although they were paid little or nothing for the long rehearsal periods that preceded their infrequent performances. Theaters were ill equipped. Audiences were small and the critics were hard to convince. Modern dance was ridiculed as well as praised.

Invigoration for those pioneers who persevered came from artists of other disciplines whose outlook was similarly progressive. The money to support their work was begged and borrowed. Some found rich sponsors. The Baroness de Rothschild supported Martha Graham throughout her company's many years of struggle.

Slowly, audiences grew in number. More quickly, the ideas put forth by the modern dance pioneers spawned new ideas. By the middle of the 20th century dance in America was experimenting with ideas so "modern" that Isadora Duncan and Ruth St. Denis might have found them hard to recognize or embrace.

TRADITION IN MODERN DANCE

Modern Dance, as a particular genre, has been around for more than a century now and has begun to develop traditions. This is ironic. The women who pioneered modern dance were purposely breaking with tradition. But as these women developed their individual philosophies and movement techniques they created wonderful choreographies and trained beautiful and thoughtful dancers. Some of those dancers were deeply devoted to their mentors and believed their work was meaningful, worth perfecting and preserving. Others did not find the work as intellectually or creatively stimulating and broke with their mentor to do as their mentors had done–follow their own dancing feet. It is in the tradition of Modern Dance to break with tradition.

Some Other Names and Things Worth Knowing

Pilobolus

A sun-loving fungus and the name of an American modern dance company. For over 30 years, Pilobolus Dance Theatre has been one of the most active touring companies in the world. Its story goes something like this.

The 1960's were years of great social change in America. Along with the Vietnam conflict and the struggle for human rights and racial equality

came a new attitude towards dance, a new aesthetic. As a result of the pioneering activities of such choreographers as Martha Graham, Doris Humphrey, Mary Wigman, George Balanchine, Agnes De Mille, Eugene Loring and others, theatrical dance was no longer considered by the American public as something imported and suspiciously aristocratic. There was nothing effete about the dances made by Alwin Nikolais, but rather an appeal to the imagination of the intellect. The phenomenological philosophy made popular by author Suzanne Langer provided a "democratic" way to look at dance. A dance, as Merce Cunningham said, means nothing more than, " . . . I am dancing!"

The traditional gender roles of our European heritage were discarded. At the Judson Church, dancers wore unisex clothing, formless coveralls and lab coats. Post-modern choreographers such as Nancy Stark Smith and Simone Forti championed the use of improvisation, requiring strength, flexibility, and attentiveness of their dancers rather than training in any specific dance technique. Steve Paxton explored and popularized contact improvisation, a genre based upon the sharing and exchange of weight and momentum between two or more people.

Dance had become a respected subject to study in the university setting, in the studio as well as the classroom. The professors who took the new faculty positions were familiar with the new trends in dance. Some were champions of them. Dartmouth, a university more oriented towards the sciences and humanities than the fine arts, began offering dance courses in 1970, at the request of a group of male students who wanted a dance experience to balance their studies in philosophy, biophysics and psychology.

Alison Chase, with a BA in Intellectual History and Philosophy from Washington University, and an MA in Dance from UCLA, was engaged as an assistant professor. Her students had no previous formal dance training, so she began by concentrating on improvisation as a means of strengthening and stretching their bodies. Within three years, four of these men had formed a company that caught the eye of the booking agents who were searching for something "new" to present. Chase left Dartmouth to join them and in a short time "Pilobolus" was sought after by dance presenters around the world.

Going to a performance of "Pilobolus" is like looking through a microscope and watching our biological building blocks morph from one intriguing shape to another. Their choreography, which touches upon many subjects, is arrived at through improvisational experimentation, but once it gets to stage is "set" and showcased with sophisticated lighting and striking costuming.

The look of "Pilobolus" has become familiar through photo images that appear regularly in trendy magazines and on gift calendars, with the dancers grouped in sculptural poses, wearing bold clear colors, or sometimes wearing nothing, with their bodies painted or carefully lit to reveal their line, weight and mass.

Momix

An offshoot of "Pilobolus" founded by Moses Pendleton and Alison Chase. One of their most popular works is based upon the images and efforts found in baseball. Another offshoot of "Pilobolus" is "Pilobolus TOO," a company composed of two dancers who perform in venues that are not equipped for the main company's complicated productions. All of the original members of "Pilobolus" remain active as choreographers, regularly creating new work for ballet and modern dance companies and for opera. Alison Chase has also designed dances for the Radio City Music Hall Rockettes and for the Cleveland School for the Arts, "An Urban Nutcracker."

Butoh

Dance of the dark soul . . . a form of theatrical dancing that developed in Japan after World War II. Some say that it is a political statement, a reaction to the devastation of Hiroshima and Nagasaki. Others point out its similarities to Tanztheatre and see in Butoh strong influences from the German abstract expressionist, Harold Kreutzberg, who taught extensively in Japan.

The first performers to bring Butoh to the United States were a husband and wife team, **Eiko and Koma,** whose slow and serenely performed dances were mesmerizing, and **Sankai Juku,** a company of men who moved even more slowly. Other Butoh companies in

Japan and around the world present images that are more visually disturbing.

Butoh is often performed outdoors, in public sites. In one dance created for Sankai Juku by **Tatsumi Hijikata,** four nearly naked men, painted white, were suspended upside down as they were slowly lowered by ropes from the fly gallery of the theatre to the stage floor. This dance was performed outdoors as well, with the dancers being suspended from the buildings and bridges of the cities they were visiting. In a Seattle performance, the rigging failed and one of the men fell to his death. After more than a year's hiatus, the company returned to the stage in Seattle for a series of performances that stirred the emotions of the entire city.

Percussion and Collision

The innovations of companies like **River Dance, Stomp,** and **Tap Dogs** reflect the current popularity of percussive and extroverted dance that is intended to delight and amaze. For more about Stomp and percussive dance see Chapter Nine.

Our current fascination with extreme physical activity is reflected in the popularity of such avant-garde choreographers as **Elizabeth Streb,** whose dancers fall to the floor from great heights and throw themselves against barriers of transparent plexiglass.

Alvin Ailey (1931–1989)

Born in Texas, trained by Horton in California and Graham in New York, and founder of the highly successful Alvin Ailey American Dance Theater. His **"Revelations,"** created in 1958, is still his best-known work and is one the most significant choreographies created by an American in the 20th Century. Danced to the spirituals Ailey heard as a child in Texas, "Revelations" is a dance about the faith, resilience, and joyous spirit of the African American. The recurring image of its opening dance, a pyramid of up-stretched hands, has become an icon of modern dance and is often imitated. Its middle section, a baptismal celebration danced to "Wade in the Water," depicts the river as it might be depicted in the traditional Japanese theatre of Michio Ito's early training, with long bands of waving cloth. The final section, "Revelations," is a Sunday church meeting set to "Rocka My Soul in the Bosom of

Abraham." Each performance of "Revelations" invariably finds its audiences demanding an encore. Since Ailey's death, his company has continued to perform around the world under the direction of long time company member and inspiration, **Judith Jamison**, for whom Ailey created the powerful solo **"Cry,"** a testament to African American women.

Bella Lewitsky (1916–2004)

Modern dance choreographer who developed the ideas of Lester Horton and developed a successful company in California, independent of the New York scene. It was Lewitsky who rationalized and codified Horton's vigorous but disorganized teaching ideas. Lewitsky was a strong advocate for the rights of choreographers and artists. In 1951 she spoke before the House Un-American Activities Committee. When questioned about possible communist activities in the art world she answered with this pun, "I am a dancer, not a singer!"

In 1990, when accepting a $72,000 grant from the National Endowment for the Arts, she deleted a clause that would have required her to refrain from obscenity. She had no intention of creating something obscene. Her objection was to censorship. She received her money only after a court ruled that the pledge contravened the right to free expression under the first amendment to the Constitution.

Loie Fuller (1862–1828)

An early free dance practitioner born in America, who had a great success in Europe, she began her career as a skirt dancer in Burlesque. Known as La Loie, she combined improvisational techniques with silk costumes illuminated by multi-colored lighting of her own design. On Isadora Duncan's first major tour of Europe, Duncan was the opening act and Loie Fuller was the headliner.

Kurt Jooss (1901–1979)

Considered by many to be the father of German Tanztheater, much of his early training was with Rudolph von Laban whose theories he embraced and developed by combining narrative with modern theatre styles. His "The Green Table" (1932), which is still in the repertory of several

companies, is a strong anti-war statement and was made a year before Adolf Hitler became the chancellor of Germany.

Pina Bausch (1940–2009)

Student of Kurt Joos in Essen, Germany, who also trained and performed at the Juilliard School in New York. As the Director of the Tanztheatre Wuppertal, her theatrical combination of poetic and everyday elements continued the aesthetic of the abstract expressionists. Her "Bluebart" (based on Bluebeard's Castle) filled the stage with dried leaves; her "Café Muller" filled the stage with chairs, and her version of "The Rite of Spring" filled the stage with wet earth.

Harald Kreutzberg (1902–1968)

An important figure in the development of German abstract impressionism. A ballet student in Dresden, he also studied with Mary Wigman and Rudolf von Laban. He traveled internationally and had a strong influence on the development of American dancer and choreographer, Ruth Page, and the Japanese dancer, Tatsumi Hijikata, one of the early proponents of Butoh.

Erik Hawkins (1909–1994)

The first male dancer to join the Martha Graham Company (1938). Hawkin's early career included study with the Harald Kreutzberg in Austria and performing with the early Balanchine touring group, Ballet Caravan. He and Graham married in 1948. He left her company in 1951 to found his own troupe and they divorced in 1954. Abandoning both his ballet and Graham training, Hawkins developed a "free flow" technique, which is "kinder" to the body than either Graham or ballet. Hawkin's devotees find that this technique releases tension in the body. More energy is available to develop strength and movement flexibility. Intellectually, it frees one to think about what one is doing. Much of Hawkin's choreography reflected his interest in American history.

Merce Cunningham (1919–2009)

With some dance experience in vaudeville, Merce Cunningham was attending the Cornish School in Seattle in 1939, at the age of 20, when Martha Graham saw him dance and invited him to join her company. As a young dancer, Cunningham was noted for his springy elevation and a particular "animal" presence. As a choreographer he was interested, not in story telling, but in exploring the basic elements of dance itself – time, space, and motion. In the summer of 1953, as a teacher-in-residence at Black Mountain College, he formed the Merce Cunningham Dance Company as a forum to explore his ideas on dance and the performing arts. Cunningham and John Cage, his musical advisor and life partner, had some radical ideas. The most controversial of their innovations concerned the relationship between dance and music, which may occur in the same time and space, but should be, they believed, created independently of one another. They also made extensive use of chance procedures, abandoning not only musical forms, but also narrative and other conventional elements of dance composition such as cause and effect, and climax and anticlimax. For Cunningham, the subject of his dances is always dance itself.

Paul Taylor (1930–)

Another male dancer who began his career with Martha Graham and then established his own voice and company. A tall and athletically built man with an elfin quality, his choreographic output ranges from lyrical musical visualization to social and political satire.

José Limón (1908–1972)

Mexican born, he was an art major at the New York School of Design when he saw a performance given by Harald Kreutzberg. He began his dance studies and performing career with Doris Humphrey and Charles Weidman in 1930. When Limón began his own company in 1946, he asked Humphrey to be the artistic director – this was the first modern dance company to have an artistic director who was not also the founder. One of the most versatile dancers of his time, he performed with a variety of modern dance troupes, on Broadway, and for Balanchine at the Metropolitan Opera. In 1951, he joined the faculty of the Juilliard School where he taught a technique that, according to

the José Limón Dance Foundation, "emphasizes the natural rhythms of fall and recovery and the interplay between weight and weightlessness to provide dancers with an organic approach to movement that easily adapts to a range of choreographic styles." Limón's choreography was vigorous and lyrical and dealt with human themes. His "The Moor's Pavane", based upon the story of Othello (to the music of Henry Purcell), has been produced by modern and ballet companies around the world. Other than the José Limón Dance Company which still exists, one of most active dance performing troupes today that has an obvious Limón base is Doug Varone and Dancers .

Doug Varone

Varone received his BFA from SUNY Purchase where he was awarded the Presidential Distinguished Alumni Award in 2007. His other honors also include a Guggenheim Fellowship, and two New York Dance and Performance Awards for Sustained Achievement in Choreography. In 2006, he won the OBIE for his work on Gluck's "Orpheus and Eurydice" at the Metropolitan Opera. His own company, Doug Varone and Dancers, which makes frequent tours, is a small ensemble of mature artists who dance with unparalleled musicality.

David Parsons

Coming from a background that included being principal dancer of the Paul Taylor Company, David Parsons formed his own ensemble in 1987. He has toured and taught with his company on six continents. His choreography is athletic and, on the surface lighthearted, but there is a palpable throb of human aspiration in his best known works, "Sleep", "The Letter", and "Flight" in which, with the aid of a critically timed strobe-light, the dancer is never seen to touch the ground.

Jiri Kylian

Czechoslovakian-born choreographer who trained at the Royal Ballet in Great Britain before becoming associated with the Nederlands Dans Theatre. His choreography, an un-self-conscious fusion of ballet and modern sensibilities, is danced by companies world-wide. Jiri Kylian's "Black and White" Ballets is readily available on DVD, and includes "Petit Mort" to the music of Mozart. Excerpts from this ballet can also be found on YouTube.

Twyla Tharp

Trained in ballet and other forms as a child, she studied modern dance with Martha Graham and Merce Cunningham and performed with Paul Taylor before forming her own company in 1965. Her choreography is swift and quirky. As in her "Sinatra Songs" and "Deuce Coupe" (danced to the songs of the Beach Boys), much of her work takes inspiration from the popular music of America. She choreographs for both modern and ballet companies, Broadway, television, and film. Her many awards include a Tony, two Emmys, and nineteen honorary doctorates. She was a 2008 Kennedy Center Awards recipient for excellence in the arts.

Mark Morris

Another American choreographer who has fused ballet and Modern Dance sensibilities. His early training included ballet, flamenco, and Balkan folk dancing. He danced in both modern and ballet companies before embarking on an independent career as a choreographer. His work is noted for its musicality and humor, as in "The Hard Nut", Morris's irreverent version of "The Nutcracker", which is easily available on DVD. His collaborative venture with Mikhail Barishnikov, "The White Oak Project", and the Mark Morris Dance Center in Brooklyn have provided artistic stimulation for both younger and more mature dancers. In recent years, Morris has become involved in opera production as both choreographer and director.

So What is Next?

Which extraordinary dancer or choreographer is about to appear to challenge existing norms? What dance craze will rise from the populace and shape the dancing of tomorrow? Only someone with a crystal ball might safely predict what the future trends and innovations in theatrical dance will be. Here is a sampling of

serious choreographers of today working in a variety of genres. They all have websites with video links. By taking a look at their work and that of their colleagues we can get a better picture of what is happening now and where things might be going.

Bill T. Jones Choreographer whose work explores the contemporary African-American Experience.

Mathew Bourne British choreographer in whose contemporary version of "Swan Lake" all the swans are danced by women.

Benjamin Millepied French born principal dancer of the New York City Ballet and choreographer. (Don't hold it against him that he was involved in the movie "Black Swan", a melodramatic thriller which provides little dancing of interest and a highly inaccurate picture of the ballet world).

Trisha Brown a post-modernist choreographer whose dancers have careened off the sides of buildings, floated on a lake, and undulated to metronomic pulses.

Ohad Naharin Israeli contemporary dancer, choreographer, artistic director, and musician who has developed an intriguing new approach to movement and performance, which is called Gaga.

Akram Khan of Bangladeshi origin. The classical Indian form of Kathak has greatly influenced his choreographic output.

Mia Michaels odern Jazz choreographer and judge on "So You Think You Can Dance".

Jorma Elo Finnish choreographer whose works have grown popular in America.

Jill Eathorne Bahr choreographer associated with the North Carolina Dance Theatre.

Alexei Ratmansky former director of Russia's Bolshoi Ballet, now choreographing in America.

Susan Strohman Tony winning Broadway choreographer.

Rennie Harris American choreographer who employs the vocabulary and sensibility of hip-hop.

Trey McIntyre young American choreographer who has emerged from the North Carolina School of the Arts and the Houston Ballet.

Jennifer Muller American choreographer from the Limon tradition.

Richard Alston British choreographer.

Sasha Waltz German choreographer.

Nacho Duato Spanish choreographer.

Google these dance companies for more visual materials.

River North Dance Chicago
Hubbard Street Dance Company
Ballet Nouveau
Complexions

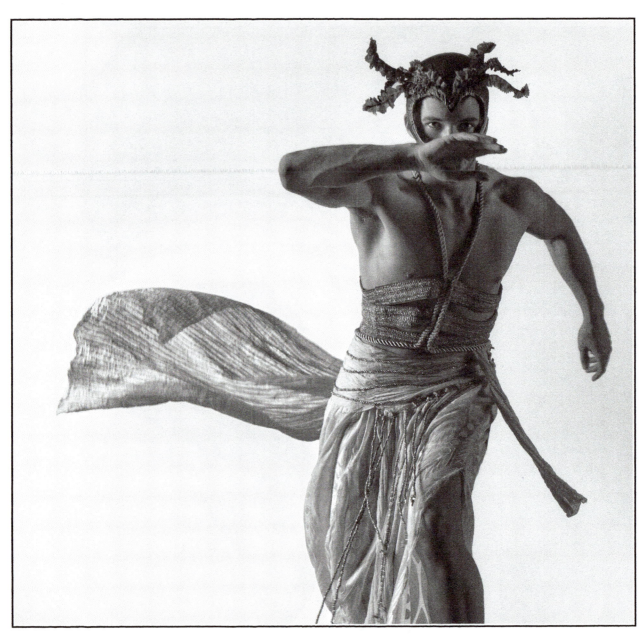

A dance can take its inspiration from a feeling, an idea, a sound, or from the act of movement itself. Classical forms around the world, including both classical ballet and India's Kathakali, often employ narratives from history, legend, and fairy tale to tell well-known stories in both traditional and contemporary settings. The first production of "Swan Lake" was set in a feudal German court. The theme of "Swan Lake" is, however, not regional or bound by time. It depicts the struggle of good to overcome evil. Some contemporary versions have ventured to change the ballet's locale to India, Bali, or the streets of London, and have explored its Freudian aspects or its current social relevance. Pictured here is Michael Clement (2011 BFA) as the villainous sorcerer Von Rothbart, half-man/half-owl, in James Clouser's 2011 version of "Swan Lake Act II" that set the action in Persia. (Costume by Lydia Harmon)

Attending a Performance and Writing About It

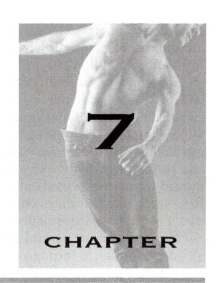

There is plenty of dancing to see on film, video and television, some of excellent quality and of more than passing interest. There is enough visual material available for purchase through mail catalogues and on the shelves of civic and university libraries for someone who has never seen a live performance to know a great deal about dance, its past and its present. But this is second hand knowledge.

When we are watching dance on a screen before us, we are seeing what someone else has decided is the most important thing about a performance that can be visually recorded. A live performance is so much more than turning on your VCR at an hour that is convenient to your busy schedule. For a real look at dance, nothing beats witnessing it for yourself, live in a theatre, not just once but repeatedly.

No one sits where the cameraman sits. No one sits where anyone else sits. You will see dance from all sorts of new angles, each of them unique. You will experience the kinetic energies of dance as well as its visual pleasures and complexities. You may be sitting close enough to hear the dancers' feet on the floor and the sound of their breathing. You may be sitting behind someone with a large hat, shifting in your seat to follow the action as the dancers move from one side of the stage to the other. If you keep your senses keen, you will feel the mood of the audience.

There may be a buzz of anticipation in the air. Everyone, including yourself, has taken pains to fit this evening into a busy life. You are all hoping to enjoy what is about to take place. If the opening of the curtain and the first appearance of the dancers can capture your energy, the performance is off to a good start.

By the time the house lights come up for the first interval break, your mood will have changed. You may be excited, puzzled, or bored. Intermission gives you a chance to stretch your legs and collect your thoughts. You can talk with your friends without the lady in front of you listening, or you can keep your reactions to yourself until you have seen more.

Be prepared to find the lines to the women's restrooms long and moving very slowly. Spending your intermission uncomfortable and anxious that you will miss the beginning of the next dance is no way to add to your enjoyment of the evening. There are some who prefer not to leave their seats at all, but I take pleasure in the ritual walk, out through the front lobby and back, looking for someone I know, listening to the chat of strangers, wondering if what I just saw is what they just saw.

By the second intermission, if there is one, I will have made up my mind. I am always thrilled when I find that I have liked what I have seen and want to see more, right then.

If I am not so sure about the dancing I am seeing, if it puzzles me, or annoys me, or seems ordinary, I will switch my focus of attention from the performance's relationship to me and

concentrate on its relationship to the people around me. I ask myself what they might see in this dance that I don't.

Sometimes I am still puzzled when, at the end of what I considered to be an obviously lackluster or shoddy performance, an audience will spring to its feet with a standing ovation. It can make a person conspicuous to be the only one still sitting. I only like to stand when I am moved by an unexpected enthusiasm for what I have seen . . . when the evening has been better than I could have imagined.

No matter how painful it might be to see a bad performance through to the end, no one should ever leave early if his or her absence would be taken as an affront by anyone involved in the presentation of the production. If it doesn't matter if you are there or not and the evening is growing intolerable, you may be able to escape. If an opportunity for you to leave without disturbing anyone should present itself, there is no disrespect in taking it. You can mull things over a hot cup of coffee or go home and get a good night's sleep.

Going to a live performance is only one half of being a witness to dance. You also have to tell about it. At some point you are going to be asked to write about it. What will you say? A typical written assignment for someone enrolled in a college dance class is to write a review of a performance, or a critique, which is something quite different.

A review is a form of reporting that lets the reader know what has been happening and what specific things, in the discrimination of the author, are most worth mentioning in the limited space a news publication may set aside. A critique is a longer, more scholarly article requiring an intimate knowledge of the subject. Any opinion stated must be well informed. The agreement of others is cited: a bibliography is expected.

Both of these forms have pre-determined literary models that require specialized skills with the written word beyond the experience of most young Americans today. As a means of teaching better writing skills and the appreciation of dance, requiring some mastery of these specialized forms is of questionable value.

I have found that some sort of report paper is more appropriate and beneficial, an article written for a school newspaper, perhaps, or one intended for a magazine catering to those interested in arts and society, in which the subject is described without judgment and personal experiences are related. Clear and descriptive writing is called for, as it would be in a review or critique, but the author is not expected to put forth any hypothesis.

Over the past few generations, American education has put a great deal of emphasis on the synthesizing aspect of learning. As a result, the roles of observation and description have been neglected.

Our technology has made much of our communication immediate, even with those at a distance. Who needs to write a letter to a dear but distant aunt, describing the wild flowers that paint the Texas hills in the springtime, when a photo image can be sent by e-mail? Even more personally, we are able to send a visual image of where we are when we are talking to someone on our cell phone. Without the need for descriptive writing or conversation, there is less reason and opportunity to keep our observational skills sharp. The camera's eye can do that for us.

Writing descriptively does not seem to come easily to my students, these days. Conditioned to being asked to synthesize, often before they have acquired any depth of knowledge of the subject, their writing is, too frequently, a jumble of assumptions and clichés where feeling and opinion are confused with fact, and original ideas get lost in the struggle to make a conclusion.

To help with their descriptive skills, I ask my students to practice writing a newsy letter or two about their class experiences to someone, imaginary or real, whose circumstances do not allow them to see dancing in the theatre or on television. Before they submit their first formal paper, one that involves attending a live performance and reporting about the experience, I provide them with a short guide to viewing and reporting. This mini-manual was developed to address the needs of college students enrolled in a general education Introduction to Dance course, but it has also proven useful to dance majors enrolled in theory courses that require written evidence of their observations in the form of reports, reviews, critiques and research papers.

Going to the Theatre

Do Make Plans!

Call the box office ahead of time. They can tell you where in the auditorium the available seats are located. Ask how many seats there are in total and if the "house" is wide or deep, and if there is a balcony. If the house seats five hundred or less, an ideal size for dance, chances are that every seat, except for those in the very front, should afford a fine view. It the house seats closer to one thousand, try to avoid being placed at the far sides of the orchestra seats on the main level of the auditorium. It would be better to take something further back but more in the center.

Consider the advantages of the balcony; lower admission prices and a more panoramic view. If cost is not an issue, consider the loge if the theatre has one. There your view will be full and unobstructed. A box seat will give you an intimate but distorted perspective. It is a glamorous place to sit. You may miss some of the action in the near up-stage corner, but you will be able to see some of what goes on back stage on the other side. You can look down on everyone in the audience, but they can also look back up at you.

Some frequent theater-goers enjoy the use of binoculars when they want to zoom in on faces of the performers during moments when only one or two dancers are on the stage. Unless you attend dance performances regularly and have favorite dancers or passages of dancing that you want to see in detail, binoculars are not worth the hassle they inevitably create.

Don't Be Late

A performance is of great importance to those who love dance. Chances are that those involved in its presentation—the sponsors, the directors, the choreographers and especially the dancers —have struggled to make it the best possible. Arriving late is disrespectful of their efforts. Make plans to be in your seat fifteen minutes ahead of curtain time.

Know when you have to leave your home. Know where the theatre is and where you are going to have to park and how much that is going to cost you. Don't ignore the possibility of making the evening especially enjoyable by joining with some of your friends at a nearby restaurant for a light supper before the performance, or afterwards which can be even more leisurely.

Do Investigate!

How much information should you have ahead of time about the performance you have chosen to attend? Certainly you should know the proper name of the company and the style of dance that is their specialty. You should know if they are presenting an evening of shorter works from their repertory, or a longer work that may have a number of sections. You should know if there is a new work being premiered on the program or if there are any outstanding performers that should be given your special attention.

Knowing something about the background and previous work of the choreographer or choreographers being presented can be interesting, but too much research can cloud your own perceptions. Read the newspapers on the weekend prior to the performance and find out what the sponsors think makes this performance special. In the house program, which you can read in the fifteen minutes you have saved by getting to the theatre early, you will find what the director of the company thinks you ought to know.

Do Be Circumspect!

Attending a live theatrical performance is not the same as going to the movies or a rock concert where eating and drinking are part of the experience. Entering a theatre should be approached as if entering someone's church. You may not be familiar with the particular customs that are given reverence there, but you do know that there will be customs. The safest bet is to dress modestly and neatly. Some theatres have an atmosphere that calls for "Sunday-go-to-meeting" clothes, dinner jackets for the men and heels for the women. In others, you will feel more comfortable in more casual attire, but anything trendy or shiny should be toned down. No shorts, please, and no bare midriffs. The performance is supposed to be the spectacle, not you. And don't wear a hat!

A live performance is a ritual in which the expressive powers of human beings are witnessed and validated by an assembly of

fellow human beings. Part of its magic is the hush that comes over the audience as things are about to commence. Your role in helping this to happen is to leave much of yourself at the door. The theatres in wintry cities often provide a place to check your coat and boots. You should also prepare to unburden yourself of any concerns that can be put aside for two hours.

Do Be Quiet!

Chances are that you will be going to the theatre with friends or will run into someone you know. Greetings and conversations should be held outside, in front of the theatre or in the lobby, if there is one.

Don't bring in that cell phone. The only thing more annoying than a phone going off during a performance is the disrupting, but all too common pre-performance announcement, usually made over a bad speaker system, reminding those who are still carrying their phones that they are not welcome.

If you are on some emergency notice but do not have a silent vibrating mode on your phone and are not sitting in an aisle seat close to an exit, you should not be in the theatre at all.

The ideal theatre has a welcoming exterior and a space for people to congregate and commune before entering. The height of the main lobby is often grand and adds to the excitement of arrival. The approach to the auditorium is made through an inner lobby with a lower ceiling, less intimidating and more softly lit. The doorways to the auditorium are found at the ends of small and darker passageways.

If you are seated in the orchestra at London's Royal Opera House in Covent Yard, you will arrive at a narrow flight of stairs that takes you up as if you were going into an attic. When you emerge, you are overwhelmed. It is all there in front of you. On one side, row upon row of seats and towering balconies, on the other, the portals of the proscenium arch and the waiting stage. Between is the concrete space of real time.

The fellow who has waited in line for hours and climbed the long stairs to the most distant and inexpensive balcony seats, called "the gods," has the same overwhelming experience. By the time he has found his place, he has left his everyday world behind and is ready to suspend his disbeliefs. When the house lights finally dim,

he eagerly shifts forward in his seat, leaning on the protective rail in front of him. Those sitting behind him have to shift forward, too.

In some theatres, the lobby is ostentatious and focuses attention on itself and the wealth of its patrons rather than standing as an invitation to something more special. In some, the lobby is drab. Some have no lobbies at all. Like a deep-sea diver emerging too quickly from the depths, you find yourself suddenly thrust into another world, perhaps not quite ready for it.

Visibility and acoustics can be less than ideal. Electronic box office procedures are not as swift as they ought to be. Have your identification and means of payment in hand by the time you are at the head of the line. Don't be fumbling through your purse or wallet while others are restlessly waiting behind you.

Attending live theatre is a new tradition for many Americans. Many of the younger people in today's audiences, and some of the older ones, too, do not understand that the dropping of one's self and one's concerns is part of the experience.

I once shared with my students a humorous e-mail communiqué from an opera singer acquaintance that listed several tongue–in-cheek suggestions for improving audience etiquette. A few weeks later, I collected the first papers my students had written after attending a dance performance. One young woman reported that when she had found herself seated behind a talkative lady, she had taken my advice and said to the offender, "Everybody hates you now because you won't sit still."

Don't Make Judgments . . . Make Observations!

If you plan on writing something about the performance you are attending, you are faced with a dilemma. How are you going to remember everything? Should you take notes in the dark? Mightn't you miss something if you are constantly looking down to scribble something you probably won't be able to read later? Put the pencil away, clear your mind, and open your eyes. Save note taking for the intermission. Write down what you remember. Make a note of things you might want to look up when you get home. Who choreographed that dance? Who was the woman in the yellow costume?

If you haven't been to a dance concert before you should not be planning to write a critique or a formal review your first time out. A simple report is what you should begin with, a well-thought out, newsy letter to a friend, a report that describes the event without judgment and reveals the thoughts it provoked in you.

Writing the Paper

Remember that in a report of this nature you are addressing a general audience, not your professor or your pen pal.

You should not assume this general audience is made up of experts, and you should not assume they know less than you do.

You should, however, assume that your reader has a genuine interest in what occurred at the dance event on which you are reporting.

Be confident that you have certain observational and descriptive skills and some knowledge of dance worth sharing.

In your pen pal letters, you spoke in the first person. Here you have to find a different voice, **the voice of the observer.**

Challenge yourself by eliminating any sentences that begin with "I."

Writing, "I enjoyed the first dance, a tarantella," says more about you than the dance and then not very much.

It would be more revealing to write something like, "The first dance was a swift tarantella, not too short and not too long, full of surprising changes of direction." This tells us something about the dance itself as well as why you found it worth mentioning.

Don't Mix and Match

It is a good practice to separate your reporting from your reactions. When you are watching a dance, your mind may be pursuing all sorts of tangential ideas in response to what you are seeing from moment to moment. Such a stream of personal thought seldom makes sense to anyone other than you.

Get as much of the describing done as you can before you address the effect the performance had upon you. This will help you with the organization of the paper and will provide a satisfying closing paragraph that does not repeat what you may have already said once or twice in the body of your paper.

Don't Use Colloquial Language!

Slang expressions are often colorful and expressive when used in the proper context but can be inappropriate, even in informal papers, unless they are pointed and specific, contributing to the reader's understanding of a dance event through its association with a particular sub-culture.

Necessary Details Only!

Sometimes a professor will ask students to staple their ticket stub or a copy of the house program to their papers, but such informational details as curtain time and theatre location are after the fact and not necessary to include in the body of your paper unless you are writing a publicity article. You should give some mention, however, of the company and choreographers being presented and of the presenting organization!

It is cumbersome and unnecessary to list the entire cast, but featured dancers performing extended passages deserve identification by name, particularly if you refer to them more than once in your report.

It is not necessary to list production staff. If you are describing the costumes or the lighting, the names of the designers should be credited, and you might include some further comments on their contributions, or lack there of, to the success of the evening.

Do report on the music or sound that accompanied the dancing! Who wrote or designed it? Were live performers used or recordings?

Report on the size of the audience and on their mood and reactions, whether they be in agreement with yours or not.

Describe for your reader the things that you found to be delightful, familiar, intriguing, and confusing.

If you are compelled to give your own opinion, make sure it is an informed one!

If you wish to use someone else's words to bolster your argument, be sure those words are set aside by quotations marks within the body of the paper and are properly credited to their original source.

Footnotes are not used in a report or a review, and a bibliography is not necessary.

Some performances are comprised of many sections and it is not important to attempt to describe all of them, but do report if an overlying theme was intended, perceived, or accomplished!

Be sure to know, before the curtain goes up, whether or not you are about to see something that is meant to be considered on its own or that will be intrinsically connected by story line or theme to the sections that will follow.

I once attended a performance of the Western Theatre Ballet given on tour somewhere in Northern England, in "the provinces" so to say. The audience was comprised of local citizens who had rarely if ever seen an evening of live dance. Following the Diaghilev example, the evening's program contained three separate works. It began with the ever-popular opening ballet "Les Sylphides." After the first intermission, the company performed a psychological ballet in which a bride discovers on her wedding night that her new husband is plagued by doubts about his sexuality. The third and final presentation of the evening was lighter fare, taking its choreographic inspiration from the playful diversions that children create for themselves, blind man's bluff, tag, and pretend. At one point a mock wedding was played out, complete with a minister and bridesmaids. As is the case with small touring companies, the dancers played several roles throughout the evening. The same two dancers who played the troubled married couple in the second ballet were also cast as the children pretending to get married in the final choreographic offering. As I left the theatre, I overheard a smiling woman saying to her husband, "You see dear, I told you everything would work out right in the end!"

What Do You Call Things?

The word performance may be used in two ways, as in "the guest artist's performance was, surprisingly, shakier than one might have expected" or "the entire performance, from beginning to end, was exhilarating."

The word performance is not used to identify individual sections. You don't want to write: "There was an unexplained delay before the curtain rose again on the second performance of the evening." If you are writing about a full-length

work such as Momix's "Baseball," you want to refer to, "The opening of the second act."

Many dance performances are composed of three or four separate works created by selected ballet, modern dance, and jazz dance choreographers. It is becoming accepted practice to use the term *ballet* when identifying a modern dance work, but many still feel uncomfortable doing so and prefer referring to a choreographic offering as a work or simply as a dance.

A full-length ballet may be divided into several acts, each of which may contain a number of individual sections that you may wish to identify. Don't use the word *number* unless you are referring to a sub-section of a musical theatre production! The term *routine* is as equally unacceptable.

Be Specific!

Leave out such general phrases as, "His popping was really good," or "Her dancing was truly beautiful."

Instead, write something like, "Mr. Harris had the intriguing ability to show sudden or lingering rhythmic impulses passing through every joint of his body," or, "Miss Kistler not only has the ideal proportions of the Balanchine ballerina, small head and long limbs, she dances Balanchine's steps with the speed and attack they require."

Don't write, "I didn't like her dancing," or, "It was boring." Instead, write something more informative like, "The choreographer's attempts to invoke a romantic image were evident, but the ballerina's angular arms did little to help the illusion," or, "The constant repetition of thematic material without development failed to sustain interest."

Being descriptive involves the use of adjectives. But, rather than using adjectives that describe a mood, use adjectives that describe an action: its speed, its duration, its weight, its direction.

Expand your vocabulary by using terms like those Rudolf von Laban employed in his Effort/Shape analysis: punching pressing, dabbing, slashing, flicking, wringing, floating, gliding, slipping, sliding, suspending, waiting, rushing.

Don't write, "His solo was sad and then happy." Do write something like, "The end of his solo contained a passage of swift, short, light and twisting movements that contrasted with the heavy and deliberately sluggish opening steps."

Using adverbs is tricky. Don't ignore their usefulness as in *deliberately* sluggish, which tells us the quality was intentional, rather than a result of faulty performance, but don't weaken your statements with useless qualifiers that give little specific information.

When you do express your opinion, be direct. Go out on a limb. Don't qualify things by describing them as being *really* good, or *quite* beautiful, or *rather* nice. It is stronger to say in plain words, good, beautiful and nice.

Don't feel compelled to summarize your paper or the performance in a pat conclusion. Please don't find yourself saying, "*Overall*, the performance was *generally satisfying*."

More effective would be to leave your reader with a clear description of what struck you as the most unforgettable moment of the evening, the moment that might sum up what you have taken away from this performance. Perhaps it is a moment of beauty, a moment of passion, a moment of confusion, a moment of unity, a moment of recognition or even revelation, perhaps a moment of humor, or even a moment of ineptitude.

Proofread, Proofread!

When you proofread your paper, you must check carefully for proper spelling, sentence structure and syntax. Be sure that you have avoided the use of first person sentence construction whenever possible. Polish your writing by looking carefully at every modifier, every adjective and adverbial phrase, and include only those that add clarity to your report.

Check that you use your commas correctly and advantageously. They should be used to help to indicate when a pause will give clarity to your sentence. When they are used to set off a modifying phrase, be sure the sentence would still be correctly constructed with subject, verb and possible object if the modifying phrase were removed!

Weed and Trim

Be sure you are not repeating yourself by returning to the same point time after time. Don't waste your words or your reader's time by beginning your ideas with "The first thing I am going to discuss is . . . !" Jump right into your descriptions!

Proofread Again!

I suggest that with this report, as with all your formal written work, you should have the first draft finished in time to be proofread by someone whose skills at writing are more sophisticated than yours . . . not someone studying with you, nor someone who accompanied you to the performance. It is not necessary for your proofreader of choice to be someone who knows a great deal about dance. It is better that you forge a relationship with someone who can objectively tell you if your writing is clear, communicative, and engaging.

The heritage of the African American has strongly influenced contemporary social and stage dancing. Here, Bea Williams dances in a tribute to Katherine Dunham, choreographer and anthropologist, whose research in Haiti added respectability to the study of dance in America.

Just What Is So African About American Dancing?

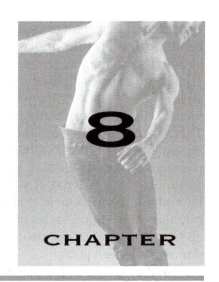

8

CHAPTER

We have been focusing on the European roots of Western Theatrical Dancing. Now we want to look at how the dance expression of other cultures, Asia, Latin America, and Africa, in particular, has contributed to dance in America, on and off stage. Dance ethnologists have taken a close look at African dance and have identified several characteristic qualities. As we begin to learn more about American jazz dance with it alleged roots in Africa, let's see if we can recognize the same characteristics.

Brenda Dixon Gottschild of Temple University has chosen the term "ephibism," with its reference to the Greek symbol of light and youth, the Phoebus Apollo, to describe one of the essential qualities of African dance. African dance is "ephebic" she points out. It is motivated by a quality of exuberance that is essentially youthful and insistently vital . . . more often playful in nature than deliberate.

African dance is polycentric and polyrhythmic. The body does not move as a unit as it does in ballet and other Western forms, with all its elements harmoniously balanced around one center. In African dance there can be many centers generating movement at the same time . . . in the head or in the torso . . . in the pelvis or the shoulder . . . in the circling of an up-reaching arm.

Western dance confronts its audience and participants with one recognizable rhythm at a time. African dance employs many rhythms existing at once . . . some echoed in one part of the body . . . some in another.

For those with African music and dance as part of their culture, the hearing of many rhythms at once and being able to move in response to them is easy and natural. For those familiar with Western sounds and rhythmic presentation, African dance might well at first appear confusing, unfocused, and out of control.

Symbolism plays a strong role in the dress, presentation and ritual sharing found in African dance, but psychological matters do not often come into play. African dance confronts its issues head on. Gottschild calls this, "embracing the conflict."

Complexities occur in Western thought, music and dance, but some resolution from conflict and resolution is sought. The African aesthetic embraces conflicting forces. It is concentrated more on celebrating the questions than it is on offering solutions.

Once the Western eye and ear become used to its visual and aural complexities, the clarity and brilliance required of African dance becomes apparent. There is an element of virtuosity . . . the showing off of the body's ability to do amazing things. But there is no concern on the faces of the dancers and no self-conscious display of ego. There is instead, a look of delight or a mask of nonchalance. African dance maintains a "cool" attitude.

African dance is often filled with high affect juxtaposition. Knees and elbows make contrasting angles. Small movements alternate unexpectedly with large ones. Internal rhythms

and dynamics change suddenly. The body bends to the ground and then snaps or curls back to its full height.

For purposes of classification, most of the styles we looked at in the previous chapter are usually identified as falling into the category of "jazz dance" or American theatre dance. This is not an ideal classification, but for now, until the passing of time gives us a clearer perspective as to just what is what, it will have to suffice. Part of the confusion is that one of the most popular of these sub-styles of the dances we are classifying as "jazz" is also referred to as jazz dance or modern jazz.

To the Western eye of colonial America, used to the dances of Northern Europe, politely unbending dances, following proscribed patterns and contained in lots of clothing, the "gyrations" of their African slaves must have seemed primitive, convulsive and dangerously subversive. Despite those who wished to outlaw all such expression, there were those wise enough to see that any relationship with their African workers was more productive when the slaves were allowed to express themselves.

Imitation plays an important role in the assimilation of cultures. In New Orleans' Congo Square, where the African community was allowed to congregate on Sundays, dances began to develop that imitated the ways of the white slave owners. In turn, some of these dances, the Cakewalk in particular, were imitated in the cotillions held by white society.

The Cakewalk is a dance in which you lean, or rear way back and kick your feet alternately in front of you while moving forward from foot to foot. The lifted leg is long but the knee remains bent until the foot achieves its ultimate high point with a quickly extended flick. The arm furthest from the audience is held high and may be waving or holding a hat. It was daring for a white woman to kick her legs that high, but the addition of extra petticoats offered an acceptable degree of modesty. It was a competition. The best couple, with the longest legs, the frothiest petticoats and the widest smiles was awarded a generously frosted cake.

Another important example of imitation enriching our cultural dance expression can be seen in the popularity of the dance halls in the early part of the 20th Century, particularly the Savoy Ballroom in New York City where the white patrons imitated the dances of the African American, including the Charleston and later the Lindy Hop and the Jitterbug.

Assimilation of the African American dances and dancers came about more slowly on the stage and in film. Out of vaudeville, an essentially Western form of theatrical entertainment, there emerged the minstrel show in which white performers imitated African characteristics by putting on black face and assuming African posture and humor. The typical minstrel show was a review not unlike today's television variety programs. The performers sat close to the front of the stage in a long row of chairs. The performance included songs and novelty dance acts which were interspersed with comedy routines provided by *Mr. Interlocuter*, who sat in the center and the two *end men* who sat were referred to by such colorful and perhaps demeaning names as "Mr. Bones."

Ironically, the popularity of humor built upon parody was so strong that when American black performers began to take the stage, the only employment that many could find was in the minstrel shows. There they were asked to put on blackface and portray the stereotypes of themselves that had developed: the loyal mammy, the kindly old man with rolling eyes, the shuffling indigent.

When the minstrel show with its contrived and misleading picture of black culture faded from popularity, the dances of the African-American continued to be integrated into the white culture, but the black performer did not receive the same acceptance as white entertainers. One notable exception was William Henry Lane (born in 1825), noted for his eccentric dancing gyrations, who became an international star under the name Juba.

There was reluctance to present African women in a romantic context. Black male dancers, however, were often presented in situations designed to evoke some sexual admiration. A well-built black male dancer frequently found himself dancing without his shirt on. Like the hoofers in the screen musicals, the African-American performers were relegated to the supporting categories of featured player or novelty dancer and were often presented in exotic Caribbean numbers.

In the late 1940s, a young dancer and anthropologist from St. Louis, Katherine

Dunham, managed to obtain a grant from the University of Chicago to study the roots of African dance in Haiti. There she was able to observe dancing that was more like that of her African ancestors than were the dances of the slaves in the Southern United States who had been cut off from their roots.

While in the Caribbean, Dunham filmed the dances and rituals of Voudon, an African based religion that, like Christianity, featured sacrifice, the symbolism of blood and communion with the spirit life, but in a much more vivid and tangible manner.

Dunham used her research to develop dances that recreated these rituals for the cabaret stage and the concert hall. She and her dancers appeared in shows and movies and toured the world, bringing a more honest representation of the legacy of African dancing than had been seen before.

To train the dancers for her company (her dancers were seldom of Caribbean origin), Dunham had to develop a technique of teaching this style of dance which, although it often looked improvisational, was distinguished by certain unique ways of moving. Dunham technique, which is more like Graham than ballet, is still taught today as a distinct field of dance study, but it has been absorbed into the mainstream of American dancing. It can be seen in the work of Alvin Ailey where it has melded with the elegance of ballet and the sensual energies of modern dance. It can be seen in the work of some contemporary companies like Urban Bush Women who continue to find inspiration in ethnic forms, old and new.

Dunham's academic approach added to the respectability of the study of dance in America. While the acceptance of the black performer or the black experience as the central factor of a stage or movie production came about slowly, the popularity of these "African" dances grew, and soon they were being taught to and danced by white dancers who had little idea of their African origins.

A dance form begins as a social behavior associated with religious or communal ritual. The circumstances that gave rise to that behavior may change, but the dance remains and becomes an entertainment. In time it may become an art.

Pedagogically, the development of a classic form of dance goes through several stages. At first, the performers learn the dance through imitation. It is a matter of being able to replicate what others around you are doing. To be successful a dancer has to be a quick study.

At the next stage, certain principles of execution are identified, and the dancing masters begin to devise technical exercises that prepare the dancers' bodies for the physical tasks they are going to be asked to accomplish. Eventually, a codified technique for performance is developed. With the help of the teacher's system and sharp eye, the slow learner can also become successful and, in the same amount of time, as highly accomplished as would a fast learner.

With the development of better-trained performers with the experience and ability to quickly accomplish a variety of styles, choreographers begin to feed upon the abilities of the dancers and no longer need to look outside the dance studios for their inspiration. At that point a dance form becomes classical and begins to develop from the inside, stewing in its own juices, as it were, and spreading its own influence to other forms of expression.

As did the early teachers of ballet, Blasis, Taglioni, Bournonville, Cecchetti and Vaganova, teachers of jazz dancing like Jack Cole, Luigi, Matt Mattox, Peter Gennaro, Joe Tremaine, Stanley Black and Gus Giordano, in their need to train dancers able to dance their works and the innovations of others, developed teaching systems that have come to be used in studios all across America.

There is not yet agreement in the dance world that jazz dance can be called a classic technique as is ballet. Some, reluctant to yet give jazz dancing its due, will be quick to point out that the ephibic nature of jazz dance and the popular music to which it is danced prevent it from dealing with "serious" subjects.

Jazz dance is still a supporting player, some say, providing back-up energy just as tapping did for the early musicals before dance itself became the subject of the movie. There aren't many dance companies that perform jazz dancing exclusively.

Others will disagree and point to the accomplishments of jazz dancing in the field of concert dance as well as to uniformity of jazz training across the country, something that ballet cannot do. Jazz dancing has become as popular a field of study as tap. Except in those

"upper-upper" classes where social, economic or political dynasty is an overriding trait, dancing has become an acceptable career choice for young men and women.

Jazz has become an essential part of most college dance programs and in some cases can be a major field of study. Jazz, its roots, and its present practices have been subjects of master's theses and doctoral dissertations. The teaching of such jazz luminaries as Jack Cole, Matt Mattox, Luigi, and Gus Giordano has filled our dance studios with two or three generations of fine jazz teachers and choreographers. The training devised by Giordano to develop talent to realize his choreographic vision has been particularly successful in training dancers adept in all styles of jazz.

The Giordano style features the coolness of the other jazz styles and shares their idiosyncratic use of isolations. As in other jazz styles, the dancer directs weight into the floor and moves explosively when defying gravity. More than the others, Giordano has rooted his dancing in ballet. His is a style that relishes high and easily performed extension. Ankles are expected to be stretched when extended and to be as articulate as a ballet dancer's.

Because of the heightened mobility provided by the ballet placement featured in the Giordano style, and its easy relationship to the floor, the fierceness of the speed and attack it affords its dancers can be dizzying.

There must have been a bit of Martha Graham in Giordano, for his style relies strongly on contraction and release. And there must have been some Africa in him too, for the spines of Giordano dancers learn to ripple and unfold as if they were Watusi warriors celebrating a victory.

There is also a strong lyrical base to jazz dancing. (In most American dance studios, to do lyric jazz is to dance in interpretation of a slow and "soulful" or inspirational song.) Training that embraces kinesiologically informed ballet placement prepares a dancer for the sensual and high leg extensions that, in jazz, are often juxtaposed with sweeping bends of the body. Properly aligned abdominal muscles combined with a well-aligned and forwardly placed connection between the pelvis and the top of whichever is the supporting thigh, give the jazz dancer the control to shift his center from one body part to another at his or the choreographer's will and end up safely at whatever place is required.

Jazz dance had history and visibility, but it was the new modern dance that academic institutions brought into their curriculum and gave a place in their women's physical education departments. The arrangement was a good one at first. It gave the devotees of physical education a degree of intellectuality that afforded them some respect in the eyes of their academic colleagues. The dancers found a home where, for the comparatively reasonable cost of college tuition, they were given four years of intelligent training, a place to dance, a place to choreograph, a place where they didn't have to worry about finding the money to pay the other dancers they needed to show their work, a place where they didn't have to rent a studio to work in and a theatre to dance in.

In some cases the marriage between women's physical education and modern dance, at that time essentially a women's endeavor, was, by its nature, less than fruitful. Women interested in sports, where the focus is upon something definable like winning, are not necessarily compatible with women interested in the artistic nature of movement where success cannot be so easily measured. In other cases, this marriage has proven mutually beneficial to both partners, particularly in those departments whose directors or chairs had the wisdom and determination to embrace what dance had to offer rather than to ignore or suffer its presence.

The first degree program in modern dance was established at the University of Wisconsin with Margaret D'Houbler at its helm. The first dance major in ballet was offered by Texas Christian University when the ballet and modern dance divisions were combined into one department, in facilities that were provided by the conversion of a large natatorium into three floors of studios. One studio was unusually large and provided a more forgiving dancing surface than the gymnasium floors on which college dance classes were often held. This accomplishment came about through the efforts of David Preston and then Jerry Bywaters Cochran, a devotee of the Graham style and aesthetic, and Fernando Schaffenberg, a Mexican born American dancer whose training and experience, prior to coming to Fort Worth,

had been steeped in the traditions of the Ballets Russes de Monte Carlo.

Many major universities are now offering degrees in dance, some in ballet, some in modern dance, some in combination of both. Jazz dancing has been taught at the University level for almost as long as modern dance and ballet, but has only lately begun to be considered as an equally important area of study rather than as something to be tolerated because it will generate a healthy head count to justify a department's funding.

Programs are beginning to favor the three-pronged model where BFA candidates in dance train with equal emphasis in ballet, modern and jazz dance. It is through the development of excellent teachers of jazz dance that this has come about, and through the wisdom of those dance educators who have embraced what the study of jazz has to offer an American dancer of any discipline.

Jazz dance shares the same roots as jazz music, but it has developed in a somewhat different manner. Both feature syncopation and shifting tonal centers. Jazz music has retained its original emphasis on improvisation. The choreography of jazz dance is more likely to be determined through a formal and traditional rehearsal process.

Jazz music most often consists of the simple playing of a song written in the classic ABA ballad form followed by a series of improvisations, each player taking the time to make a bit of delightful mischief with the tunes melody and the harmonies. Whichever instrument is carrying the rhythm, piano, string bass or drum, can exercise some control over the length of each section, but the form has a contemplative nature and takes a long time to unfold. The kinetic nature of dance, and jazz dance in particular, makes it a more immediate experience and less suited to lengthy development.

Jazz dance is seldom performed to jazz music and most likely turns to the energies of current popular music, often with a rock or Latin beat and with a form even simpler than that of a ballad, sometimes as simple as one idea or musical phrase being repeated over and over again. With its basic, unifying, syncopated beat, jazz dance has become the dance of America. The elements of jazz that reflect our national characteristics—youthful vigor, coolness, high affect

juxtaposition, and the isolation of impulses in shifting centers of attention—may be similar to those of our African ancestors, but they are American traits now, and particularly expressive of what young Americans are making of life in the 21st century.

OTHER INFLUENCES

A culture is *all* of the beliefs and behaviors that are common to members of a certain group – their language, religion, dress, music, literature, and dance expression. The *all*, in the case of the United States, a multicultural nation, is a tapestry so broad, so complex, and so spontaneous in its design that it seems beyond comprehension.

The dances of the indigenous inhabitants of the New World were ceremonial in nature, not theatrical and for reasons that are both political and religious; they have only been woven into a tiny corner of the fabric that is American dance. More visible are the influences from our neighboring countries and from the homes of our ancestors.

Along with the relatively staid folk dances of Northern Europe, American dancing has embraced looser-hipped dances, the rumba, the samba, the cha-cha, etc. These dances are called **Latin** and are acknowledged to have come from South American and Cuba. They are a fusion of Spanish Colonial dance and African sensibilities. The Spanish part of the equation has its African factors as well. The overhead carriage of the arms in Spanish dancing and **Flamenco**, so reminiscent of classical ballet, traces back through Morocco, to Egypt where it is characteristic of the middle-Eastern form, **Raks Shakri** (known today as Belly Dancing).

Dance ethnologists are inclined to believe that such use of the arms and the complex use of the feet to produce sophisticated rhythms can be traced back further to North Eastern India and a dance style called **Kathak**.

Other dance forms from India can be seen throughout our culture. Although the particular movement content of **Kathakali**, which is based a great deal upon stylized posing, has not been absorbed into American dance, its theatrical elements have. Kathakali's dance

dramas present familiar stories with elaborate costumes and spectacular oversized masks. These productions are very like the Broadway hit, "The Lion King", choreographed by Garth Fagan and directed by Julie Taymor whose ingenious mind has also embraced concepts of puppetry and other theatrical devices from Cambodia, China, and Japan to illustrate an African story for an American audience.

It is the intricate and isolated use of arm, wrist, hand, and even finger gestures called **mudras** employed by another form of Indian dance, **Bharatya Natyam** that inspired both Ruth St. Denis and Jack Cole. This "Eastern" influence colors much of our Modern and Jazz dancing. Bharatya Natyam was first performed by the Devidasis, temple dancers who might at times in history have served as royal courtesans. Today, after periods of political and social controversy, Bharatya Natyam is again considered to represent the finer things in Indian society and culture. In America, daughters of Indian families train in Bharatya Natyam, not to prepare them for performing careers but to give them social skills and an appreciation of their heritage. This is similar to the way young Mexican-American women prepare for their **Quinceanera**, a dance-filled celebration of their coming of age.

Advancements in communication and transportation have shrunk the world. What was once exotic and rare is now available to us easily, often without having to travel anywhere. We can witness for ourselves the dancing of others, historical and innovative, not just read about it. The evolution of our cultural forms is proceeding at a dizzying pace. We cannot quite see where we going, but what we have around us cannot be said to be dull.

In a unique cultural exchange, the craze in "Bollywood" production has fused Eastern and Western contemporary sensibilities. While aficionados of break-dancing and hip-hop argue endlessly about whether everything started in Brooklyn or Los Angeles, choreographers are developing the style to new levels of sophistication. Ballet dancers are learning the "moves" and so are the fathers of teenagers, to perform at ball games.

Note must be made of the prime-time televisions shows on which aspiring dancers and desperate celebrities vie for prizes by presenting a series of short "numbers" that purport to show their skill in different styles. Although the grins, grimaces, and high kicks found in every dance blur the lines between techniques they do reveal something about America's taste for sincere hard work, perseverance in the face of adversity, and high-affect juxtaposition. The competition aspect of dance is not new (remember Congo Square) but it troubles some who believe the purpose of theatrical dance is to show something, not win something.

Our nation is so vast and the variety of dance experience found within its borders is so diverse that it would be difficult to choose one dance that could be seen as representing America (as the **tarantella** represents Italy). The **electric slide** might be one if the youth of America were to choose; or perhaps **square dancing**, if the decision was left to those with one foot still left in the past. The majority of Americans have experienced neither of these dances, but they all have experienced tap and jazz dancing, in film, on television, on stage, and in the studio. It is these forms, because of their diverse roots, that have become uniquely American.

When the clogging of the dances of the British Isles came to America and met the dances of the newly arrived African-Americans, tap dancing came to be. Truly a form of the New World, tap has in turn integrated with other Old World forms. Here, dancer and choreographer, LoRee Kenagy uses tap to illustrate the Mad Hatter in an Alice in Wonderland tribute.

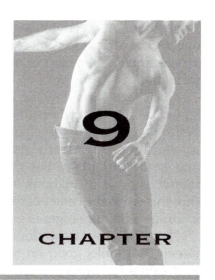

Out of the Melting Pot Something New

CHAPTER 9

It is recognized around the world as the beat of America. Jazz! A steady stepping pulse . . . optimistic in its playful and often complex use of syncopation, sometimes driving, sometimes bluesy . . .

The very sound of its name says what it is . . . something that is vibrant and exciting . . . something that is up.

You hear it in American music and speech . . . you feel it in American dance. You don't have to look far to see it. It comes in many manifestations.

It drives our parties and dances. It is in our nightclubs. We see it in the halftime entertainment at our sporting events. We see it in our movies. It distinguishes our Musical Theatre. It provides energy to bolster the appeal of the stars of our variety shows and music videos.

Its energy and appeal fills dance schools across the country. Dances created to the jazz beat of America are so much a part of our experience that we sometimes forget how remarkable they are.

Let's start with hip-hop. As did rap and break dancing, hip-hop developed in the ghetto streets of those American cities that had experienced an immigration of Latin and African Americans. Hip-hop is essentially a flat-footed dance depending very little on the extension of the ankle and foot. Knees are relaxed. Legs and arms do not stretch out to suggest a larger space as they might in ballet. In hip-hop, they move within the ordinary reach expected of the average person. Hip-hop is danced to urban songs made popular through the media. All one needs is a "boom box" or some friends to sing along. The musical phrases are predictable in length. The rhythm is as basic as *one two . . . one two.*

Steady, energetic but contained hopping and kicking movements of the legs are countered by punchy and syncopated movements of the arms that explore the potentials of restricted time and limited space, sometimes with dizzying complexity.

Hip-hop and break dancing, with its inverted spinning and joint-defying popping and locking, were originally the dances of individuals expressing their feeling about urban life. There was often a strong element of competition. As rappers dueled with words, the street dancers used their bodies to dazzle and outdo the others. Camaraderie grew and the best dancers were given great respect.

These dancers were very like the noblemen who danced in the courts of Renaissance Europe. They were dancing for themselves and to let others know that they were the best, the "coolest."

Hip-hop, more than break dancing, has been assimilated into our theatrical forms. The energy of the dance and the designs made by the hip-hop dancer are well suited to the stylized frontal presentation used in Western theatre.

The appeal is strengthened when many dancers are creating the same design at the

same time. As seen today in dance concerts and recitals, hip-hop is most often presented by an ensemble assembled in a tight and ordered formation.

Such formation dancing is particularly well suited to television where there is a distortion of depth and a receding perspective. On the small screen things are clearly seen on a horizontal and a vertical plane but distance is another matter. Simple formations appear deeper and pull the eye to the center of the screen where the leading dancer or singer is usually placed.

Tap is another dance form that began in the streets and looks good on television and even better on a big movie screen. Tap, like hip-hop, is a vertical dance decorating a limited space with movement and sound as well. The spine is more fluid than in hip-hop. The arm movements are lighter and simpler. It is cheerful, non-confrontational style dealing with the pleasures of sound and syncopation.

The musical rhythms underlying tap dancing are, like those of hip-hop, uncomplicated. They can be most often counted *as a one and two . . . a one and two*, but like clogging, tap sometimes uses a measure of three.

Tap is uniquely American, a result of our melting pot. Close to the floor, tap dancing resembles the jigs and reels of our Scottish and Irish ancestors, dances requiring great energy and determination. From our African forbears there is the same exuberance, but looser limbs, a more fluid spine, and a more evident delight in execution.

Tap is probably the most recognizable dance form in America. There is surely to be found at least one tap dancing school in any small city or large town. Tap developed its unique qualities at a time when American theatrical entertainment was shaping itself in the developing industrial cities near the East coast. Its widespread popularity came with the development of the American cinema. Tap owes much to the development of film sound technology, an advance that benefited dance as much as it did speech and singing.

Hundreds of thousands of people who had never before seen a play . . . or a dance . . . or a musical . . . filled the new movie theaters that were at first makeshift, and then grand.

To meet the enthusiastic demand for their product, movie studios had to produce a great deal of material, quickly and affordably.

Formulas for success were devised. The devices that made certain films popular . . . the stars, the settings, the plot . . . were noted and repeated. The appeal of these early films was not literary. It didn't matter what story was being told. What mattered was that a picture could move with such vitality. It required an evocation of emotion through sensation rather than through thought, something that dance does very well.

In the musical films of the late 1920s and early 1930s, tap dancing and similar stage styles were introduced to provide audience-pleasing numbers scattered throughout a predictable plot. It soon became evident that if show numbers and dancing were what was needed, it made good sense to center the plot in places where dancing could be found. The genre of the backstage musical was born.

The typical story centers around the trials and tribulations involved in putting up a show. There are plenty of opportunities to see leggy chorus girls performing, rehearsing, resting or gossiping. There is apt to be a case of mistaken identity. Someone has misunderstood someone else's motives.

Often an important character is a sincere, talented, but naïve dancer, a young woman perhaps, from somewhere in the Midwest who goes from hopeful but green beginner to understudy to Broadway star with a fiancé and a happy ending. Such a plot is hardly realistic, but what an amazing opportunity it provides for dancing!

The stars of these movies, like Buddy Ebson and Ruby Keeler, were hoofers. Hoofing is a style of tap dancing where the weight of the body is centered over the heels, rather like in clogging which is a country style.

Keeler's rise to movie stardom was, according to the Hollywood studio publicity, the overnight emergence of a fresh new talent, just like in the movies she made, but I suspect she did a lot of hard hoofing before she was "discovered."

A Broadway tap dancer and choreographer, Busby Berkeley, was originally brought to Hollywood to do no more than provide attractive dance routines. Through his innovative use of technology, he created a cinematic image that still influences how we see dance in America.

Berkeley developed techniques for suspending and moving cameras around and

above his dancers to provide depth to the image, and to give the audiences a kaleidoscopic and surrealistic perspective they could never get in a stage show. The great Hollywood sound stage was used to film his extravagant numbers that often contain what looks like hundreds of dancers and parades of stylishly dressed women. His movies were filled with beautiful faces and long legs.

Before Busby Berkeley and the Broadway producer Florenz Ziegfeld began presenting long-legged showgirls, a show dancer was expected to be a spunky hoofer. The tap dancers in a Ziegfeld show were called ponies.

When Hollywood paired their winsome young box office talent, Shirley Temple, with the noble Bill "Bojangles" Robinson, who featured a light footed style with his weight held more forward, tap dancing got off its heels and became sophisticated. Hoofers found themselves relegated to the status of the novelty dancer, providing vigorous diversion between the more serious moments of a stage or movie production.

Sophisticated dancers like Fred Astaire and Ginger Rogers became the stars in a generation of movies that were about the elegance of urban life. Astaire had had his first successes as a stage performer in an act with his sister Adele. He insisted that his dances be filmed from a singular point of view, as one might see them on stage, without the cuts or close-ups available through film editing technology. He felt that a dance pieced together from a number of takes could not convey the wonder of the skillful and fit dancer who didn't need any tricks to disguise unwanted slip-ups or lack of stamina.

The ease with which Astaire danced gave the illusion that he was improvising . . . that the dance was being spontaneously created on the spot. This quality gave him the ability to slip from a song into a dance without anyone noticing he was no longer acting as a normal person might but had transformed reality to a theatrical level of presentation. Astaire's skill at creating this illusion can be seen in the documentary, "That's Entertainment Part III" where, in a split screen projection, Astaire is shown performing the same dance in two different takes and wearing two different costumes. The tiniest seemingly casual details are repeated identically.

Much of Astaire's nonchalance was expressed by the way he carried his hands and fingers in a relaxed position, never fully extending them. This came from his concern that his hands were too long for his slender build.

Astaire was a superb partner. When you have rented one of his films and are watching him dance with Ginger Rogers, Rita Hayworth or even Audrey Hepburn, who was not in his class as a dancer, watch how he uses those amazing hands to guide his partner through the trickiest of pathways with genuine concern for her appearance.

Astaire has received great recognition for his contributions to American dance and cinema. No one can deny that he was one of the finest dancers of the 20th century. The contributions of Ginger Rogers, the partner who inspired his best work, are sometimes overlooked. Rogers was an Academy Award winning actress who managed a wide variety of roles, and when it comes to her dancing, you have to remember that she did everything that Astaire did, and she did it backwards.

Up from the streets and dance halls came new styles, jitterbug and jive. With the patriotism evoked by World War II, tap dancing and its new cinematic forms began to return to a more muscular quality, but the sense of classiness that had permeated the dances of the 1930s did not disappear.

Ballet was becoming popular in America and Hollywood welcomed its elegance. Even Gene Kelly, whose appeal was in his athleticism, managed to present himself stylishly with such balletically-trained dancers as Cyd Charisse and Leslie Caron.

Gene Kelly presented a new picture of the dancing American. Handsome and muscular with great teeth and an all-American grin, he looked more like a factory worker than a man-about-town. He often appeared on the screen in a military uniform and made it look like the most normal thing in the world for a man to do was to dance.

Kelly and movie director Vincent Minnelli embraced new film techniques. With lenses capable of wider perspectives and quick zooming, and with sophisticated editing-room procedures, they were able to convince movie going audiences that dance didn't just happen where you might expect it: at a party, in a club, a

studio, or in a theatre. It could happen anywhere that pleased his imagination. In his films, Kelly danced on rooftops and tabletops and managed to partner both Mickey Mouse and Tamara Toumanova, a glamorous personality known as the Black Pearl of The Russian Ballet.

In 1951, Kelly received an honorary Oscar for his "American in Paris" in recognition of his integration of emotional powers of dance with the technical powers of film. His most powerful influence upon American dancing has been, in my opinion, through the healthy vitality of many individual numbers he created, like those in "Singing In the Rain" . . . dances performed straight through, filmed using a minimum of cuts, and with the camera staying back a little letting the dancers do their stuff.

There were many other fine choreographers during the heyday of the Hollywood musicals, who made great contributions to American jazz dancing, among them Jack Cole, who came from a Denishawn modern dance background, Hermes Pan, Michael Kidd, and Bob Fosse. Through their movies, Americans all across our country discovered how other people were living and dancing.

Not all the activity was in Hollywood. A new form of theatrical presentation was evolving on the east coast, the American musical theatre. Its roots were in the entertainments of European music halls and American vaudeville, a type of variety entertainment that consisted of a series of comedy, music, or dance routines, each separately created and having no unifying theme other than the desire to entertain. Vaudeville comedy tended to be of the baggy pants variety. A singer was meant to be good looking. Dance had to be upbeat or unusual.

The American stage absorbed the loose-limbed dances of the northward immigrating African-Americans. Dances of African origin, such as the Charleston, were imitated in white variety shows and were again imitated at white parties and clubs and in the speakeasies that arose during the Prohibition years where the young gathered at night for a smoke, some gin, and some social interaction.

Black and white met at the Savoy Ballroom in New York City where the latest African-American dances, like the Lindy Hop (supposedly named after the aviator) and the Jitterbug, made their way into mainstream culture and into the vocabulary of the professional dancer. And then another element was thrown into the mix of dancing that also proved to be expressive of the beat of America . . . the lyricism of ballet enriched by the fluid spine of modern dance.

As American musical theatre developed into what today we immediately recognize as a "Broadway" style, it continued to combine music, acting, and dancing and began to bear some resemblance to opera and its parallel form, the operetta.

Opera had been born some four hundred years earlier, in the same court spectacles that had produced ballet, and provided a model for those who envisioned a theatrical form that amalgamated all the theatrical arts: story telling, script and song writing, musical composition, choreography, dance, singing, acting, and the designing of scenery, costumes and lighting.

Opera is the plural of opus, the Greek word for the noun work. A work is something that has come about through deliberate or accidental forces. This name implies that opera's aesthetic relies on all the theatrical arts for its realization. In truth, opera, as often as not, exists without dancing or any particular attention to evocative staging beyond placing the singers where the audience can hear them and where they can see the conductor. The movement aspects of opera, and even the visual contributions made by the elements of scenic design, are not essential. An opera can be quite fully enjoyed by listening to a good recording of its aural components.

Opera was "high brow" even when it dealt with humorous subjects. American audiences preferred more democratic fare. Vaudeville and the stage reviews from which musical theatre sprang may not have provided this new form of entertainment with a model for dramatic cohesion, but it did produce choreographers who were skilled in building dances and staging crowd scenes. The choreographer has always maintained more influence on Broadway than in opera, and the power of movement expression has remained a distinguishing factor of American musical theatre.

In opera, the music tells the story. In musical theatre, the story tells the music. Its performers have to act, sing and dance with admirable skill and attractive grace. The song or the dance emerges when the characters can no longer contain their emotions in mere speech.

There was a constant interchange of ideas and talent between Hollywood and Broadway. Jack Cole choreographed for both, as did Agnes de Mille, Gower Champion, Bob Fosse and others. Cole's interest in the exotic dances of the East and the tropics, perhaps stemming from his training under Ruth St. Denis, filled his choreography and that of his imitators with angular arms, rippling shoulders and heads swinging in seeming isolation from the rest of their bodies. Isolation, one part of the body moving independently from another, is still at the heart of jazz dancing today.

During the 1930s, a dance in a Broadway musical or a Hollywood movie was skillfully used as something to move the pace of the performance along. It had not yet been utilized as something that might also move along the development of the plot.

By the 1940s many Russian ballet teachers had established themselves in the United States, and a large number of young dancers with strong ballet training were flocking to New York in hopes of securing a career with Balanchine, or with the newly formed Ballet Theatre or the Ballet Russe de Monte Carlo, an offshoot of Diaghilev's Ballets Russes. They were eager to learn their craft and not above accepting work on Broadway. Agnes De Mille was one of the choreographers who hired them.

De Mille's background was in classical ballet, but she was also a great admirer of the work and the person of the modern dance innovator, Martha Graham. De Mille had worked closely with Antony Tudor, the British choreographer whose work became the hallmark of American psychological ballet. She believed that dance, if integrated into the plot of a musical, could reveal the thoughts of a character at a moment of decision as clearly, and perhaps, more effectively than a speech or a song. The well-trained dancers she found available to her in New York City were perfect material for her ideas.

The success of the dream ballet that she created in 1943 for the closing of the first act of "Oklahoma!" proved her point. De Mille collaborated on many more Broadway shows in which dance forwarded the plot or expressed a character's dilemma such as "Carousel," "Bloomer Girl," "Paint Your Wagon" and "Brigadoon." She choreographed for ballet companies as well,

creating works that fused classical vocabulary and modern dance with folk styles.

De Mille's "Rodeo" was a slice of life and courtship on a Western ranch. In "The Bitter Weird," which developed from the Scottish highland dances and characters she created in "Brigadoon," she explored jealousy. In her "Fall River Legend," De Mille told the story of the alleged axe murderer Lizzie Borden and had the audacity to alter history's verdict to one of guilt. De Mille's last image leaves Lizzie standing at the foot of the gallows, a clearly more theatrical choice than presenting an acquittal. By doing this De Mille succeeds in making the ballet more than just a colorful and psychologically complex story. She compels us to think about the end of our own existence and what burdens we might be carrying.

Today, De Mille's choreography, which has been notated and preserved, seems simple in comparison to the flashy technique that dancers are able to produce these days. At moments her dances seem no more than simple stylized gestures connected in a manner that is more pantomimic than abstractly expressive.

De Mille's choreography is still worth experiencing, especially when it is performed by dancers of compact build whose execution of her characteristic outward-reaching choreography conveys a certain effort not evident in dancers whose limbs fly into the air with ease. Although the vocabulary of steps used by De Mille is basically that of ballet, there is a Graham-like use of impetus that gives the simplicity of the steps, when clearly performed, a compelling quality.

Although De Mille's elite New England background and her Hollywood family connections gave her an imperious air, she was a genuine person and inherently patriotic. She considered the life of each individual as something important, something that binds us together as Americans. She wrote journals throughout her life and her many colorful books are addressed to those who want to know about the professional world of dancing; how an American woman survived war time separation from her husband, or how a female choreographer successfully invaded the worlds of ballet and Broadway, where male choreographers and producers had traditionally held all the power.

Other choreographers followed De Mille's lead. Producers and audiences began to take more seriously the potential of musical theatre dancing. Choreographer's such as Michael Bennett in "A Chorus Line" and Twyla Tharp in "Movin' Out" now put dance and dancers at the center of their productions.

Perhaps the most widely known musical in which dance plays a pivotal role is Jerome Robbins' "West Side Story" with music by Leonard Bernstein. Robbins' background, like De Mille's, was in ballet, but his pulse was more in the energies of contemporary American urban life than in the memories of our nation's roots.

The 1961 movie version of "West Side Story" is still worth seeing more than once, particularly "Cool," a scene in which a song turns into a dance about containing doubts and embracing conflict.

The musical is about kids caught up in inner-city gang warfare. In "Cool" there is lots of leaping and spinning yet the dance hugs the floor as if it could give protection. The steps Robbins has asked the dancers to perform come as much from the vocabulary of ballet and studio jazz dancing as they do from the streets of New York. Except for some finger snaps and the affectation of the "cool" city walk of a hoodlum, nothing the dancers do looks much like anything anyone might actually do in that situation. Yet when it is over, you are convinced of the reality of what has been presented to you.

The emergence of American theatre dance as a recognizable form in which an artist can express himself and his environment may be seen as the inevitable result of the assimilation of cultures over time, but a dance form does not just develop because of societal trends and changes alone. It is through the emergence of individual geniuses, dancers and choreographers with unique talents and unlimited imaginations, that our American theatre dance has been forged.

Consider Bob Fosse, a choreographer who has been recognized with top awards for his work as a choreographer and director on Broadway, television, and in the movies. Starting with a specialty act in neighborhood musical reviews, he made his way in out of the seamy world of burlesque before becoming a professional dancer, first in New York and then Hollywood. There his particular genius was recognized by choreographer Hermes Pan who let Fosse create much of his own choreography for a supporting role he was playing in "Kiss Me Kate."

Fosse's career was involved with television right from its start. In his choreography, he explored the compelling effect that even the tiniest movement can have, if clearly executed. His dances were filled with the juxtapositions of unexpected isolations. His strutting, slithering, and finger snapping is still imitated today.

There is a sardonic wit, a fatalistic humor that underlies Fosse's choreography and which is well suited to musical theatre, where serious matters fare best when presented with irony. There have been several television documentaries made about his life, his career and his muse, the dancer, Gwen Verdon. The movie, "All That Jazz" directed by Fosse himself, was a dark fantasy about his personal struggles with professional success, nicotine, drugs, heart disease, and women.

Fosse's style of jazz dancing was built upon all that he had experienced first hand and all that he could learn from his colleagues and mentors. To that he added himself, his wiry body and his wry personality. He affected a "cool" slouch to hide the fact that he was round shouldered. He often wore a hat of some sort to hide his receding hairline. That slouch and that hat work, which have nothing to do with America's European or African roots, are now taught in studios across the country. Anyone in America with a passing interest in theatre and dance is bound to recognize the "Fosse" style with its snappy isolations and fists opening sharply into outstretched fingers.

There are three films that I recommend you search out if you want to see the Fosse style at its best and purest. In the 1957, "Damn Yankees" there is "Who's Got the Pain When They Do the Mambo?" Here, Fosse makes a cameo appearance to dance with Gwen Verdon, and both are at their best. In the 1966 film, "Sweet Charity" there is "Big Spender." If you can only manage to see one Fosse number on film, I recommend that it be "Steam Heat" from the 1957 Film "Pajama Game."

With our present obsession with the muscular aspects of fitness, a more forthrightly percussive approach to stage dancing has come into vogue. Hoofing has gone through a period of revival, accompanied by the popularity of step dancing and clogging.

"River Dance" popularized Irish culture through the presentation of Celtic dancing, one of the root forms of America's tap. Irish folk dancing is distinguished by the maintenance of an undisturbed, erect, and cheerful posture of the upper body while all the movement is concentrated in the ankles and the feet which insistently and untiringly pound out, with great clarity, complicated variations of simple rhythms which delight the ear and the eye.

Another touring group, one that has inspired several clones, is "Stomp," a troupe of hunky men who celebrate their muscularity by playing with the sounds they can make with the things that men find around them . . . hammers, lumber, boots. One of their dances takes them high onto a rooftop billboard and one is set in another domain of men, the busy kitchen of a gourmet restaurant.

As innovative as this may seem to today's audiences, percussive dance has always used found objects for its accompaniment. The first music-making instrument outside of the human body was surely a found object, a hollow log perhaps.

In the pre-Civil War South, plantation owners forbade their slaves to use drums to accompany their dances, in fear of their communicative powers. In response, the slaves improvised with the household implements available to them, pots and pans, anvils and spoons. Dances developed that involved the use of slapping and shouting. This must have caused even more fear amongst the misguided slaveholders. The first use of "taps" to accentuate the sounds the feet can make was the nailing of worn copper pennies to the tips of dancers shoes.

In the middle of the last century, in the era of the great Hollywood musical, the found object was often at the center of a dance. Donald O'Connor danced with a dummy and Fred Astaire danced with a coat rack. Gene Kelly danced with an umbrella and in "It's Always Fair Weather" he choreographed a brilliant number for three men and three trashcan lids.

The theatre dances of America and their movie images have reflected the beat of jazz in many different ways. Some dances, like tap, are erect and immediate. In some, the dancer is charged with providing his or her accompaniment. Some styles focus on improvisation and challenge with the object of communicating with fellow performers. Others are designed to dazzle an audience. Some show the influences of our Latin American immigrants and their particular rhythms that we have found attractive and made our own. In some the lyricism of ballet and the bending spine of modern dance can be seen. Some ask for order and precision. Others value individuality of expression.

Without having the ability to project ourselves into the future in order to have a good look back at what is being presented in our theatres right now, we can only guess what the next lasting development or trend will be . . . what American theatre will embrace and make its own. For now there is plenty of variety in American theatre dance to see and think about.

Dances from Latin America are developing their own American personalities. The tango is popular and salsa seems to be everywhere. Twyla Tharp's loose looking but ingeniously organized mixture of ballet, modern and jazz, where double tours en l'air are combined with shrugs, has its admirers and imitators. In total contrast, the kick line has made a comeback.

The most famous line dancers in the world, after London's Bluebelles, the Rockettes, began with the opening of the huge and luxurious Roxy Theatre in New York. After moving to Radio City Hall, they continued for many years to present their precision routines four or five times a day in a stage show that occurred between showings of newly released movies. The Rockettes became a must-see attraction for tourists visiting New York City. Similar groups were formed in professional theaters and amateur dance clubs across the nation.

With the concurrence of new and increasingly greedy procedures for distributing films, and the switch in public taste from film to television and from traditional family entertainment to rock and roll, the stage shows were discontinued. But now the Rockettes are back and touring the country, several troupes of them. Their popularity has caused some controversy in communities where their Christmas time performances have come into direct competition with the local professional ballet companies' productions of "The Nutcracker."

There are forms of theatrical dancing that seem to be coming from the martial arts. Like capoeira, a dance form which originated in

Brazil for the utilitarian purpose of self defense, the Eastern forms of karate and tai chi are now practiced by Americans and performed in public displays in which the focus has been transferred from one of utility to one of appreciation of beauty and skill. This is similar to how the ritual dances of India and the Middle East, once sacred in nature, have been accepted as dances of entertainment and have contributed to the development of new forms of artistic dance expression and presentation.

Over the past few decades the film industry has made fewer musicals than it once did and there are no longer stars that are primarily dancers. Often the leading performers today are not really "dancers." This is true of the recent cinema versions of "Chicago" and the "Moulin Rouge." To what surely would be the chagrin of Fred Astaire, today's editing techniques and the tolerance of the fleeting image we have acquired from television have produced a situation in which the stars of a movie musical can be chosen strictly for the appeal of their box office image. It really doesn't matter that they are in no way of the sinew to slug their way through those dance numbers, night after night, as the characters they are portraying are supposed to do. More encouragingly, a spate of movies have appeared recently that have at their core someone's determination to make dance a major part of their life despite any objections from family, friends of society.

One of the leading indicators of what dance in America is becoming is television. The emergence of the music video and the television channels that present them owe a debt to the vitality of the dance images they present. The amount of dancing used in television commercials has greatly increased in the past few years. And if you look closely you will see that not only is jazz dancing used but so is ballet. Even the abstract sensibilities of modern dance are being exploited to sell a product.

If one is a purist and clings to the idea that our traditional forms of ballet, modern and jazz belong on the stage, the easy to assimilate images of dance on television may disappoint. But it is encouraging to many dance lovers to see so many different kinds of dance being aired. If you have cable, you have the opportunity to see locally presented dance events and specials presenting leading professional dance companies from around the world. The phenomenon of the reality show has found dance to be a fruitful subject and speaks to the popularity that dance is currently enjoying.

Today, Western theatrical dancing has become a rich fusion of ballet, Modern Dance, African dance, and other folk and world styles. Ballets can be danced in bare feet and can use Graham contractions. Jazz dancers go on pointe, sometimes in sneakers. Ballerinas spin and so do hip hop crews, sometimes on their heads. The forms of dance are ever changing. What is constant is the urge to give physical manifestation to our feelings and ideas. Here, Alison Yurcak (BFA 2012) and Corbin Kalinowski (BFA 2011 and member of Ballet Nouveau Colorado) depict the abstract idea of temptation in James Clouser's Carmina Burana. (Costumes by Sally Waldmann and Jeremy Barney).

The Creative Act, Inspiration, Ingenuity, or Craft?

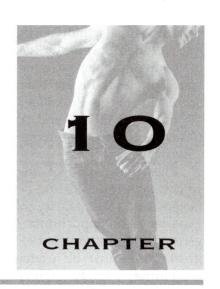

10

CHAPTER

Pleasure is a feeling of satisfaction or joy resulting from an experience that fulfills a need . . . to itch, to be soothed, to share, to be uplifted, to laugh, to cry.

Beauty is a combination of qualities that give pleasure to the sight or other senses, or to the mind.

Art is the process and the product of deliberately arranging elements in a way to affect the senses or emotions. Art is the creation of beautiful or significant things. An art is a superior skill that you can learn by study, practice and observation.

Creativity is the act of making something new.

Creativity is found in every aspect of the art of theatrical dance; it is not the realm of the choreographer alone. You may tend to agree with Merce Cunningham that it is the function role of the audience or viewer to determine and assign meaning to a work of art or you may think that perhaps choreographers should take some responsibility in making their intent clear; but in either case, the role of the audience is crucial. If they bring with them to the theatre, a richness of personal experience, an embarrassment of curiosity, and a certain amount of discrimination, (the same things the choreographer should have) each performance will be something new and unique.

The dancers, too, partake in the creative process. They must have the intellectual receptivity, emotional sensitivity, and physical facility to help the choreographer realize his or her vision. Many of the details of choreography come from the dancers.

When a dancer is chosen for a new ballet, he or she are said to be "creating" that role. When a dancer learns and performs a role that has been done before by others, they are expected to bring something new to the role. The dance teachers and coaches who prepare the dancers for the stage must be noted for their contributions as well.

Choreographers have particular dancers who inspire them. Margot Fonteyn was the muse of Sir Fredrick Ashton. Zizi Jeanmaire was the muse of Roland Petit. Gwen Verdon inspired Bob Fosse. George Balanchine had a succession of muses including Maria Tallchief, Tanaquil LeClerq, (who was stricken with poliomyelitis), and Suzanne Farrell.

Musical composition is an art in itself. During the Romantic and classical eras, composers such as Pugni, Minkus, and Delibes were skilled in writing dance scores following the specific directions of the choreographer. Tchaikovsky, following the dictates of Petipa, wrote some of the world's finest music contributing greatly to the success and longevity of, "Swan Lake", "The Sleeping Beauty", and "The Nutcracker".

Stravinski's "The Rite of Spring", considered to be the most significant musical composition of the 20th century, was written for the ballet. The many collaborations between Stravinski and Balanchine epitomized the neoclassicism of their time. Aaron Copland's best known

works, "Appalachian Spring", Billy the Kid", and "Rodeo" were written to the scenario of choreographers. Commissions from the state ballets of Russia have resulted in great scores by Serge Prokofiev ("Cinderella" and "Romeo and Juliet") and Aram Khachaturian ("Gayane", with the famous Saber Dance, and "Spartacus").

The commission of original scores is not so common today, owing perhaps to economic factors and the paucity of composers with experience or opportunity to compose in the genre. If the music is not to be performed live, great taste must be exercised in employing something already written for a different purpose. Expertise with today's acoustical technology is needed to reproduce the music or sound score to its best advantage. In the field of Musical Theatre or film, the creative collaboration takes place between the choreographer and the musical arranger hired to put together the dance music from the themes of the show's composer or composers.

Costume designers work more closely with the choreographers. Their job, like the job of the lighting designer, is to enhance the choreography without drawing undue attention to themselves. Some of today's most skilled designers and musicians work in films, and on television and Broadway.

The essays that make up this text are intended to be independent of one another and can be read in almost any sequence that suits a reader's unique interests. If they are being read in the order that they are published here . . . now . . . after our discussion of the beginnings of the modern dance in the first half of the 20th century, it is time to stop and face the often avoided question of aesthetics.

Someone who is seen to be appreciative of beauty is said to be aesthetic. An object, a song, or a gesture that appeals to our artistic taste is said to be aesthetic. The taste that unifies an artist's work and makes it identifiable is referred to as the artist's aesthetic.

An art form has its own aesthetic, one that includes certain particulars by which that art form is distinguished from other forms. The aesthetic of dramatic theatre in the West calls for the audience to remain quiet during the performance and save their reaction until the end, at which time the performers are expected

to come out of character to receive the audiences approval, which is indicated by the clapping of hands. Vocal response is used only in reaction to something extraordinarily good or bad.

The aesthetic of comic theatre calls for the audience to interrupt at will, hopefully with laughter. Without the laughter you would not recognize the play as a comedy. Television's frequent use of a laugh track is a result of this aesthetic, but we would be offended if canned laughter was used during a live performance.

The aesthetic of ballet calls for the forward presentation of the inner aspects of the foot ankle, calf and thigh. Without that you are not sure if you are watching ballet or not. It was the flagrant disregard of this aesthetic that caused much of the controversy surrounding Nijinsky's choreography for "The Rite of Spring". Nijinsky asked the dancers to forwardly present the outward aspects of their limbs . . . in other words . . . to turn-in.

The aesthetic of Modern Dance embraces the use of bare feet. This was once even insisted upon. In making a dramatic statement of protest against the artificiality of ballet and "toe-dancing," early modern dancers presented an equally unnatural but more democratic world where no one wore shoes, not even to the ball. Footwear in jazz dancing is from the street; stylish, sturdy and flexible. The aesthetic of Jazz dance is also from the street, a syncopated, off-beat, "in your face" attitude.

Ballet may be plain or fancy, severe or flowery, athletic or ethereal, but its aesthetic involves an adherence to classical principles that are deemed to exist outside the individual; balance, order, and harmony. Ballet dancers draw their hair back to accentuate the beauty of the human face and its proportions. The aesthetic of Modern Dance, barefoot or shod, involves an adherence to the philosophies and kinetic intentions that lie within the individual choreographer. In the realm of Modern Dance they have permission to see things differently.

Aesthetics is a branch of philosophy dealing with the principles of beauty in art. So, what is art? Art is the production of something beautiful, the creating of a dance, a painting, a song. Art is the skill at producing something beautiful, the talent of the dancer, of the painter, of the singer. Art is the product of that skill, the dance itself, the painting, the song.

Art has many functions. It can please or entertain us. To entertain is to hold our attention. Art can soothe or invigorate us. It can be a needed outlet for expressing feelings and ideas that might otherwise overwhelm us. Art can help social groups to become and remain cohesive. Art, at its most successful, reveals to us what is new in the familiar and what is familiar in the new.

So, what is beauty? Beauty has something to do with pleasing the senses. When explaining why they are not pleased by something that others find attractive, or vice versa, many people will say that . . . *beauty is in the eye of the beholder.* This, I contend, is a cop-out, perhaps a fear of the unknown, a fear of being found ignorant, or a fear of being considered "artsy." What insights into life are we missing if we dismiss as unimportant the opportunity to understand why someone would find something beautiful that we find displeasing? Clinging to this simplistic point of view avoids addressing more than a few seemingly unanswerable but thought provoking questions.

Are some shapes universally admired? Are some sounds preferable to others? Do we agree with the ancient Greeks that beauty is found in recognizable classification, order, balance, and harmony? What is balance? Why do we find some things harmonious when placed together while the juxtaposition of others is considered ugly? Is there no beauty to be found in disarray? Is beauty an absolute in itself or a complicated matter of varying preferences resulting from cultural indoctrination as well as from environmental circumstance?

Which satisfies you the most: stark undecorated dances following the principals of Martha Graham that call for introspective contemplation, or the elaborate choreographic designs of a Marius Petipa or George Balanchine that dazzle and beguile? Or do you prefer something with a jazzy kinetic punch that energizes your body and sets your mind reeling? How about the Japanese Butoh company, Sankai Juku, naked men painted white, heads bald, eyes receded, moving so slowly it is terrifying?

Do we prefer dances that create a mood or tell a story? Or do we derive pleasure from the act of dancing itself? What is it that fascinates us, the shapes and forms that greet our eye . . . or the thoughts those images provoke . . . or the amazing phenomenon that a movement can provoke a thought, an emotion, or another enjoyable movement? When do we nod with satisfaction upon seeing a dance or an individual dancer and say to ourselves, "That is beautiful?"

There are certain shapes that seem to be employed in the artistic expression of all cultures: bold right angles, circles, and parabolic curves that lead the eye and the mind outward, inward, downward and upward. Perhaps our admiration of these shapes is rooted in our memories of the shapes presented to us by our earliest caretakers.

Emotions aside, mathematicians have made a good case in arguing that certain abstract shapes are universally admired. Consider the example of what they call the divine or golden rectangle. Its specific proportions were used in building the Parthenon in Athens, the beauty of which I have never heard denied by anyone.

In a world that is filled with cacophony, we search for the sounds that comfort or excite us. Music theorists point to the evocative power of certain vibrations isolated by themselves or in juxtaposition with coexisting vibrations. A tone seems so compatible with another tone that vibrates exactly twice as fast or twice as slowly that they almost seem the same. The addition of a vibrating tone that is one sixth slower than the original, what a musician trained in the West would call a flatted seventh, produces an effect that, though harmonious, does not seem resolved. This phenomenon is employed by jazz music where it evokes a feeling we can best explain as "the blues."

Balance is essential to the execution of the most basic tasks. We struggle to maintain erectness. To stand is to be alive. In our physical structure we find harmony. It is basic to us. One side has to go with the other or things just don't work. An inept movement is considered comical or ugly, not beautiful. A graceful walk is recognized anywhere.

Is their beauty to be found in disarray? There seems to be something spontaneous about capturing beauty and something beautiful in capturing the spontaneous. Pierre Beauchamps, ballet master for Louis XIV, is said to have devised his choreographic patterns by watching chickens scurry after the corn he scattered for them. Three hundred years later, in his determination to avoid predictability,

American choreographer Merce Cunningham was throwing the *I Ching*, an ancient Chinese fortune telling game in which sticks of different lengths are scattered and in their disarray indicate, without prejudice, which choices the thrower should make.

If we are looking for an example of what is universally considered beautiful, we need look no further than to the human body. Except in the most prurient of sub-cultures, the human body has always been the object of aesthetic admiration. As the subjects of painting, sculpture, and photography also attest, almost any way we look at it, we find the human body beautiful. This is particularly true of the moving body; it creates splendid shapes and evokes feelings that we are inspired to recreate in art, dance and music.

I find myself readily agreeing with those who believe there are universal forces at work in the establishment of our tastes and our aesthetic standards, forces that can be discovered in our very physical structure. I can also recognize that we sometimes find beauty in things, or something less satisfying, not because of what they are but because of how we are indoctrinated to them.

There is a particular geometric shape made of right angles, in which four prongs or groups of prongs reach out in four opposing directions. It occurs independently in Greek, Amerindian, Celtic, and Hindu cultures as a symbol of good fortune. But for those who know of it as the symbol adopted by the Nazis in World War II, the very sound of its name, swastika, may be abhorrent even though the word's vowels and consonants may each be individually attractive. For some there is little beauty to be found in its shape or that of shapes that are reminiscent of it.

Fortunately, not all circumstantial events have such a lasting effect upon our preferences. Our tastes change as we make progress through our lives. Hopefully, we find more and more that pleases us.

If our ears are not accustomed to the chromatic musical scales of the Middle East, we are likely to find them dissonant, at least at first. If we are exposed to them long enough, and if we listen to them with enough curiosity, we may find them fascinating and soon grow to welcome them.

The same is true of cuisine. In our multicultural society we have around us a dizzying array of foods to please our palates. Unfortunately, it is too easy for many of us to stick to the same old fare. We have tried new foods but our tongues, dulled by salt and sugar, did not find them appealing. Too bad!

With current technology, the variety of music that is available to us is staggering: classical, country, jazz, Latin Rock, Rap, alternative styles, and World music from exotic cultures. Why then, is the one rhythm you hear from every electronic source the same,"*uh one, two . . . uh one two*"? It is the ubiquitous rhythm of our youth, safe and comforting like sugar and salt.

Most of us have our first experience looking at dance in the studio or from seeing a TV show or a recital. Each of these venues calls for frontal orientation and encourages ensemble choreography with everyone dancing in unison. Our eyes are not initially trained to appreciate a visual image that has several layers of activity. Dances of complexity with their possibilities of intellectual stimulation are not to our taste. Too bad!

An important step in re-training the eye to see more is to change our expectations. We should not begin by looking to understand, only to describe. We need to suspend judgment and not let our need for comprehension cloud our vision.

The more dancing you watch, on YouTube, TV, and on stage, the easier it will be to wean yourself from the immediate reassurance of the familiar. Your eye will become more skilled in seeing all that is going on and in focusing on something particular without any worry about missing the rest. What you initially may have found to be a distraction, two or more things happening at once, you may come to recognize as an essential moment of texture in a dance that might otherwise not hold interest. But you might also continue to see it as a moment where, in your opinion, a mistake has been made, purposely or inadvertently, and the choreographer or the dancer has, indeed, lost focus.

Whether you write a report, discuss a performance with a friend or think it over by yourself, matters of judgment and discrimination are going to come into the dialogue and it may seem that an opinion is being called for.

Opinions are dangerous for they are apt to reveal the limitations rather than the scope of our knowledge. Instead of deciding or declaring

that something is "good" or not, center your dialogue on the things you found particularly beautiful, an inclination of the head, a fleeting phrase of movement, and unexpected moment of exhilaration.

Abstraction or Expression?

No two audience members are going to bring the same experience to the viewing of a dance. One may have seen the dance before or heard something about it and have certain expectations. Another may know very little about the dance he is about to see. His expectations are of a different sort. One arrives at the theatre early and enjoys a moment to put distracting thoughts about the day's mundane activities out of mind. Another encounters heavy traffic on her way to the performance, is forced to park an uncomfortable walking distance from the theatre, and has to shuffle sidewise to her seat, squeezing past several pair of strange knees only to find that she has no time to read the house program before the lights go down. It seems evident that each audience member, because of her or his unique geographical, psychological and intellectual perspectives, will see in the evening's dance something different.

The question being asked by the generation of choreographers, who were products of the Denishawn era were often addressed to the matter of the responsibility for the meaning of a work of art. If any meaning is to be attributed to a dance, does that meaning lie in the intent of the choreographer, in the unique experience of each viewer, or purely in the form of the created object itself, without regard to any psychological or emotional baggage that either the choreographer or viewer might bring to it?

Will we enjoy Balanchine's "Meditation" more if we are aware he created it for a particular dancer whom he considered his muse and whom he loved from a distance of age and propriety? Or does the pas de deux itself, well danced of course, stand alone as something unusual and beautiful?

Choreographer Paul Taylor dealt with these ideas in one of the first concerts he gave after leaving a successful dancing career with Martha Graham. He included a solo for himself in which he stood motionless for several minutes, literally leaving the assignment of the meaning entirely to the audience. The New York Times critic, Louis Horst, who had also been Taylor's choreography teacher at the Juilliard School, responded by leaving a conspicuously blank space in his review of the performance.

Luckily for the dance world, Taylor's impish and rebellious nature was tempered with talent and resilience. He soon established himself as a choreographer with an intriguing and independent voice.

Taylor's dances call for a determined and athletic muscularity but they have a lyrical nature. Most of his works like his early masterpiece "Aureole," and the later "Esplanade," have no story and could be considered abstract. Whether or not Taylor had specific intentions in making his dances, audiences and dancers have found them beautifully designed and uplifting in spirit.

Taylor dealt with a variety of subjects. His "Cloven Kingdom" was inspired by his fascination with animal behavior and movement. In other works like his "Big Bertha," whose central character is a homicidal automaton in a carnival sideshow, Taylor is intentional in his expression of darker feelings. In "Orbs" he used the music of Beethoven as background for a study of family relationships. He enjoyed how different music could make the repetition of the same movement appear entirely new. One of Taylor's more recent and currently most popular works is "Company B" in which he uses the cheerful voices of the Andrews Sisters to remind us that war is a cheerless affair.

In the middle of the 20th Century there arose a great interest in philosophical theories that involved something termed phenomenology. In "phenomenalism," a given subject is described in terms of appearances without needing to postulate anything else. It is a point of view that finds the meaning of a work of art in the experience of the recipient rather than in the intent of the deliverer.

Merce Cunningham, who also spent some time dancing for Graham, was more seriously affected by this trend towards phenomenology than was Paul Taylor.

When Cunningham first began to make his own dances, he became associated with the up and coming luminaries of art in New York City, Philip Johnson, the architect, and the young artists whose work Johnson's Museum of Modern Art was collecting. These artists, although they had sophisticated technique and often painted realistic objects, were not realists. They were abstractionists endeavoring to be free from any emotional attitude which might prevent a viewer from seeing what is really there rather than what they expect should be there.

Robert Rauschenberg was one of these artists. It was his ideas, and those of his colleague, the composer, John Cage that caught Cunningham's imagination. Cunningham was, at their first meeting, a would-be choreographer in search of a voice that would express why he felt urged to dance. The connections he was making through his friendship with Johnson and Rauschenberg introduced him to a world of wealthy and widely educated art patrons who took an interest in his ideas.

Apparently Cunningham had a loyal group of accomplished dancers eager to work for him. Soon he was providing evenings of dance for society parties and fundraisers that established his reputation as an artist who should be taken seriously by any one who liked to take their art seriously. Several of the dancers Cunningham used went on to join his first official company which, after its initial residency at Black Mountain College in Virginia and many years of struggle, established itself as one of the most respected and influential modern dance companies of the Century.

Outside of the work presented by Cunninghams's own company or television productions, his choreographic work is only rarely performed these days. The same is true of the music of Cage, but together, the two rode the crest of a revolution in modern dance as significant as that begun by Duncan and St. Denis.

Basically it had to do with choice and how a choice was made. When a choreographer decides to make a dance, there are some initial choices to tackle. How long might the dance be? How many dancers might be used? What sound or music might be used to accompany them? Not all of these questions may be answered by the time the dancers have been assembled for the first rehearsal. Then the choreographer must make some more decisions. How should the dance start? What does the choreographer want the audience to see first—an empty stage, a preliminary pose, or a dancer or dancers already in motion? What steps should the dancers do, and in what order?

Traditionally a choreographer learns to make these decisions through experience and observation. The making of choices becomes a sophisticated and subconscious matter reflected in and spurred by the choreographer's intent. A phenomenological viewpoint, however, questions the relevance of the choreographer's intent. Responsibility for providing the meaning in a work of art is shifted from the deliverer to the recipient.

The problem for a choreographer was, as Cunningham saw it, to devise movement that does not spring from one's own immersion in the clichés of the stylized dance forms with which one is already familiar.

Cunningham sought originality. But how can an artist be sure his choices are original and not just another reworking of predetermined reactions to given and familiar situations? John Cage offered Cunningham a solution to this dilemma . . . chance!

It was not the responsibility of the composer or choreographer, Cage argued, to meet any expectations that an audience might have. He maintained that any sound was considered music when it was listened to with the same attention we might give to what we already consider as music.

Cage and Cunningham gave the same consideration to the relationship between ordinary movement and movement that for some reason is considered to be dance. It was the looking at an ordinary movement *as dance* that made it *a dance*.

Cage composed by employing chance methods, placing notes at random on a page of manuscript or employing I Ching, an ancient Chinese fortune telling game that called for the throwing of sticks, whose scattered arrangement would then direct the thrower's choices. The more options one had in choice and the freer one could be from predetermination, the more chance the choice had for success and the avoidance of cliché . . . the chance to create something unlike anything else.

Cage liked the fact that his ideas sometimes disturbed people. He gave an outdoor concert in New York where he played nothing. The composition was the experiences of the crowd who gathered to watch the setup of the portable stage and the piano and then watched in puzzlement as Cage sat without playing a note. The event, Cage would point out later, was certainly more memorable than had he actually played.

At a concert performance, one of his works called for five radios to be randomly tuned to different stations. After a period of conflicting unintelligible voices and crackling, the melodious sounds of a classical symphony were heard and the audience broke into applause and laughter. Cage, who liked to confound and amuse, was pleased with the outcome. Perhaps his most popular score was written to accompany Cunningham's "How to Pass, Kick, Run and Fall," for which Cage read randomly from his daily journal.

Cunningham adopted and refined Cage's chance methods. They provided him with a method to avoid cliché-ridden material. Cunningham and Cage entered into a long and productive collaboration, creating many highly acclaimed works together. Beyond the overall length of their performances, something dictated by circumstances beyond their control, they took care that chance played a role in all of their decisions.

Once the length of a proposed new work of choreography was decided upon, Cunningham, Cage, and Rauschenberg, (or the other composers and designers Cunningham sometimes commissioned) went their separate ways. Using a stopwatch, Cunningham would devise the requisite amount of choreography but without any concern for what sound might accompany it.

At the same time the composer would be devising a score comprised of sounds that made no attempt to coordinate with the choreographer's ideas. Likewise, the stage designer would randomly arrive at a setting and color design that did not anticipate any particular need but its own.

At some predetermined time, as close to the proposed performance date as possible, the collaborators would bring their work together. Sometimes the dancers did not know until just before the curtain rose on the premiere of a new work what order the choreography would take.

Chances were that they would not yet have heard the music they would be performing to.

Needless to say, this "chance" method took the chance of producing something that just didn't jell but Cunningham had as many successes as did those working in more traditional ways.

For me, Cunningham's most pleasing work is "Rain Forest," with eerie music by Cage and an unforgettable setting by Andy Warhol. "Rain Forest" seems to present a world of beautiful people at ease in a world where transparent pillows float on eddies of air stirred by dancers who are no longer where they were a moment ago.

The most puzzling and disturbing was "Winterbranch," a seldom-performed work that employed two concurrent but separately composed musical scores by Cage and David Tudor, each more painfully screechy than the other. A row of bright lamps was hung over the footlights and shone into the audience who sat there like deer caught in headlights. There was dancing taking place on the dark stage, but it was only illumined by the occasional, and, naturally, arbitrary strafing of the stage manager's flashlight.

Cunningham's choreography does not feature the descent to the floor, as did Graham's and Humphrey's. His dancers are most often asked to maintain an erect posture. Except for a rather more unyielding carriage of the arms, they are as elegant and articulate as any ballet dancer. The use of the contraction can be detected as the source of impetus but it has been softened and no longer occurs just in the lower torso, but in the separate joints of the extremities as well.

Cunningham has remained innovative throughout his long dancing life. He now choreographs with the aid of a computer program. If the juxtapositions of his chance methods evoke humor or emotion, he gives those moments the attention they call for, but he does not purposely seek them out. He never has seemed interested in telling a story or manipulating the evocation of a mood. For Cunningham and the dancers who embrace his philosophy, dance is most pertinent, most enjoyable, when it is freed from predetermined expectations . . . what Cunningham and Cage sometimes referred to as "the tyranny of form."

A loosely organized band of dancers called the Judson Church Group emerged in an area of lower Manhattan called the Village, a neighborhood filled with young intellectuals living a "bohemian" life. Their creations, however, were more concerned with the present than the past. Their professional association with Merce Cunningham was unclear, but they shared many of his concepts. They were, however, *downtown*. Their performances were rougher than were Cunningham's. Their production budgets were minimal. Their experiments were more daring and more absurd.

At the urging of Walter Terry, then dance critic of the New York Herald Tribune, I attended several of their performances during the 1960s. My first impressions were always of the audiences crowded in the church lobby. The same people were always there, the hippies in their rags, and the beatniks. And at each visit, one particular woman would be there festively dressed from head to toe in every Zebra print imaginable. New York is a metropolis but this was a neighborhood affair and everyone was eager for the performance to begin.

One evening, Yvonne Rainer, Steve Paxton, James Cunningham and even Rauschenberg were among the performers. Rainer, who was well assembled and well trained, was a leader of the group, and has been referred to as a Terpsichore in sneakers. She had issued a manifesto that called for an end to any attitude of presentation or technical display. She performed her "Three Spoons" to the music of Erik Satie, which I had seen before at Connecticut College and can still remember for a recurring odd tilt of the head and a finger pulling the mouth into distortion.

Another leader in the group was Steve Paxton whose exploration of contact and support as the inspiration for improvisational performing has greatly influenced the vocabulary of modern dance. His contribution to this particular performance consisted of the manipulation of some tubes of cloth that were rather unsuccessfully inflated by some electric fans. It was in this work that Rauschenberg appeared.

I remember writing in my journal, "yes, I do understand that looking anything like a dancer or performer in search of audience approval is what these dancers are trying to avoid. But . . . if all the dancers on the stage looked as little like a dancer as did the seemingly hapless Rauschenberg, the performance would have ground to a halt under the dull weight of its material!"

Except for Rauschenberg who was, I hoped, pursuing a lark, the cast was composed of trained dancers who could not help but draw upon their professional discipline despite their supposed rejections of such techniques. To avoid display, they had chosen a mundane vocabulary. But something in their appearance and behavior, their proportions and their attitudes made them more interesting to watch than a non-dancer like Rauschenberg doing the same activity.

For James Cunningham's portion of the evening, the audience was given tiny balloons into which air could be blown and then expelled noisily to accompany a gentle dance that consisted of little more than the singing of "Second Hand Rose" by two dimly lit performers.

The last dance of the evening, if dance is the appropriate word for the spectacle we were presented with, consisted of piles of lumber being thrown from the church's choir loft to the floor of the nave where the other dances had been presented. Throughout the performance, the dancers had done nothing but perform their tasks showing no concern for the display of technique. They had not taken any bows, nor had they in any other way courted the audience's favor or approval. They did their thing. It was "take it or leave it." Now they were standing in a line, holding hands as if they were at the end of an uptown ballet or modern dance concert, rushing forward to receive the audience's enthusiastic applause. Why would they do that, I asked myself, considering the strong stand they seemed to take about the artificiality of performance? Was approval really needed after all?

Concurrent with Cunningham's career as a choreographer, teacher and modern dance guru, was the reign of George Balanchine as the Ballet Master of the New York City Ballet. Balanchine, like Cunningham, was a vital force for a new generation of dancers and audiences

who were interested purely in the act of dancing itself. Balanchine and Cunningham were like many of the painters of the time for whom their medium, the paint itself and the act of painting, had become the subject matter.

For many of the next generation of choreographers, the subject matter of dance was dancing, freed of what was considered by some the burden of having to express something other than itself.

But it was a period of strong and varying opinion. The American Ballet Theatre and other companies still followed the Diaghilev principle of presenting a varied bill to reach those of all tastes. The belief still prevailed, in both ballet and modern dance that the function of dance was to express something beyond itself.

In Chapter Seven we spoke of Jose Limon, Doris Humphrey's student and protegé who refined her principles of breath, fall and recovery. Lester Horton's students, Alvin Ailey and Bella Lewitsky, began to create works that impressed with their undecorated physical and emotional sensuality. Alwin Nikolais, a Hanya Holm student, began to produce work that explored the evocative potential of shape.

Nikolais' approach was often visual. He dressed his dances in witty and colorful costumes that were often designed to alter or distort a dancer's physical appearance. He developed new lighting techniques to support these visual tricks and created original music scores made from the recorded and altered sounds of unusual objects, strips of metal that he found in junk yards, paper that could be rattled, tubes of all sorts that could be struck or blown across to produce a unique sound. With these elements, Nikolais created non-figurative works of great novelty and intriguing mystery that are still considered "avant-garde," but which owe a debt to his training in, and admiration of, abstract expressionism. Although the physical training of Nikolais' dancers was intense and sophisticated, the appeal of his work seems to be chiefly communicated through the visual and the intellectual.

The first male dancer to join Martha Graham's company was Erik Hawkins, an athletic and thoughtful young man whose previous training had been in ballet with Balanchine. The presence of one male in what had been an all-female company changed the focus of Graham's work. She and Hawkins were briefly married, but eventually personal and professional conflicts arose and Hawkins left to form his own company.

Hawkins' choreography often dealt abstractly with subjects taken from North American history. His devotees consider his movement technique to be more aesthetically pure and injury free than that of ballet or Graham. Hawkins toured the country for many years, giving performances and master classes at universities across the country, inspiring the inclusion of dance in the physical education curriculum, and the addition of courses in kinesiology for dancers.

Despite her rocky experience with Hawkins, Graham went on to include other men in her company and came to rely upon their presence to expand the scope of her vision. To work for Graham you had to be strong, intelligent and thoughtful. This implies that you would also be of independent mind. But independence was not called for: the vision was Graham's vision and either you whole-heartedly agreed with her, kept your ideas to yourself, or crossed swords. It was only natural that several of her dancers would eventually leave to explore their own ideas.

Everything was being questioned, not just the how of dance or the why, but the very nature of what constituted theatrical dance. These questions are still being asked today.

Does a work of art have a function? Does it have to have a function? Does a dance have meaning? Does it have to mean anything? If it does have meaning, who takes responsibility for it? Does a dance have more meaning if the viewer knows who composed it, and when and why? Can a dance or any work of art be understood completely by just experiencing it without any background knowledge?

Concert dance in America is still an eclectic matter with no one particular philosophy prevailing. Modern dance choreographers still champion their individuality, but audiences do not seem to be as divided in their loyalty as they once were. Instead, they have learned to appreciate the wide palette of dance available to them.

Some Other Names and Things Worth Knowing

Robert Joffrey (1928–1988)

Master teacher, ballet director, and choreographer. His company, The Joffrey Ballet (now situated in Chicago under the direction of Gerald Arpino), was like a living museum, presenting revivals of important classics done with careful detail to historical accuracy: Massine's "The Three Cornered Hat" with sets by Picasso, Agnes De Mille's "Rodeo" to the music of Aaron Copeland, and Nijinsky's "The Rite of Spring." At the same time, he presented the works of New York's post-modern choreographers, Lucinda Childs and Twyla Tharp. His own ballet, "Astarte," and Arpino's "Billboards" were danced to rock music.

Jiri Killian

Hungarian-born choreographer whose work combines ballet and modern dance and is performed by most European ballet companies. This fusion of ballet and modern has also become the hallmark of **Nacho Duato**, a Spanish choreographer and **William Forsythe**, an American choreographer whose work is better known in Europe.

Doug Varone

American choreographer trained at the State University of New York at Purchase. His dances employ ballet and modern dance vocabulary and the naturalism of the Judson Church dancers. His choreographic inspiration comes from the texture and timbres of the music. In the past few years, Varone has become active in stage and opera direction.

Rennie Harris

American choreographer who employs the vocabulary and the sensibility of hip-hop in his concert choreography.

Bill T. Jones

American choreographer who uses contemporary choreographic techniques to shape his material which comes from his experience as a gay African-American. His ideas are often presented in the form of an epic narrative in which the heroes are not the victors of conflict but the survivors who have refused to be defeated. In his "Last Supper at Uncle Tom's Cabin/The Promised Land," he employed a large cast of untrained performers, men, women, and children of all ages.

Liz Lerman

American choreographer whose touring residencies invites member of the local community without any formal dance experience, particularly senior citizens, to train and perform with her company.

Mark Morris

Sometimes referred to as the bad boy of ballet because of his impish outlook on life and dance. Like many of our contemporary choreographers, he works in both dance and opera. His "take" on "The Nutcracker," entitled "The Hard Nut," is available at any good video rental store. His barefoot "Waltz of the Snow Flakes" is a long way from Petipa and Ivanov, but there is an underlying classicism in Morris's work and a respect for modern dance tradition as well. His company, the White Oak Project, has encouraged Baryshnikov's escape from ballet and has presented "Jocose," created by modern dance pioneer Hanya Holm at the age of 91.

Pilobolus

A sun-loving fungus and the name of an American modern dance company. For over 30 years, Pilobolus Dance Theatre has been one of the most active touring companies in the world. Its story goes something like this.

The 1960's were years of great social change in America. Along with the Vietnam conflict and the struggle for human rights and racial equality came a new attitude towards dance,

a new aesthetic. As a result of the pioneering activities of such choreographers as Martha Graham, Doris Humphrey, Mary Wigman, George Balanchine, Agnes De Mille, Eugene Loring and others, theatrical dance was no longer considered by the American public as something imported and suspiciously aristocratic. There was nothing effete about the dances made by Alwin Nikolais, but rather an appeal to the imagination of the intellect. The phenomenological philosophy made popular by author Suzanne Langer provided a "democratic" way to look at dance. A dance, as Merce Cunningham said, means nothing more than, " . . . I am dancing!"

The traditional gender roles of our European heritage were discarded. At the Judson Church, dancers wore unisex clothing, formless coveralls and lab coats. Post-modern choreographers such as Nancy Stark Smith and Simone Forti championed the use of improvisation, requiring strength, flexibility, and attentiveness of their dancers rather than training in any specific dance technique. Steve Paxton explored and popularized contact improvisation, a genre based upon the sharing and exchange of weight and momentum between two or more people.

Dance had become a respected subject to study in the university setting, in the studio as well as the classroom. The professors who took the new faculty positions were familiar with the new trends in dance. Some were champions of them. Dartmouth, a university more oriented towards the sciences and humanities than the fine arts, began offering dance courses in 1970, at the request of a group of male students who wanted a dance experience to balance their studies in philosophy, biophysics and psychology.

Alison Chase, with a BA in Intellectual History and Philosophy from Washington University, and an MA in Dance from UCLA, was engaged as an assistant professor. Her students had no previous formal dance training, so she began by concentrating on improvisation as a means of strengthening and stretching their bodies. Within three years, four of these men had formed a company that caught the eye of the booking agents who were searching for something "new" to present.

Chase left Dartmouth to join them and in a short time "Pilobolus" was sought after by dance presenters around the world.

Going to a performance of "Pilobolus" is like looking through a microscope and watching our biological building blocks morph from one intriguing shape to another. Their choreography, which touches upon many subjects, is arrived at through improvisational experimentation, but once it gets to stage is "set" and showcased with sophisticated lighting and striking costuming.

The look of "Pilobolus" has become familiar through photo images that appear regularly in trendy magazines and on gift calendars, with the dancers grouped in sculptural poses, wearing bold clear colors, or sometimes wearing nothing, with their bodies painted or carefully lit to reveal their line, weight and mass.

Momix

An offshoot of "Pilobolus" founded by Moses Pendleton and Alison Chase. One of their most popular works is based upon the images and efforts found in baseball. Another offshoot of "Pilobolus" is "Pilobolus TOO," a company composed of two dancers who perform in venues that are not equipped for the main company's complicated productions. All of the original members of "Pilobolus" remain active as choreographers, regularly creating new work for ballet and modern dance companies and for opera. Alison Chase has also designed dances for the Radio City Music Hall Rockettes and for the Cleveland School for the Arts, "An Urban Nutcracker."

Marko Goecke

Since 1609, when the Duke of Wurttenberg introduced court ballet to Stuttgart, the city has attracted such influential figures as Jean-George Noverre, Filippo Tagilioni, Oskar Schlemmer, Nicholas Beriozoff, and John Cranko to live and create there. Perhaps we should keep our eye on the works of the young German choreographers like Marco Goecke who has recently taken over the direction of the Stuttgart Ballet after proving himself as a choreographer of interest.

The Latin Influence

It was a Brazilian-born ballerina, **Marcia Haydee**, who brought the Stuttgart Ballet to international prominence. Under Fidel Castro's communist regime in Cuba, **Alicia Alonso,** an American trained ballerina, widely recognized as one of the world's greatest, fought successfully to maintain a state supported ballet school. Her faculty was made up of both American and Russian trained pedagogues. Alonso, who was legally blind and could only see a pinpoint of light in front of her, danced demanding roles at the age of sixty. As well as being a great stylist, she was noted for her vertical alignment and her ability to turn. This amazing talent for turning is a trademark of the Cuban-trained dancers who are now appearing as principal artists with nearly every major ballet company in the world.

Pina Bausch

German born choreographer who studied at the Juilliard School in New York with Jose Limon, Lucas Hoving and Antony Tudor. Bausch is one of the chief proponents of "Tanztheatre" which many consider to be a new form of the abstract expressionism of Mary Wigman, Kurt Joos and Harold Kreutzberg.

German Tanztheatre developed in a society that suffered the loss of two world wars and was threatened by being geographically situated between two rival world powers, Soviet Russia and the United States. A sense of loneliness and despair permeates the works of Bausch that have been shown in the United States. In her version of "The Rite of Spring," the dancers perform on a stage covered with mud. In "Café Muller," the stage is filled with chairs and tables that impede the dancers' progress. A scene from "Café Muller" was featured in Spanish film maker Pedro Almovodar's 2002 Academy Award winning film, "Talk to Me."

Technology

The arts that accompany and support the performance of theatrical dance—stagecraft, lighting, costuming, and musical accompaniment—have shared their technical advancements with dance, and dance has changed its form and tempo because of them. Video technology that allows you to record an improvisation and immediately see it repeated, forward or backward, faster or slower, has revealed the beauty and choreographic potential of movements we may have taken for granted or not realized we were making at all.

One of the most difficult moments for a choreographer comes at the beginning of the rehearsal process. It is an exciting moment for the dancers who have been chosen to part of the creation of a new work. They are eager to be given something challenging and satisfying to perform. Rarely does the choreographer arrive with everything planned out. He may know where he intends to take this new dance but rarely has more than a vague idea of how to start and where the journey will take him and the dancers . . . and the dance.

As he experiments with the bits of movement or patterns he has devised to discover if they have any potential, often changing his mind or forgetting some step that had occurred to him in a moment of improvisation, the dancers grow restless and their bodies become unconsciously uncooperative. This is the reason why choreographers prefer to work with the same dancers over and over, dancers who realize they must, for the moment, be no more than putty.

Experimentation can now be done on a computer screen. Not only can the choreographer imagine what the dancers might do, he can see what he has imagined. He can see it from any angle, top or bottom if he should so choose. He can see how it looks at any speed. He can see how long it would actually take for a dancer to reach a certain destination or a formation to be made. He can see if there are going to be any collisions along the way. He can change his mind and use the potential collision, which would probably have been avoided by living dancers, to his advantage.

What takes long hours in the studio and tries the dancer's patience can now be accomplished on the computer screen. Boot-up your computer. Go to your favorite search engine and type in "DanceForms," and then, "Life Forms Merce Cunningham." Treat yourself to a look at some software programs designed to aid choreographers.

Education

The inclusion of dance as a major area of study in state supported American universities has spread the understanding and love of dance to every corner of our country. You don't have to go to New York or Chicago to see the works of the choreographers I have mentioned above. They are performed on university and community fine arts series in cities as remote as Yuma, Arizona and Bangor, Maine, and are frequently featured on cable television specials. Many local access channels carry The Lloyd E. Rigler–Lawrence E. Deutsch Foundation's superb and eclectic collection of filmed dance excerpts. There is more than dance here; there are classic moments from drama, comedy, symphony, song, film and opera.

There was a time when attending a dance concert was not a part of the American experience. Now, there are Americans of all ethnic, social and economic backgrounds who would just as soon go to a dance performance as spend their free evening in any other fashion. These new audiences are treated to everything that is currently fashionable. What they next will want to see is going to be a large factor in what next comes along.

Because of their early association with physical education, college dance programs require the study of **kinesiology**. Sometimes taught as biomechanics or dance physiology, kinesiology encourages the dancer to focus on matters of anatomy, physiology and neurology that are pertinent to the demands of the technique and aesthetic of the styles in which he or she is training.

Some traditional teaching methods no longer pertinent to the needs of today's dancers have been replaced by more advantageous approaches. Today an aspiring performer's dance classes are supplemented by exercises done under the watchful eye of an instructor trained in such kinesiologically informed techniques as Pilates, Alexander, and Feldenkrais. Today's American dancer is better aligned, stronger and more flexible than ever, and armed with a Theraband, an exercise ball, and a massage roller, is preparing to accomplish whatever new styles may come in favor.

Looking Forward to Looking Back

I would like to be around in twenty years or so, for I have no idea what American dance will be like then. Still vibrant, I hope! Any resolution of race relations will have made great changes in the dance of America. New conflicts and concepts will be driving the choreographers. Already our dance, like our music, is becoming world encompassing, not regional. Americans have been quick to embrace the music, foods, and dances of the many diverse cultures with which they now are in daily contact.

I don't think I could identify any particular dance as being a nationalistic expression of America, as one might associate the traditional mazurka with Poland or the tarantella with Italy. I have noticed, however, that circles in which the participants direct their energy inwards, away from anyone else who may be nearby, seldom occur in our dances. Close partner dancing is also rare. A dancer may take another by the waist or around the shoulders, but the intimacy of the circle is opened into a line where the individuality of each performer can be displayed.

Twenty years from now, individuality and eccentricity will, I hope, still be valued, and I am crossing my fingers in hope that some genius emerges who can bring to the choreographer a software program that provides the impetus that the will of the dancer brings to the creative process.

We now look back at the great moments of dance . . . the glory days that our books and our teachers tell us about . . . the days when Louis XIV was intent upon perfecting the *entrechat* . . . the days when Marie Taglioni was not only *Queen of the Dance,* she was the icon of an era . . . the days when Isadora Duncan tossed her shoes and her corsets into the wind . . . the days when Nijinsky captured the world's attention . . . the days when Fred Astaire, Martha Graham and George Balanchine were on magazine covers!

In twenty years we will be looking back at what we are now looking forward to. We will be remembering the diversity and vitality of dance at the turn of the 21st Century and saying to our children and our students, "I wish you could have been there!"

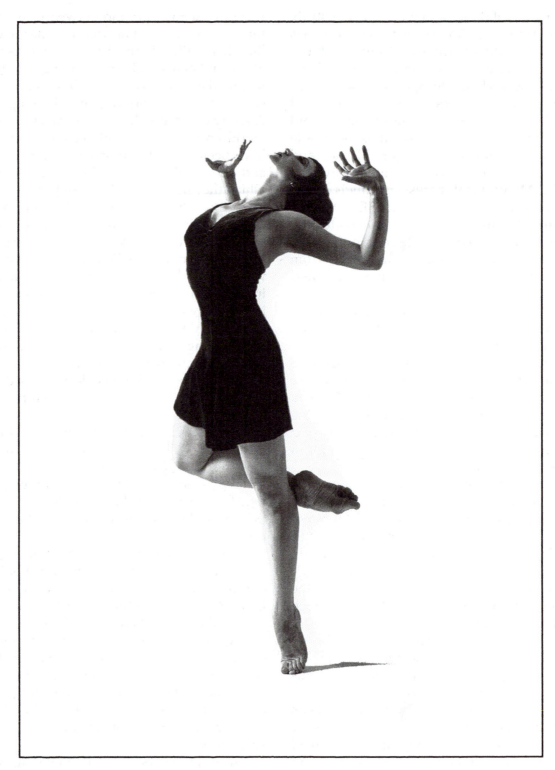

This young dancer, like hundreds of thousands around the world, trains daily so that her body and mind are strong and flexible, and when fused, can become a conduit for the articulation of self-expression and the eloquent communication of the ideas that inspire her.

Appendix

Reviewing Chapter 1

To be sure that you know the basic elements that dance historian Selma Jeanne Cohen says are required for **theatrical** dance to occur, list them here!

By the time you finish this study of dance it should be second nature for you to spell the word **rhythm** correctly. To begin . . . write it out by hand five times!

Then be sure you understand that rhythm is not the beat, or the measure

Rhythm is a _____, _____ of _____.

Be sure you also understand the meanings of the words **order and dynamics** as Walter Terry uses them in his definition of theatrical dancing.

Familiarize yourself with the eight action words that Rudolph von Laban used to describe **effort**.

A quick, strong, and direct movement..............**punching**
A quick, strong and indirect, movement...........**slashing**
A quick, light, and direct movement................**dabbing**
A quick, light, and indirect movement..............**flicking**
A sustained, strong, and direct movement.........**pressing**
A sustained, strong and indirect movement......**wringing**
A sustained, light and direct movement...........**gliding**
 A sustained, light and indirect movement........**floating**

Identify a physical activity, (from everyday life, dance, or sports, etc.) that could serve as a clear example of each of these efforts. For example, "The principle movement involved in texting is **dabbing**."

Start **looking** at dance and practice **describing** movement in your daily writing.

Reviewing Chapter 2

AFTER READING CHAPTER TWO, SEE IF YOU CAN FILL IN THE BLANKS

The ideals of balance, order, and harmony are often associated with the Greek god _____ _____. Theatrical dancing in Ancient Greece originated with the _____, a sometimes wild celebration in song and dance dedicated to the god _____, who represented chaos and new life for old forms. A rebirth of the Ancient Greek ideas of aesthetics and scientific education in the 14th and 15th centuries, called _____ _____ , gave birth to the first ballet. The first prominent member of the nobility to sponsor ballet was _____. The first ballet was presented in the year _____. Its choreographer was_____. In 1651, _____ _____ founded the first academy of dance in Paris. In the year _____, Mlle la Fontaine was the first female dancer to appear at the Paris Opera. In the 18th century, to prove that virtuoso dancing was as much a women's profession as it was a man's, _____ _____ took a pair of scissors and shortened her long skirts. The costume innovations of her rival, _____ _____ were in the service of expression of inner feelings, not technical display. Reflecting the democratization of Europe, one of the first ballets to present ordinary people rather than gods, princesses, or mythological figures as its leading characters was _____. It was choreographed by _____ _____ in the year _____.

Reviewing Chapter *3*

The cast of characters that played out the Golden Era of Romantic ballet are like the cast of characters in a modern soap opera. See if you know who they were and why their personal lives as well as their professional contributions help us understand the romantic nature of dance. Identify the following descriptions with the appropriate name from the given list. You will be able to better remember the names and their importance if you write each one out in full.

Benjamin Lumley	Jules Perrot	Theophile Gautier	Marie Taglioni
Filippo Taglioni	Carlotta Grisi	Lucille Grahn	Arthur St. Leon
Catherine the Great	Marius Petipa	Fanny Ellsler	Fanny Cerrito

- He groomed his daughter for stardom. _____

- In 1845, she was considered *"la reine de la danse,"* and the epitome of the ethereal nature of Roma nticism. _____

- He knew a good box office draw when he saw it. _____

- She represented the earthier side of Romanticism but did not receive an invitation to appear in the grand "Pas de Quatre" but did dance for the American Congress.

- Not only was she good enough to dance alongside Taglioni, she had well-turned calves, something always admired in ballet, and a beguiling smile. _____

- The youngest of Marie Taglioni's rivals, she was the protégée of the Danish choreographer, Auguste Bournonville and could turn on her toes. _____

- He choreographed "Pas de Quatre" but lost his wife to his critic and went abroad.

- After his reviews and articles had made a certain ballerina famous, he stole her from her choreographer husband. _____

- Considered by many to be a more complete dancer than Taglioni, she was the first to portray the role of Giselle, but was not so true to love in her private life.

- She lent royal support to the development of ballet in Russia.

- He choreographed "Coppelia" in Paris and worked in Russia.

- He was the Frenchman who was to change the face and make the name of "Russian Ballet."

NOT YET SURE?

Here is a little true or false exercise to check your grasp of what we have covered so far. If you are not yet sure of a particular answer, don't guess, pencil in **NYS** for not yet sure. If you find something untrue, pencil in something that indicates what is.

_____ All dances tell a story.

_____ The Greeks personified their ideals of order and harmony in the god, Apollo.

_____ The celebrations in honor of the god, Dionysus, featured the dithyramb, a slow dance of contemplation and reverie.

_____ During the Renaissance, dance was frowned upon as a useless pastime of the lower classes.

_____ Ballet was born on the streets of Madrid.

_____ The first "ballet" was presented in 1581.

_____ Only women were allowed to appear in its cast.

_____ Catherine de Medici and Catherine the Great were the first ballerinas to appear on the stage without wearing masks.

_____ Marie Camargo and Marie Sallé were strong defenders of tradition.

_____ Although the leading ballerina of "La Fille Mal Gardée" is a peasant girl the attitudes and épaulement with which she moves had royal beginnings.

_____ Marie Taglioni and Fanny Ellsler retired and opened a private studio together.

_____ The hero of a Romantic Ballet is most apt to be a pessimist.

_____ The leading male role in "Coppelia" was first portrayed by a woman.

_____ The toe shoe was developed as an adaptation of a farmer's boot and was initially used for percussive dances.

_____ As it turns out, perhaps the most important name in the development of Russian classical ballet is that of a Frenchman.

Here is a list of some of the most important producer/patrons, teachers, composers, choreographers, and dancers each of whom has contributed to the development of classical ballet in Russia or in its subsequent Diaspora and contemporary development around the world. Write the name of each person in the proper category and add a few words that will help you remember each person's contribution and the period in which they were active. Some of these folks may fall into more than one category.

Catherine the Great	Agrippina Vaganova	Enrico Cecchetti	Marius Petipa
George Balanchine	Serge Diaghilev	Vaslav Nijinsky	Piotr Ilyich Tchaikovsky
Igor Stravinski	Lincoln Kirstein	Mikhail Baryshnikov	Leonid Massine
Serge Lifar	Ninette de Valois	Marie Rambert	Lew Christensen
Alicia Markova	Anna Pavlova	Michael Fokine	Tamara Toumonova

- Producer/Patrons:

- Teachers:

- Composers: *(list their significant dance works and the choreographers with whom they collaborated)*

- Choreographers: *(list their significant works and the composers with whom they collaborated)*

- Dancers:

See if you can list these ballets in their chronological order. Can you identify the choreographer of each?

Serenade	The Firebird	Push Comes to Shove	Giselle
Swan Lake	Ballet Comique de la Reine		The Grand Pas de Quatre
The Nutcracker	La Fille Mal Gardee		La Sylphide

1. _____ by _____

2. _____ by _____

3. _____ by _____

4. _____ by _____

5. _____ by _____

6. _____ by _____

7. _____ by _____

8. _____ by _____

9. _____ by _____

10. _____ by _____

GO SEE A LIVE PERFORMANCE

If you haven't already done so, make plans to attend a live concert dance performance. In order for you to exercise your looking skills and your expanding knowledge of dance you should get your tickets for a company that has a professional reputation. For the purposes of this study of dance, you should avoid any performance that is in reality a recital for a private studio. Such performances, no matter how earnestly done, serve a different goal than a performance by a professional company or serious academic center.

A Musical Theatre production should not be your first choice unless there is no other option and you have been assured that the show you are going to see contains a substantial amount of dancing and has bone fide dancers in its cast, not actor/singers who can hoof their way through an entertaining "number".

Start your search for what you would like to see. Buy your tickets in advance and mark your calendar. Read Chapter Seven "Attending a Performance and Writing About it" and begin to prepare yourself for the event and for the report that you will want to write.

INTERVIEW THREE DANCERS

Somewhere in your acquaintance you should be able to identify three people who are presently dancing professionally or are seriously preparing to do so. Ask them to describe the moment when they realized that dancing was an extraordinary activity. Get them to speak of the reasons they believe they are dancers by nature and are willing to accept the sacrifices that the pursuit of that nature entails. Note the things about which they are concerned. Ask them where they think they got their talent and what role they can imagine that dance will play in their lives when their performing careers are over.

Work sheets for Chapters 6/7

I. **Here is a list of important figures in the development of modern dance. Write each name (correctly spelled) in the blank that occurs in the sentence that briefly describes each person's accomplishments.**

Alvin Ailey	Jack Cole	Merce Cunningham	Eugene Dalcroze
François Delsarte	Isadora Duncan	Martha Graham	Erik Hawkins
Hanya Holm	Louis Horst	Lester Horton	Doris Humphrey
Kurt Joos	Harald Kreuztberg	Bella Lewitsky	David Parsons
Ted Shawn	Ruth St. Denis	Paul Taylor	Rudolph von Laban
Charles Weidman	Mary Wigman		

_____ threw her shoes and corset to the wind and set out to return simplicity and naturalism to theatrical dancing.

_____ was inspired by the exoticism of other cultures and, with her husband, opened a school that provided comprehensive training for young American dancers.

Her husband _____ formed an all men's group and founded the Jacob's Pillow Dance Festival.

Much of the early modern dance choreography explored the theories of the evocative power of gesture put forth by the French painter _____.

_____ developed Eurhythmics, a system for teaching music through movement.

At the Denishawn and Juilliard Schools, _____ taught modern dance choreography through the study of pre-classic forms.

Among the choreographers he mentored was _____, who embraced the concept of "contraction and release".

Her colleague at the Denishawn School, _____, was more drawn to the concept of "fall and recovery".

The choreography of _____, another Denishawn dancer, was often humorous and socially sensitive.

Both Hollywood and Broadway benefitted from the talents of another Denishawn alumnus, _____.

"The Green Table", an anti-war ballet and powerful example of abstract impressionism was choreographed by _____.

His colleague, _____, put forth theories of effort and shape and devised a system of movement notation.

Another German dancer and choreographer, _____, spread the influence of abstract impressionism to the United States and Japan.

The choreography of _____was often strong, percussive, and independent of music.

A student of German Tanztheatre, _____, came to America just before World War II and established herself as a Broadway choreographer and a beloved teacher of Modern Dance.

A student of Michio Ito, _____settled in California and developed a vigorous system of training that helped form the aesthetic of his students, in particular _____, the choreographer of "Revelations", and _____, a woman of fearless conviction.

The first male dancer to join the Martha Graham Company but left to pursue a gentler approach to movement was _____. _____, another male dancer who, for a time performed with Graham, preferred to create his choreographies employing chance methods.

_____ also left the Graham Company to form his own company, which became widely popular because of his humor, athletic lyricism, and tongue-in-cheek satire.

One of his principal dancers, _____, in the tradition of Modern Dance now heads his own company, which often performs a work in which the dancer is never seen to touch the ground. What would Martha Graham think?

II. **Can you answer these true and false questions correctly?**

_____ 1. Both the aesthetic and the movement vocabulary of ballet demand that the accomplished dancer of that style have a sophisticated vertical alignment.

_____ 2. The five basic feet positions of ballet were codified at the Denishawn School in California.

_____ 3. As did the Russian choreographers during the Soviet era, American choreographer Bella Lewitsky conformed to governmental restrictions on the subject matter of her dance works.

_____ 4. Paul Taylor first danced for Martha Graham before forming his own company.

_____ 5. Isadora Duncan rejected the use of Grecian tunics as old fashioned and inappropriate for 20th century Theatrical dancing.

_____ 6. Alvin Ailey choreographed "Serenade" in 1939.

_____ 7. Merce Cunningham, left the Martha Graham company because he wanted to make dances that told stories.

_____ 8. Balanchine's ballet "Agon" was choreographed to the music of Igor Stravinski.

_____ 9. All dances tell a story.

_____ 10. In the neo-classic ballets by Balanchine the elaborate costumes and headgear worn by the dancers accounts for the stateliness of the choreography.

_____ 11. In "La Sylphide" the choreographer Taglioni dressed his daughter in a short tutu that revealed the thigh as well as the ankle.

_____ 12. The orientalism that Ruth St. Denis employed in her choreography was inspired by her many years of study in China.

_____ 14. After the Communist revolution in Russia the government banned all ballet performances.

_____ 15. "Revelations" was an evocation of choreographer Alvin Ailey's Italian heritage.

III. For each of the previous statements that were false, could you provide two different changes that would make it correct? For instance, in reaction to question # 5 you might say . . . "Isadora Duncan embraced (rather than rejected) the use of the Grecian tunic", and then you could also say, "Duncan rejected Ballet"

IV. Could you list these ballets in their correct chronological order? It would be even more impressive if you could also list the choreographer of each, correctly spelled.

Serenade	*The Firebird*	*Push Comes To Shove*	*Giselle*
Swan Lake	*Ballet Comique de la Reine*	*The Grand Pas de Quatre*	
The Nutcracker	*La Fille Mal Gardee*	*La Sylphide*	

1. _____ by _____
2. _____ by _____
3. _____ by _____
4. _____ by _____
5. _____ by _____
6. _____ by _____
7. _____ by _____
8. _____ by _____
9. _____ by _____
10. _____ by _____

CREATE A POWER POINT PRESENTATION

With all the information and materials now available by just surfing the internet, preparing a PowerPoint presentation on a visually appealing subject such as dance would be an effective way to demonstrate your ability to engage in independent research and present your findings in a cogent and interesting format.

Prepare a PowerPoint presentation that explores an aspect of dance that is of particular interest to you but is not covered in great depth in this book or any of the lectures associated with it. Make it something that you might present to your family or to a group at a community center, or prepare for a class assignment. You might present an illustrated exploration of the history and significance of a particular social dance such as the polka, the tango, etc. You might present an illustrated exploration of the life and work of someone who had made a significant contribution to society through dance. You might do something a little more personal. Here are some other suggested topics: "Aerial Dance", "Percussive Dance", "The Place of Dance in Ritual", "Dances of my Ancestors". Since chances are you will probably not be presenting this project to a live audience, keep the written notes that accompany each slide to a minimum. Try to present all the information on the slides themselves. Don't forget a title slide with your name on it and a slide (or more) containing bibliographic information.

WRITE A SHORT STORY

Use your knowledge about dance to create an authentic setting and describe an incident when the life of an ordinary person was touched by a dance experience.

Reviewing Chapters 8/9

COULD YOU WRITE A BRIEF, INTERESTING, AND INFORMATIVE PARAGRAPH ABOUT ANY OF THE FOLLOWING TOPICS CONCERNING OUR AFRICAN AMERICAN DANCE HERITAGE?

What happened when drums were taken away from the slaves?

Why should we remember Congo Square and the Cakewalk?

Who was William Henry Lane (known as Juba)?

What happened when Appalachian Dances were combined with those of the African-American?

What happened when Alvin Ailey combined his childhood experiences as a black American with Modern dance techniques?

The misguided but important place of the American Minstrel Show.

What did Bill Bojangles Robinson do for tap dancing?

The Savoy Ballroom, the Lindy Hop, the Jitterbug, and Swing!

From East Saint Louis to Chicago, to Haiti to Hollywood, what were the many contributions of Katherine Dunham!

The theatrical development of the street dances of contemporary urban America.

Here are ten names of dancers or dance styles discussed in this chapter. After careful consideration draw arrows to match them with the appropriate description.

Fred Astaire

Punch and contained
Simple in rhythm
Full of complexity

Jack Cole

Vertical torso
Active and audible feet

Hoofing

Enthusiastic tapping with the weight
mainly on the whole foot

Busby Berkeley

Brought sophistication to tap dancing
by getting the weight off the heels

Jerome Robbins

Dancing movie star
The epitome of sophistication

Hip-Hop

Brought his war-time experience to the
creation of pattern dances that were
filled with pretty faces, pretty legs
and innovative camera angles

Agnes de Mille

Brought his all-American smile,
athleticism and ingenuity to the
Hollywood musical

Tap Dance

Broadway and Hollywood choreographer
Studied at the Denishawn school
Noted for the use of isolations

Gene Kelly

Choreographed for ballet and Broadway.
Noted for developing the story of a musical
through the use of the dream ballet

Bill "Bojangles" Robinson

Choreographed for ballet and Broadway
and for the Academy Award winning
movie "West Side Story."

BE SURE YOU ARE FAMILIAR WITH THE INFLUENCES ON JAZZ DANCE THAT COME FROM OUR WESTERN THEATRE HERITAGE

Vaudeville dances become more sophisticated

The Russian ballet Diaspora reaches California

Busby Berkeley and the extravagant movie production number

The Denishawn School in Hollywood

Jack Cole (who brought influences from Asian Forms . . . including "isolations")

Lester Horton (Alvin Ailey's teacher)

Fred Astaire and Ginger Rogers

Hermes Pan Gene Kelly Jerome Robbins Bob Fosse

Gus Giordano from Chicago

Michael Jackson and MTV

The theatrical development of the street dances of contemporary urban America

IF YOU HAVE BEEN WATCHING JAZZ DANCING ON CURRENT TELEVISION SHOWS AND ON YOUTUBE, HAVE YOU BEEN PAYING ATTENTION TO THE CHOREOGRAPHERS?

WHO ARE THE NEW CHOREOGRAPHERS OF TODAY WHO ARE RIDING THE CREST OF POPULARITY? COULD YOU IDENTIFY THOSE WHOSE WORK PLEASES YOU AND WHY?

FROM WHERE YOU ARE SITTING, IN WHAT DIRECTION DO YOU THINK TODAY'S TRENDS ARE TAKING THEATRICAL DANCE?

Reviewing Chapter 10

- What do you think about the following statement?

 "It is the looking at an ordinary movement *as dance* that makes it a *dance*." Would Selma Jeanne Cohen agree?

- Do you understand what is meant by the term "phenomenalism"?

- Who do you think is responsible for the meaning of a dance? Is it the choreographer? If not, why not? Is it the dancer(s)? If not, why not? Is it the critic, journalist, or historian? If not, why not? Is it the viewer? If not, why not?

- Who was the young American choreographer who created a solo for himself in which he did not move? Why do you suppose he did that? How might you have reacted had you been in the audience?

- Who was the choreographer who is best known for embracing the concept of making choices by employing chance methods?

- Who was the composer that most affected him?

- Who was the 20th Century ballet choreographer who stripped away the stories that once were expressed through classical ballet and created works that deal with the act of dancing itself and are often referred to as "abstract"?

- Who was Louis Horst and what were his contributions to dance?

- Who was the first male dancer to join Martha Graham's company?

- What was the background of Alwin Nikolais' teacher?

- What was the philosophy of the dancers of the Judson Church group? Do you think they had a tenable idea?

- What are the dances that you have most enjoyed viewing?

- Could you identify the periods of history when dance was Apollonian and when it was Dionysian?

- Having looked at the trends and development of theatrical dancing, how would you describe the dancing of today? Might you guess where the next trend will be?

THE STUDIO EXPERIENCE

Part of learning about dance is looking at it, part is about discovering its history, and part is about experiencing it . . . kinetically . . . for yourself . . . in a dance studio or other space where people can dance together.

The dance studio is a unique space. It serves as classroom and research laboratory, sometimes doubling as performing space or gallery for photographs and trophies. It is a haven for many, whether insanely busy or serenely deserted, and it is never big enough. A dance studio may appear cluttered and casual, even chaotic at times, but there is a certain order and etiquette that is not always understood by outsiders. In a way, going into a dance studio is like going into a church. You may not know what the exact rituals are, but giving respect to what you see will keep you from making a faux pas.

Cell phones should be turned off as you approach the door. Be prepared to take off your street shoes the moment you enter: dance floors may look scruffy but they are kept as clean as possible. Except for bottled water, food and drink are not allowed. Lurking is not acceptable. It makes the people around you nervous. Don't hang back! Join in the activity!

Don't be concerned about your level of expertise. Workshops such as the six suggested here can be found in any active community. They are specifically designed for people with limited dance experience. The class will be more enjoyable if you go with some friends but once you are there, work by yourself or with someone new you have just met.

Be sure to know what attire and footwear is recommended or required. Bare feet would be suitable and even recommended for a first experience in each of these genres. Unless you are taking a ballroom or flamenco class, a dance workshop is apt to include a warm-up and cool-down period when you will be asked to lie on the floor; so if you insist on wearing a skirt, make it a long and full one.

And don't be late! The warm-up and opening moments of a class are, more often than not, the most valuable. When entering the studio, lower your voice and refrain from any unnecessary conversation. Once the class begins you do not speak at all unless it is apparent that the instructor is calling for your questions or for answers to her or his questions. It is not always the case in workshops such as these but it is a tradition for a dance class to applaud the teacher and accompanist at the end of the session. This applause acknowledges the experience that has been shared and, as it eliminates the need for each student to thank the teacher and musician individually, it leaves more time for dancing.

During the class, don't think too much, just experience the movement. You can think about what you have done afterwards and about the relationship of the experience to what you have been reading and viewing. Be sure to take time to write down those thoughts.

SOCIAL DANCING

A country-western workshop or a lesson in salsa would be suitably challenging for both the beginner and the person with a little more experience. Here a skirt would be the proper attire for the women, a full one with petticoats for the country-western, or a slinkier one for the salsa (or any other Latin dance you may prefer to start with), but almost anything will do, even slacks, as long as you have a defined waist. The gentlemen, too, need waistlines and should tuck in their shirts. The gentlemen will act like gentlemen, not a bunch of guys at a party, and the ladies will not giggle. Everyone respects their partner whether or not they are easy to dance with. Don't apologize when you think you have made a mistake. Smile at your partner, say thank you and try again!

It will help you understand and retain what you have learned in the session by describing it in writing afterwards. Be sure that you can report how you felt before the studio session began and how you felt afterwards.

AN INTRODUCTION TO BALLET

A bona fide ballet dancer's outfit is not required for a first class in ballet fundamentals. Ballet slippers take time to break in before they are comfortable. Wearing tights and leotards will only make you and the rest of the class uncomfortable. Fairly snug but stretchy sweat pants would be the best thing to wear, something that allows you to bend your knee and lift it to the side without binding. Athletic shorts are so baggy these days, they can in no way help you experience the aesthetic of ballet. Besides, you want to keep your muscles warm.

AN INTRODUCTION TO MODERN DANCE

If the instructor of your Modern Dance workshop has a background in Graham Technique you will certainly spend some time doing floor work and learning about "contraction and release". Your workshop might be based upon Doris Humphrey's concept of "fall and recovery", or upon release techniques that are designed to minimize tension. You may be encouraged to move spontaneously, at your own pace, and in your own manner.

AFRIKANA DANCE

As you experience polyrhythm and polycentrism your head will become a locus of movement. Be sure you have a head band to keep your hair from distracting you. If your instructor adheres to the teaching of Katherine Dunham, you will have a vigorous warm up and there will be more than mild stretching in the cool-down. Your legs will enjoy a good hot soak afterwards.

JAZZ DANCE

You'll want to look snappy for this workshop. Hair can be free if you would like, but, as in every dance class, it mustn't be a distraction. Whether your class is based upon Bob Fosse's style or Gus Giordano's teaching, it will contain elements that can be traced back to Jack Cole. Hip-hop might be included as well as some wonderful "vintage" dances, such as the Lindy Hop and Swing.

CREATIVITY

A studio experience in creativity, the making of something original, is not a room full of people aimlessly searching for new steps or ideas. Through improvisation and more guided exercises, this sort of workshop presents strategies to help a dance maker get started and keep going. During the process of discovering, identifying, and ordering movement material, the decisions that have to be made are no longer theoretical.

SOME MORE THINGS TO DO

GO OUT DANCING

A sure way to see dancing and to participate is to attend a family wedding reception. Latin dances are popular today with salsa being a particular favorite. Country Western dancing is done in bars and in social clubs that cater to senior citizens, teenagers, and families. If there is a college in your vicinity, there will be some establishment that provides suitably loud music and a good-sized dance floor. Go on a night you can expect it to be crowded. Work up a good sweat.

ENROLL IN A DANCE CLASS

Take some new steps. If you are not already enrolled in a dance class of some sort, search out a similar movement experience. Your age or previous dance "know-how" does not matter. Look for something that is more than a one-time event. Going out one night to learn a little salsa dancing or country swing can be invigorating and enlightening, but the idea here is to seriously explore something that is just a bit beyond your grasp.

Somewhere near you at a school or community center, at a YMCA or a private studio, you will find a class suitable to your interests, your abilities and your schedule, a ballroom class perhaps, or ballet, folk dancing, or jazz.

As you look at the movement classes available, give your consideration to those involved in arts and entertainment . . . where the end result is to reach an aesthetic goal, not just to strengthen or stretch.

If you have taken studio classes before, consider exploring a new form of dance expression, even though it may be a little awkward or difficult for you at first.

You will learn the most from your classes if you will approach them as does the professional dancer, as a daily exercise in humility, requiring the careful scheduling of your time, cheerful submission to informed discipline, and an honest effort to suspend judgment about your own performance.

WRITE A LETTER

Benjamin Franklin advised that the best way to learn to write well is to compose letters to imaginary individuals. Pretend that you have just begun an overseas correspondence with a pen pal who speaks and writes English and who has indicated some interest in dance. Compose a letter that tells your correspondent how you came to be reading this book or ended up in a class that uses it. Share with your correspondent specific information about your experience (or lack thereof) in matters of dance. If you have recently enrolled in a dance class, describe some of the material of that class and share with your correspondent what you have learned so far, interesting or useful, and how you feel about it.

WATCH OTHER PEOPLE PERFORM

Go to some occasion where people perform movement in front of other people, a show, a ballet, a half-time event with the marching band and cheerleaders. Most community festivals will have a pavilion where local singing and dancing talent is featured, and where tap, jazz, and hip-hop are likely to be seen, as well as clogging and Mexican folkloric dancing. Many festivals will have African dancing, and, if you are lucky you may find dances from South America or India, or the countries on the other side of the Pacific Ocean.

Compare the demeanor of the performers with that of the dancers you have seen when you went out social dancing and, supposedly so, one was "performing". Some people are good dancers, some people are good performers, and some people are both. Pay attention to how the inexperienced dancers make their way through a performance, with frozen smiles on their faces. Look at the assurance of the older, better dancers. Watch the audience watching the dancers. What are they enjoying; the earnest effort of the dancers or the catchy rhythm?

KEEP A JOURNAL

The more you sharpen your observational powers, the more you will see. The more you see, the more you will want to remember. If you don't already keep a journal, start one to accompany your investigation of dance. Write down what you remember of what happened each time you have seen dancing. Describe the activity as clearly as you can. Then go on and write about how you felt or still feel about it.

A journal sharpens your observational skills. It frees your mind from the burden of having to remember everything all of the time. Sometimes your ideas become more lucid when you are discussing things with yourself than when you are worrying about what others think you ought to think. A journal can help in the writing of a letter or paper directed to someone else, but the best thing about a journal is that you don't have to agree with anyone else, and you don't have to pretend to understand.

DO SOME INDEPENDENT READING ON ONE OF THE MOST FASCINATING PERIODS OF HISTORY

The development of the classical ballet in Russia and its Diaspora, first to Paris with the Ballets Russes and then around the world, is a story of colorful personalities caught in a world of change. There is a great deal of fascinating and first-hand information available in the books written in and about this period. Start with an internet search of the names listed here. They are sure to lead you to more than one book which appeals to your particular interests.

Leon Bakst Cyril Beaumont Alexandre Benois Adolph Bolm Enrico Cecchetti

Alexandra Danilova Serge Diaghilev Isadora Duncan Serge Lifar Leonid Massine

Mikhail Mordkin Bronislava Nijinska Vaslav Nijinsky Pablo Picasso Marie Rambert

Olga Spessivtseva Ruth St. Denis Igor Stravinski Ninette de Valois

DANGEROUS AND FORBIDDEN WORDS

Presently, we are part of a culture in which "texting" provides an alternative but not always appropriate language for communication . . . where the short cut is the norm, the cliché reigns, and full sentences are rarely written. There will be a great deal of writing asked of during this course of study. Descriptions need to be made with clarity so the person reading your words can, to some extent, share in your experience. The cautions made here are aimed at improving the effectiveness of your writing by correcting common mistakes that are made too often these days . . . mistakes that prevent you from using the English language to its full potential.

DANGER
USE WITH CARE

FUN and VERY FUN

FUN is **not** an adjective, it is a noun. You can have **fun** but it is not correct to say "I had a **fun time.**" Say, "I had a good time. I had fun. It was fun." Fun is a noun and as a noun it is modified by adjectives...**good** fun, **outrageous** fun, **gentle** fun.

The modifier "**very**" (like really and truly and unusually) is an adverb. Adverbs modify adjectives and verbs, not nouns. Your meaning is fuzzy when you say **"very** fun." Your meaning becomes clearer when you say "unusually **good** fun", "truly **wild** fun", "really **gentle** fun".

But you can be even clearer. **Fun** is often used as a catch-all term that gives a general but not specific meaning. What does it mean, "I had fun!" (or if you wish to include others involved in the experience) "We had fun!"? Give us some interesting details..."**we sweat, we laughed, we lost our breath, we skipped down the hill**" . . . something that gives more specifics than just "It was fun." Tell us what made **the experience** "fun"!

UNUSUAL and UNIQUE

Unique means **unlike anything else, truly one of a kind**. Don't use **unique** when you mean **unusual** (or **strange, odd, extraordinary, abnormal, bizarre, remarkable, atypical**, etc.) **Unique** does not take the modifier *very*. It is either one of a kind or it is not. You might say, however, that something is *truly* unique.

PLETHORA

It may sound fancy, but **plethora** does not mean "a great many"! **Plethora** means "more than enough", "an over abundance", which is not usually the best of situations.

INFAMOUS

It may sound fancy, but **infamous** does not mean "well known". **Infamous** means having or deserving a bad reputation.

SIMPLE and SIMPLISTIC

Do you know the difference between **simple** and **simplistic**? **Simplistic** is not a complementary term, it means to simplify something unjustifiably. A dancer in an undecorated form-fitting unitard is wearing a **simple** costume. When Marie Antoinette was informed that the Parisian citizenry had no bread to eat, her solution, "Let them eat cake!" was **simplistic**.

MOVES and ROUTINES

Don't use the word **moves** when referring to the movements or steps of the dancer(s). Use the words movements, steps, choreography, or even maneuvers. The term **move** is common slang within the profession but most choreographers and dancers do not appreciate their dances or dancing to be called **moves**. Nor do they always like their work or particular sections of their work being referred to as **routines** or **numbers**.

IN SYNC and SYNCHRONIZATION

"**In sync**" is a slang expression. Be sure to use the full and proper term **synchronized** (and there is an **h** in there). Although the word suggests that several things may be happening at the same time it doesn't mean they are happening **in unison,** but rather, with sophisticated coordination of individual tasks to reach a common goal.

MORE or LESS (Than What?)

It is pointless to say one type of a dance is **"more of a fast dance"** unless you tell us **"faster than what"**. The same is true of "less." Don't say a dance is less energetic unless you tell us that it is less energetic than another type which should also be identified.

TYPE and PACED

Let's get rid of the words **type** and **paced!** Saying *"It was a fast-paced type dance"* is a double redundancy. Simply say *"It was a fast dance."* Rather than saying "The Tarantella is a *more fast–paced type of dance"*, say that "The *Tarantella is a faster dance than the waltz."*

RHYTHM

Many people find the spelling of rhythm difficult. Writing the word out, over and over, like a child on a blackboard in school can help with this problem As well as spelling the word properly, be sure to use it correctly as well. As discussed in Chapter One, rhythm does not refer to the beat, the meter, or the velocity of a dance. Rhythm is a repeated pattern of emphasis.

BASED ON not BASED OFF OF

Things are set **on** a base, not off it. When a choreographer, director, or author uses an idea or storyline that already exists, he or she is basing his new work **on** an earlier one. If the work is satirical it could be referred to as a **take off**. If the work is not original and has usurped someone else's ideas it would be referred to as a **rip off**.

TRANSITION (as a noun or a verb)

A **transition** is the passage from one mode or state of existence to another, not just a move from here to there. Although the noun **transition** has begun to be accepted in a verb form, **to transition,** it is a faddish and unattractive term. There are so many other more specifically descriptive words that are better able to give nuance enhance to your meaning; to grow, to change, to transform, to shift, to progress, to go by foot, etc.!

INSPIRATION

To inspire is to stimulate a person to activity or to the expression of certain ideas.

Just feeling good about something is not the same as being inspired by it. For instance, on YouTube there is much footage available showing dance groups for the disabled. Upon seeing these groups many people will report that they were inspired. But without a resultant action they have not been inspired . . . just encouraged to "feel good" about the disabled. If they were inspired they would donate to the cause of the disabled, send the video to lots of friends, or sign up for a dance class. . . . or commence some other activity.

Being inspired by something tells us about the writer but not about the thing that stimulated the writer. Tell us what it was about this phenomenon that moved you into action and what action you took.

AVOID HYPERBOLE AND EXAGERRATION

Use vocabulary that is active and descriptive. Fancy phrases sometimes tell us too little about the topic and too much about the author.

AND WHEN YOU PROOF READ, CHECK YOUR MODIFIERS!

Do you need all those adjective? Try reading your sentences without them. If they don't add anything, don't use them!

DANGER
FORBIDDEN WORDS DANGER

Here is a challenge that will help build your working vocabulary in pursuit of clear, informative, and engaging communication.

WHEN YOU ARE DESCRIBING DANCE CAN YOU REFRAIN FROM THE USE OF THESE WORDS?

ACTUAL or ACTUALLY

Actually is the one of the most unnecessary words in common usage today. It litters our conversation and communication. It infers that the person to whom we are addressing the information might have some reason to doubt what we are telling them.

AMAZING and AWESOME

The word **amazing,** which means **overwhelming with wonder** has become a common slang term for anything mildly impressive. The word **awesome** has, in common usage, also begun to lose its essential meaning. Don't use **awesome** or **amazing** in your formal writing unless you are describing an experience that has stopped you in your tracks and made your jaw drop as you were overwhelmed with wonder! Look for words that tell us about the experience, such as, surprising, startling, bewildering, thrilling, confounding, etc.! And then go on to describe what it was that thrilled or confounded you.

Here is a passage from "Balanchine Variations", a recently published collection of commentary on the choreographic works of George Balanchine, by Nancy Goldberg. Notice how Miss Goldberg uses the word "amazing" and then tells why. About "The Four Temperaments" she writes . . .

"My own favorite adjustments to the aerial arabesques are the ones the Sanguine couple does. They are amazing, in part, because the man carries the woman at chest level rather than at full arm's height. Flying at such low altitude, and with a seamlessness that creates an illusion of slow motion travel, the woman is the image of inverted power. She is capable not of mowing the world down, but of absorbing it into her own being."

IMPACT (as a noun or a verb)

Although the noun **impact** has begun to be widely used in the verb form, **to impact (something)** is a faddish and unattractive usage of the word. The essential meaning of the word **impact** implies a collision or a blockage occurring because of the collision (such as impacted teeth). **To be impacted** . . . what an unpleasant image that brings to mind when all you really want to say is that something had an influence on you. There are plenty of other words that can tell more about the experience; moved, prompted, persuaded, affected, propelled, swayed, impressed, etc.

OVERALL or ON THE WHOLE

Remember that you are observing and describing. It isn't always necessary to sum things up and come to a neat conclusion but if you feel so compelled, don't equivocate! Do not start with ambivalent phrases like **overall** or **on the whole.** Avoid such modifiers as **rather, somewhat, kind of,** and **generally.** Make strong statements that tell us why you did like some things but are not comfortable in reporting that everything achieved the same level of performance or presentation.

PREFORM(sic) for PERFORM

You must avoid this careless, too common, and potentially embarrassing mistake of writing the nonexistent word **preform** when you mean **perform. Pre-form** means to form something ahead of time.

TO A WHOLE NEW LEVEL (or worse) TO A WHOLE OTHER LEVEL

You must avoid these clichéd and empty phrases when extolling the accomplishments of a particular dancer or choreographer. Tell us what the conditions were before this person made his/her contribution(s) and what followed.

"&" for "AND"

Texted English, with its necessary and sometimes colorful abbreviations, is not the same as written English. It is as if those who text are bilingual, which is a good thing, but don't get your languages mixed up.